PHOTOSHOP
Photo Effects Cookbook

PHOTOSHOP
Photo Effects Cookbook

Tim Shelbourne

ILEX

PHOTOSHOP PHOTO EFFECTS COOKBOOK

Copyright © 2006 The Ilex Press Limited

First published in the United Kingdom in 2006 by:

I L E X

The Old Candlemakers, West Street

Lewes, East Sussex

BN7 2NZ

Publisher: Alastair Campbell

Executive Publisher: Sophie Collins

Creative Director: Peter Bridgewater

Managing Editor: Tom Mugridge

Project Editor: Ben Renow-Clarke

Art Director: Julie Weir

Designer: Ginny Zeal

I L E X is an imprint of the Ilex Press Ltd

Visit us on the Web at:

www.ilex-press.com

This book was conceived by:

I L E X , Cambridge, England

British Library Cataloguing-in-publication data.

A catalogue record for this book is available from the British Library.

ISBN 1-904705-61-8

Printed and bound in China

For more information on this title please visit:

www.web-linked.com/sdpeuk

Contents

READY
TO COOK

INTRODUCTION

This is a cookbook with a difference. You won't need any perishable goods to follow these recipes, and there's no slaving over hot stoves. Adobe Photoshop CS2 is your virtual kitchen, and the only ingredients you need are your own creative talent and enthusiasm. The analogy with cookery is really more accurate than it might at first seem. Photoshop presents the digital creative with an amazing range of cooking tools and ingredients, which, when used in the right combinations and amounts, enable you to make rich, cordon bleu images.

Essentially, nothing is impossible with Photoshop. Reality can be turned on its head, and you can perform digital alchemy. Day can be turned to night, skin can be transformed to stone, and your pet dog can sport antlers and a knowing grin on next year's Christmas card. If your experience of digital image manipulation so far consists of simple tonal adjustments and color correction, then you're in for many tasty treats as you read through the following recipes. If you're a more advanced Photoshop user, you will find a wealth of new ingredients and techniques that you can use in your Photoshop kitchen. Like any other cookbook, Photoshop Photo Effects Cookbook is an invaluable resource that you'll return to again and again—a real help at those times when inspiration runs short, or whenever you need to pin down a particular effect. The book is organized into sections, each covering a particular genre of Photoshop techniques and effects, allowing you to easily find anything from simulating rain to cooking up the look of stunningly realistic oil paintings.

There are a number of key skills and specific tools that are used a lot throughout the book, so this first section is a great place to begin to familiarize yourself with—or to refresh your knowledge of—the basics.

It's time to rattle those virtual pots and pans and get ready to cook up a storm!

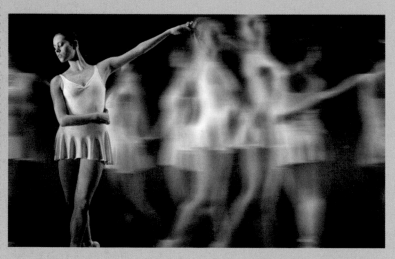

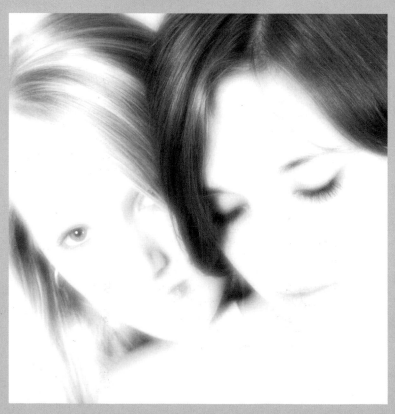

8

The ability to make accurate selections is key to the art of successful image manipulation. Active selections are indicated by the familiar "marquee," an animated dotted line that is also sometimes referred to as "marching ants."

THE SELECTION TOOLS
The selection, or Marquee, tools consist of:

 The Lasso tool: used for making arbitrary freehand selections.

The Polygonal Lasso tool: again for freehand selections, but it constructs polygonal (straight-sided) selections, and is useful for making selections based on geometrically shaped elements within an image.

The Magnetic Lasso tool: this tool attempts to automatically "snap" to high contrast edges within an image. Its settings can be adjusted in the Tool Options bar.

Above this nest of selection tools are the geometric marquee tools. These consist of Rectangular and Elliptical Marquee tools, and also feature Single Row and Single Column selection options. The geometric marquee tools are handy for many things, such as creating borders and vignettes. The edges of all selections made with these tools, and indeed the edges of any active selection, can be feathered (using the Feather value in the Tool Options bar) for softer transitions between selected and unselected areas.

Using the Magic Wand tool, you can instruct Photoshop to select areas of a similar color or tone within an image. These areas of color can be contiguous (joined) or non-contiguous (located in different parts of the image). The Magic Wand works on a tolerance principle, which dictates how close in tone or color two or more pixels must be before both can be selected with a single click of the Magic Wand. The tool can also be set to make a selection either from the current layer only, or from all visible layers within the image. After setting the Tolerance and other options, selections are made by simply clicking within the area of the image that you wish to generate a selection of.

OTHER SELECTION TECHNIQUES
There are a couple of other methods for making selections within Photoshop that, although not accessible from the Toolbox, are vitally important when it comes to making accurate selections. Quick Mask is the best method for creating complex and finely tuned selections. You can enter Quick Mask mode by using the icon at the base of the Toolbox, or by hitting Q on the keyboard.

Once you're in Quick Mask mode, you can make a complex selection by painting onto the image using the Brush tool. Painting with black applies the mask and painting with white erases it, with varying shades of gray making the resulting selection semitransparent. The selection is generated when you switch back to normal mode.

There are many advantages to using Quick Mask for selections:
• The edges of the selection mask can be blurred or smudged where desired, rather than the all-over edge softening of Feather.
• The selection can be partially opaque in some areas and fully opaque in others.
• You can erase or add to the temporary selection mask using any of the geometric selection tools.

The final selection method that warrants a mention is Color Range, accessible via **Select > Color Range**. Once the dialog box is open, simply click on the color in the image that you want to select. The Preview window will instantly change to show what will be selected. White areas in the Preview window will be included in the selection, and black areas will not. The Fuzziness slider within the dialog box is similar in function to the Tolerance setting used for the Magic Wand. With this variable, you can dictate how close together two or more colors or tones need to be before they are both selected throughout the image.

The Color Range dialog box also gives you the very useful option of applying a black or white matte, or even a Quick Mask, to your image so you are in no doubt as to which parts will be selected when you click OK.

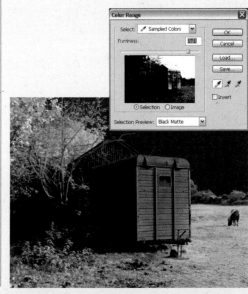

9

WORKING WITH LAYERS

Layers are the foundation of successful image editing in Photoshop. By using them, it's possible to make all manner of changes to an image without affecting the original background layer. The simplest analogy is to think of layers as separate sheets of clear acetate laid over your original image. Each sheet can contain different data that can be changed or moved around independently from the other sheets. Photoshop goes much further than this analogy allows, though, and enables you to change the way layers interact with each other by altering their opacity, blending mode, or by adding layer styles.

The key to moving layers is the Move tool. This tool, located in the top right of the Toolbar, can be used to drag layers into position within the image. This repositioning can be on a grand scale, from one side of the image to the other, or you can move the layer literally one pixel at a time by using the arrow keys on the keyboard.

Layers can also be scaled or distorted using the **Edit > Transform** menu. All kinds of adjustments can be made from this menu including resizing the elements on the layer, distorting them, rotating them, or altering their perspective.

Once you have selected one of the Transform options, the image elements on the target layer are enclosed by a bounding box. The layer can be adjusted by dragging any of the handles around the edge of this box.

One of the most basic ways to create a new layer is to make a copy of an existing layer. To make a duplicate layer, simply right-click/Ctrl-click the layer in the Layers palette that you want to copy, and then choose Duplicate Layer, or just hit Ctrl/Cmd+J.

STACKING ORDER OF LAYERS

Layers can be stacked in any order in the Layers palette, with the exception of the original background layer, which is always fixed at the bottom. The layers can be moved in the layer stack by clicking and dragging them. As you drag to move a layer, its new location in the layer stack is indicated by a highlighted line.

ADJUSTMENT LAYERS

There are some types of layers, known as adjustment layers, that look completely blank, but still have a marked effect on the layers beneath them. Adjustment layers are used in various ways to make global color or tonal changes to the image that can be readjusted throughout the editing process. They can also be used to apply subtle color fills, textures, or patterns without having a permanent effect on the original image.

SAVING LAYERED IMAGES

To preserve the multiple layers in an image, it must be saved in Photoshop's native file format, PSD. It is possible to save layers in a special TIFF file, but this is not recommended, as some applications will be unable to open the file. If you want to save the finished image as a JPEG or standard TIFF file, the layers must be flattened before saving. When a layered file is flattened, all of the layers are merged together into a single unlayered image. Once an image is flattened, the layers are no longer editable, so you must make sure that you have finished working on the separate layers before flattening. To flatten an image, go to **Layer > Flatten Image**.

LAYER MASKS

Layer masks are so called because they quite literally mask out part of a layer. Layer masks are linked to an existing image layer, and work on the same principle as Quick Mask: black areas on the mask hide the layer, and white areas reveal it. To add a layer mask, first choose the layer in the Layers palette to which you want to apply the mask, and then click the "Add layer mask" icon at the base of the palette. You can paint onto a mask with any of the standard painting and drawing tools. By using shades of gray in the mask, you can accurately control the transparency of the associated image layer. A simple application of this is to create a vignette effect.

The grayscale contents of a layer mask can be blurred or have any number of filters and gradients applied to them for an almost infinite array of effects. You can also view and modify layer masks in isolation. Simply Alt/Opt+click the thumbnail for the layer mask in the Layers palette to view the mask in its pure grayscale form.

TYPE LAYERS

To add type (or text) to an image, simply choose the Horizontal or Vertical Type tool from the Toolbar.

When you add type to an image with any of the Type tools, the type is automatically placed on a layer of its own. This is indicated by a large "T" symbol in the thumbnail for the layer in the Layers palette. Type layers are different from the other kinds of layers that make up a Photoshop image. Until it is rasterized (that is, converted into a standard image layer), a type layer is vector-based, and can be edited and re-edited as many times as you like. Using various type settings, you can change letter size, font, color, position, and alignment, as well as the words themselves. Once you have made all your changes, you can rasterize the type layer and treat it like any other image layer. A word of warning here: once you rasterize type, it is no longer editable as type.

To add type to an image, choose one of the Type tools from the Toolbar. With the Type tool active, click within your image. A new layer will appear in the Layers palette, and a flashing cursor will appear on screen, indicating that you can now type your text using the keyboard.

After typing the text, you can change the typeface, size, and color of the type via the Options bar. To change the properties of text that you have already typed, you first need to highlight the type by clicking and dragging over it. You can move the type anywhere within the image by clicking and dragging anywhere on the screen outside of the actual type area. Once you're happy with the appearance of the type, make sure to click the Commit checkmark in the Options bar.

As long as it hasn't been rasterized, you can re-edit the type at any time by double-clicking the thumbnail for the type layer in the Layers palette. This will automatically select all of the type on that layer.

Nested below the Vertical and Horizontal Type tools in the Toolbar are the Type Mask tools. These differ from the standard masking tools in that they make an active selection based on the typeface you've chosen. This can be incredibly useful, as you can actually paint within this type-shaped selection or even fill it with another image. The Type Mask tools do not generate a type layer in the Layers palette, but simply make a selection that can be active on any layer you choose.

Combining type and images can create stunning results and striking graphic images. Ultimately type should be looked upon not only as an independent component, but as another essential ingredient in your Photoshop kitchen.

11

LAYER STYLES

Layer styles decorate and enhance layers, and are a powerful weapon in your fight against boring digital imagery. Layer styles are applied only to layers, and, more particularly, they are only applied to the visible elements within the target layer. You can add a layer style to a layer by clicking the symbol at the base of the Layers palette.

The available layer styles are:
Drop Shadow
Inner Shadow
Outer Glow
Inner Glow
Bevel and Emboss
Satin
Color Overlay
Gradient Overlay
Pattern Overlay
Stroke

One of the most frequently used layer styles is Drop Shadow, which, when used with subtlety, can add depth and realism to an image. Once a style is chosen from the list, Photoshop displays a dialog box for the style, with a comprehensive selection of style properties that can be modified.

12

Individual layer styles can be combined together on a single layer, and remain editable for as long as the attached layer is visible in the Layers palette.

More varied and unusual layer styles can be found in the Styles palette, which can be revealed through **Window > Styles.**

These are packaged combinations of layer styles, fills, and textures, that can be useful for creating particular surface and texture effects. In addition to the default styles in this palette, you can load other style sets for particular uses, such as creating buttons and roll-overs for web sites, or for specific text effects.

To re-edit an applied layer style, double-click the effects pane attached to the layer in question to call up the dialog box.

FILLING LAYERS

You can access special fill layers using the Layer menu (**Layer > New Fill Layer**). From here you can choose Solid Color, Pattern, or Gradient fills.

SOLID COLOR FILLS

A Solid Color fill layer is exactly what it sounds like, a simple layer filled with a solid color that can be chosen from the standard Color Picker. These Solid Color layers are useful for providing areas of continuous tone and color across a layer, or can be used in conjunction with blending modes and opacity to tint all or part of an underlying layer. Solid Color layers appear with a layer mask attached to them by default, and, as we've already seen, by painting onto this mask you can hide parts of the fill layer.

GRADIENT FILLS

Gradient fill layers supply you with fills featuring transitions between a number of colors or opacities. Photoshop ships with many preset gradients that can be chosen directly from the Gradient Picker. New gradients can be created, or existing gradients edited, using the Gradient Editor. To open the Gradient Editor, select the Gradient tool, and then double-click on the gradient preview that appears in the Tool Options bar.

PATTERN FILLS

Pattern fill layers (again accessible via **Layer > New Fill Layer**) are layers that contain patterns supplied by Photoshop. On first examination, these may seem to be fairly unexciting and redundant, as we're initially limited by Photoshop's supplied patterns. However, there is real power in Pattern layers when used in conjunction with layer blending modes. As you'll see throughout this book, Pattern layers can, for instance, be used to create very realistic paper and surface textures. Like gradients, the actual patterns themselves are chosen from swatches in a drop-down picker, and extra sets of patterns can be loaded via the small, right-pointing arrow. The actual scale of the pattern can be controlled via the Scale drop-down, allowing you to adjust the size of your pattern to be in proportion with the image that it is being used with.

It is easy to create new patterns to be used as fills. First, open an image that contains the design you'd like to have as a pattern. Use the Rectangular Marquee tool to select the area of the image that interests you, and then go to **Edit > Define Pattern** and give the pattern a name. The pattern will now be available for you to use, and will be added to the end of the pattern list.

Often, images direct from a digital camera are a little soft, and benefit from judicious sharpening. Indeed, it's often better to disable any in-camera sharpening and then sharpen images in Photoshop later, as this gives you far more control over the final degree of sharpness.

Your one-stop-shop for sharpening images in Photoshop is the Unsharp Mask filter. This wonderfully powerful sharpening device is derived from an age-old darkroom process that improved the sharpness of an image printed from a film negative. Because its effect can be so powerful, using the Unsharp Mask filter demands some restraint, and it's often better to use it a couple of times at a low level rather than going for the single big hit.

One point to bear in mind is that sharpening any image should be the finishing touch within Photoshop before saving the final version of the file, and after all other image manipulation has been completed. This is to prevent having to sharpen an image again after amending it, which can result in obvious white artifacts appearing.

The Unsharp Mask filter works by identifying the edges in an image and subtly exaggerating the contrast between the pixels that lie either side of this edge. In an unsharp image, the boundaries between these pixels are too soft and indistinct. When using the Unsharp Mask filter, you actually instruct Photoshop to narrow these boundaries, and tell it how wide and how much contrast the boundaries need to have before the edge is sharpened by the filter. Essentially, the higher contrast between the tonal boundaries gives the appearance of a crisper image.

There are no hard and fast rules for using the Unsharp Mask filter, as the individual settings required depend very much on the image you are sharpening.

There are three fields of variables within the filter:

Amount
This slider governs the overall extent of the sharpening effect. You can think of this slider as the sharpening volume control, as it controls how powerfully the effect of the other settings are applied to the image. It's useful to set this slider at a high value initially, say 200%, so you can easily see the effect of the settings of the Radius and Threshold sliders, and then slowly reduce the Amount value to control the severity of the sharpening effect across the entire image.

Radius
The Radius setting determines the width of the sharpening effect, or how far across the edge boundaries the sharpening effect is spread. This slider needs to be used with great care, as increasing the Radius value too much can result in ugly white halos along sharpened edges. A Radius value of 1–3 is often enough for most images.

Threshold
With the Threshold slider, you tell Photoshop how different in brightness two or more pixels should be before the boundary between them is considered an edge, and therefore should be sharpened. Using a very low setting will sharpen the majority of pixels within an image, and higher settings will sharpen only obviously contrasting edges. As a consequence, a higher setting here will sharpen the edges in an image but not sharpen subtle textures.

A good starting point for the settings in the Unsharp Mask filter is Amount 250, Radius 2, Threshold 1. Although these setting are likely to be too severe for many images, starting with these settings will make any modifications to the Radius and Threshold values more obvious.

Here's a typical sharpening scenario:

1. Although this image is fairly sharp, there are signs of the slight softness often associated with images direct from a digital camera.

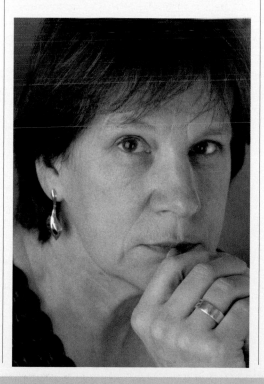

2. As discussed previously, these settings for Unsharp Mask are a good starting point, although the results strike as rather too sharp and unnatural. While the sharpness has improved from the original image, the texture of the skin has been over-sharpened because of the low Threshold value.

3. This close up, with the Radius value set to 10, illustrates the danger of using the Radius slider at too high a value. The skin texture is very exaggerated, and ugly halos are starting to form around the edges in the image.

4. By reducing the Radius setting to 2.5 and modifying the Threshold value to 4, we've achieved just about the right amount of sharpening in the right places. Skin textures are not overemphasized, but essential edges and details are nicely sharpened. The overall degree of the effect can now be controlled with the Amount slider—which I've set here to 245%.

13

PATHS

Most imagery in Photoshop is rasterized, i.e., made up of millions of pixels. Every digital-camera image, scan, or brush stroke is made up of pixels, which render photographic information flawlessly, creating subtle gradations of color and tone. One disadvantage of working with rasterized images is that they are completely dependent on resolution—the combination of the individual pixel size and the dimensions of the image—to maintain detail and sharpness. Owners of low-resolution digital cameras will often be surprised and disappointed to discover that their images are not print-quality resolution. And there's not much they can do about it, even with Photoshop. There is only so far a rasterized image can be enlarged before the pixels themselves become visible as small blocks of color.

Vector shapes, on the other hand, are not subject to these constraints, because they are not pixel based. Vector art is made up of points and paths, and is resolution-independent. A vector-based object will print with optimum sharpness at the size of a postage stamp, and yet can be enlarged to the size of a billboard with no loss of image quality or sharpness. Text in Photoshop is vector-based for this reason. Unlike other applications like Adobe Illustrator or Macromedia Freehand, Photoshop is not vector-based, yet it includes some very useful vector-based features. One of those features is paths, which are invaluable for cutting out and isolating complex shapes, among other things. It's worth learning to use paths well, as many of the recipes in this book use them.

Your one-stop-shop for path creation in Photoshop is the Pen tool. When you draw a path with the Pen tool, essentially you plot anchor points. To plot these anchor points, click with the Pen tool. Two anchor points are needed to form a path—the path itself being the line segment between the two anchors. A straight path segment is created with a single click, while curved path segments (known as "Bézier Curves") require you to click-and-drag the tool. These curved path segments have direction handles attached to them, which can be dragged and repositioned to change the curve. There are two types of paths—open and closed. An open path is just that—open-ended—and can be stroked with any of Photoshop's drawing and painting tools. A closed path encloses an area, and can be filled with solid color or a gradient. Closed paths can also be used to make selections of very complex shapes on existing image layers. The paths you create are stored in the Paths palette, which usually sits behind the Layers palette. A path that is in the process of being created is called a "Work Path," and appears in the Paths palette. Individual paths can be saved for later use. Double-click on "Work Path," rename the path, and click OK to save it.

① This simple closed path is made with four clicks of the mouse, giving us 4 straight path segments. The path is visible as the current Work Path in the Paths palette:

② Here, the path is made up of both curved and straight path segments. You can see the curved segments are indicated by the presence of the direction handles.

③ This path is made up of curved path segments, created by clicking and dragging with the Pen tool.

Here you can see the direction handles that are attached to each or the curved anchor points in the path.

The handles can be moved to adjust each curve, by holding down the Ctrl/Cmd key and dragging one of the direction handles.

④ By right-clicking/Ctrl-clicking the current Work Path in the Paths palette, you can choose to do one of three things: Fill the Path with color...

Stroke the outline of the Path...

or convert it to a selection.

Tip

PRINTING PATHS
Although paths are visible on-screen when they are active, they won't print unless you stroke or fill them.

Throughout this book, you'll often use Photoshop's Lighting Effects filter (accessed using **Filter** > **Render** > **Lighting Effects**). With this filter, you can create some incredibly realistic lighting effects with just a few simple clicks. It's hard to overestimate its usefulness, which covers everything from creating convincing textures to adding realistic studio lighting to a portrait. You can also use alpha channels in conjunction with this filter, to provide detailed and accurate texture maps that control how the light falls and interacts with a virtual surface. You'll see some examples of this technique in the Texture Effects section of this book, starting on page 136.

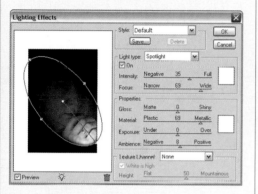

The Lighting Effects filter is surprisingly easy to use. In the Preview pane of the filter dialog box, the pool of virtual light is indicated by an elliptical outline with handles anchored to it. You can rotate and expand the light pool in any direction by clicking-and-dragging these handles. Various preset light styles can be chosen from the Style box, where you can select many different types, colors, and combinations of lights.

Once a light preset has been selected, the various sliders in the dialog box can be used to modify every aspect of the light, and the way it interacts with the actual image. You can control the intensity of the light, increasing it from a very gentle glow to a powerful blast of light, and how the imagined surface of the image reacts with that light, either simulating the effect of a very shiny, reflective surface, or one which is completely matte. You'll be given the exact settings to use for these sliders whenever you use the filter throughout this book, but it's still worth experimenting with the various options as you go to see how you can modify, or improve, the effects to suit your own work.

Alpha channels, used as textures within the filter, can be loaded via the Texture Channel box from within the filter itself. Again, I'll cover their specific use throughout the book, but essentially the principles of texture channels are easy to grasp. An alpha channel, when used in the Lighting Effects filter, is a grayscale image created as an extra channel in the Channels palette in Photoshop. White areas in the alpha channel—or to be more precise, the texture channel—are interpreted as high points, or peaks, on the virtual texture surface, and black areas are interpreted as low points or valleys. Here's a typical example of this, using a simple fill created by the Clouds filter within the texture channel itself:

1. Start by creating a new document and filling it with a solid red color.

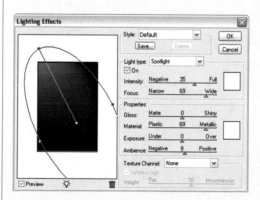

2. In the Channels palette, add a new alpha channel via the "Create New Channel" button at the base of the Channels palette. Notice that the foreground and background color swatches revert to black and white because channels can only contain shades of gray. Now go to **Filter** > **Render** > **Clouds** to fill the channel with a clouds texture. Follow this by going to **Filter** > **Render** > **Difference Clouds** to give the fill a little more depth. You'll use this channel for the texture channel in the Lighting Effects filter

3. Return to the Layers palette, and click on the filled background layer. Run the Lighting Effects filter, leaving the settings at their default values. Rotate the light pool with the handles around the edges, so that the light falls from top left to bottom right.

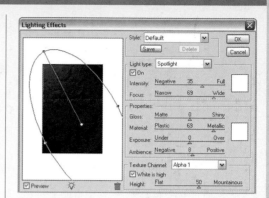

4. Select Alpha 1 (the clouds-filled alpha channel you just created) from the Texture Channel box. Notice in the Preview pane that the surface suddenly features a realistic texture, taken directly from the alpha channel. You can increase the depth of the high and low parts of the texture with the Depth slider, taking the depth scale from Flat, all the way up to Mountainous. Click OK to apply the lighting and texture.

5. The completed image, from simple flat fill to convincing textured surface.

15

TONAL AND COLOR EFFECTS

High-key and low-key effects
Psychedelic poster effect
Creative black and white
Selective coloring
Tone separations

High-key and low-key effects

As a general rule, we all aim for images that are well-balanced tonally, with a fairly equal range of light and shadow throughout. However, there are times when deliberately narrowing this tonal range can yield interesting results. For high-key images we restrict the tonality to the upper range of the tonal scale, resulting in a soft, milky, and rather romantic effect. Low-key uses the lower end of the scale and inspires moody and rather somber images.

The ultimate advantage of doing this with Photoshop is that we can experiment and fine-tune the effect. It is important not to confuse high-key and low-key effects with simple over- or under-exposure. In the completed images, the full tonal range should remain, but with a higher percentage of certain tones represented. Here we'll give a single image the high-key and low-key treatment to demonstrate the dramatic difference between the two effects.

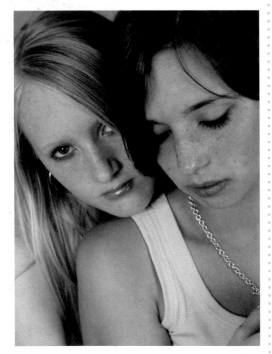

High-key effect

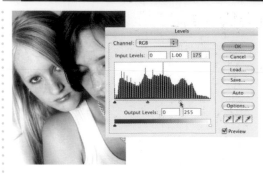

1 Open the original image in Photoshop, and go to **Image > Adjustments > Levels**. For high-key we need to restrict the majority of the tones to the upper tonal range. Begin the adjustment by moving the White Point slider below the histogram to the left. Move the slider until the input value for the white point reads 175.

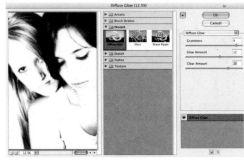

2 Duplicate the background layer (Ctrl/Cmd+J) and call it "Diffuse Glow." We need to add some diffused light to the image now, so hit D on the keyboard to revert to default foreground/ background colors and go to **Filter > Distort > Diffuse Glow**. Use these settings: Graininess 9, Glow Amount 12, Clear Amount 15. Click OK and set this layer to Screen, opacity 91%.

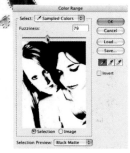

3 Now the high-key look is taking shape, but the image still needs a little softening. Add a new layer (Ctrl/Cmd+Shift+N), call it "White Fill," and select the Eyedropper tool. Click with the Eyedropper in the lightest part of the faces and go to **Select > Color Range**. Use a Fuzziness slider setting of 79 and click OK.

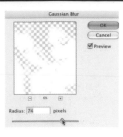

4 With the selection active, go to **Edit > Fill**, choosing White for Contents. Now blur this layer with **Filter > Blur > Gaussian Blur**. Use a Radius value of 74 pixels. Set the blending mode for this layer to Soft Light, and the opacity to 78%.

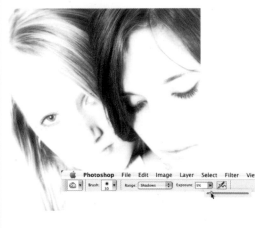

5 Flatten the image with **Layer > Flatten Image**. The few remaining dark tones in the image now need reinforcing, so choose the Burn tool from the Toolbar. In the Options bar, set the Range to Shadows and set the Exposure slider to 9%. Now carefully use this tool over the dark tones in the image, subtly intensifying them here and there.

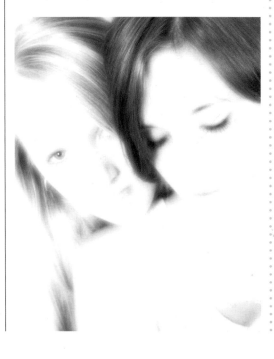

18

1 The technique for creating a low-key version of the image is rather different. Again, begin with the original image and go to **Image > Adjustments > Levels**. This time we need to push the tonal balance in the opposite direction. Grab the Black Point marker and drag it to the right. This will darken the shadows and the midtones. The farther to the right we drag this slider, the more dramatically low-key the final image will become.

2 Pull the White Point slider a little to the left to give the highlights a bit of a boost. An input value of about 246 should do it.

3 Now, to give the image added depth, duplicate the background layer (Ctrl/Cmd+J) and go to **Image > Adjustments > Desaturate** (Ctrl/Cmd+U). Set the blending mode for this layer to Multiply and reduce the layer opacity to 45%.

4 A low-key effect usually works best in black-and-white images, so go to **Image > Mode > Grayscale**. In the subsequent warning dialog box regarding layers, choose Flatten.

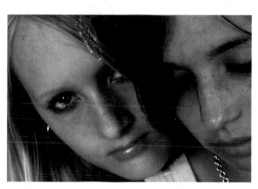

5 The image is almost complete—it just needs a little fine-tuning. This time, use the Dodge tool to lighten a few areas for added impact. Choose the Dodge tool from the Toolbar and set the Range to Midtones in the Options bar. Set the Exposure value to 10%. Use the tool on the whites of the eyes and throughout the lighter tones in the hair.

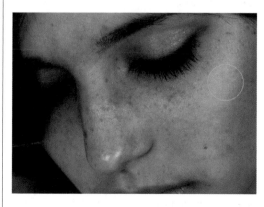

6 Increase the size of the Dodge tool with the right-facing square bracket key on the keyboard, and use it sparingly over the midtones in the girls' faces, lightening them slightly.

Tip

DODGE AND BURN

The Dodge and Burn tool in Photoshop relates to the traditional darkroom methods of making selective tonal adjustments to an image. Dodging (reducing exposure in selected areas, to lighten them) and Burning (increasing exposure, to darken them) can add real impact to lackluster black-and-white images. Both tools are subject to "Range" options, where we select from Highlights, Midtones, or Shadows to determine which tones within the chosen image will be affected. The strength, or exposure, of the tools is governed by the Exposure slider in the Tool Options. Far better and more controlled results are achieved with both tools by using a very low exposure setting. Both tools can be used freehand, or can be used within a selection.

7 Change the Range for the Dodge tool to Highlights in the Options bar. Now use this tool over a few of the lightest areas in the image. Be selective here, using the tool to enhance only the existing highlights.

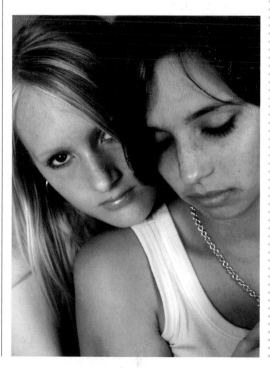

Psychedelic poster effect

Every now and then, as creative people, we crave images with a bit more impact. Fortunately, with Photoshop, the possibilities for going beyond the norm are almost limitless.

In this exercise, we'll take a fairly run-of-the-mill image and give it a psychedelic touch. The intention is to replicate the effect of an iconic '60s poster, complete with halftone printing patterns. To create this image, we first have to convert it to a bitmap, so that we can generate the halftone pattern. This is a very useful process that will come in handy time and time again.

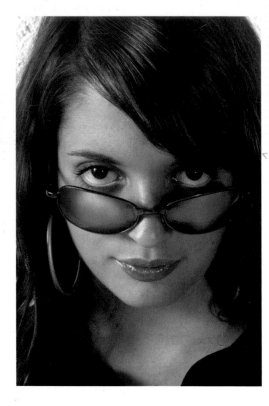

1 First, open the original image in Photoshop and desaturate it using **Image > Mode > Grayscale**. Click OK. The image is a little too dark and too flat, so we need to tweak the contrast. Go to **Image > Adjustments > Brightness and Contrast**. Increase the Brightness to 10 and the Contrast to 38.

2 To achieve a halftone printing effect, convert the image to Bitmap mode. To begin that process, go to **Image > Mode > Bitmap**. In the Bitmap dialog box, set the Output resolution to match the input (here it's 300 ppi), and choose Halftone Screen for Method. Click OK. In the next dialog box set the Frequency to 20 lines/inch, Angle to 45, Shape: Round. Click OK to convert the image.

3 Now, we need to convert this file back to RGB so we can add color to it. First, go to **Image > Mode > Grayscale**, choosing 1 for Size Ratio. Then go to **Image > Mode > RGB Color**.

4 To change the color of the halftone print effect, use a Solid Color Fill Layer. Go to **Layer > New Fill Layer > Solid Color**. In the Color Picker, choose an intense shade of red. Now change the blending mode for this Solid Color layer to Lighten. Flatten the layers in the image using **Layer > Flatten Image**.

5 Double-click the background layer in the Layers palette, and rename it "Main Image." Now add another Solid Fill layer as before, name it "Orange," and fill it with a bright orange color. Then grab the Main Image layer in the Layers palette and drag it above this orange fill layer. Then change the blending mode for the Main Image layer to Darken.

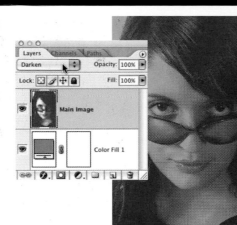

6 Add a new layer (Ctrl/Cmd+Shift+N), and name it "Border." Choose the Rectangular Marquee tool and drag a selection just a little way inside the outer edge of the image. Now go to **Select > Inverse** (Ctrl/Cmd+Shift+I) so the selection makes a border around the image. Choose the Eyedropper tool and sample the red in the image. Fill this selection using **Edit > Fill**, choosing Foreground Color for Contents.

7 Now go to **Select > Inverse** (Ctrl/Cmd+Shift+I) again. Click in the foreground Color swatch and choose a bright blue. Go to **Edit > Stroke**. Choose 20 for Stroke Width and Inside for Location. This will apply a thin blue line to the border around the poster. Hit Ctrl/Cmd+D to deselect.

8 Sample the red again with the Eyedropper and select the Brush tool. Choose a hard round brush from the Brush Picker and paint inside the lenses in the sunglasses to make them solid red.

9 To add the type, choose the Horizontal Type tool. Click in the image and type the text. Here, I've used a typical '60s typeface, called "BellBottom." With the text highlighted, go to **Window > Character** to display the Type properties palette. The Width and Height of the type can be adjusted from here. Now Click the Warp Text button in the Options bar. From the Warp Text dialog box, choose Arc from the Style Box. Click the Horizontal Radio button and adjust the Bend and Vertical Distortion values to give a pleasing effect. Here, I've used -21 and +8 respectively. Click OK to apply the Warp to the text.

10 Click the Commit checkmark in the Options bar to apply the type. We can move the type into place with the Move tool. Finally, flatten the image using **Layer > Flatten Image**.

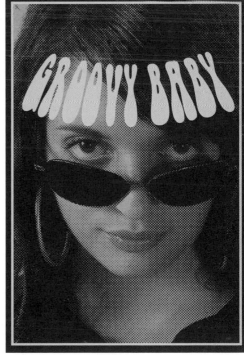

Creative black and white EFFECTS

To achieve a black-and-white effect in Photoshop, we can always take the route of simple desaturation or conversion to grayscale. However, both of these methods sometimes result in rather dull and uninspiring images. The best black-and-white images have real impact, with sparkling highlights and rich, velvety dark tones.

To achieve stunning black and white, we need to invoke the much-overlooked Channel Mixer. This Photoshop feature allows us to decide which values from the individual Red, Green, and Blue channels will be visible as tones of gray in the final black-and-white result. This degree of control gives us the power to create truly jaw-dropping black-and-white images that have impact and clarity.

1 A standard desaturation in Photoshop produces a very flat grayscale image with too little tonal latitude and a lack of contrast. This is because when Photoshop desaturates an image or converts it to grayscale, it averages out the tones in that image.

Red

Green

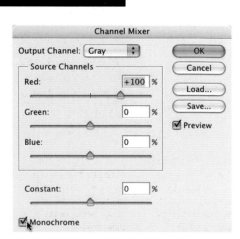

Blue

2 Every RGB image is made up of three channels: Red, Green, and Blue. Each of these color channels is represented by a monochrome image. Essentially, each channel image appears as it would if we were to take a traditional photograph using black-and-white film with a corresponding Red, Green, or Blue filter on the lens. These RGB channels can be combined in varying proportions in Photoshop to create a more dynamic monochrome image.

3 There are two routes to the Channel Mixer black-and-white conversion technique. We can access the Channel Mixer dialog box directly using **Image > Adjustments > Channel Mixer**. The disadvantage of this method is that any changes we make to the image are permanent. Alternatively, we can use a Channel Mixer adjustment layer. The great advantage of adjustment layers is that the effect can be modified

and adjusted throughout the entire process, without affecting the underlying background layer.

Add an adjustment layer by going to **Layer > New Adjustment Layer > Channel Mixer**, or click on the "Create new fill or adjustment layer" icon at the bottom of the Layers palette and select Channel Mixer. Make sure that the Monochrome and Preview boxes in the Channel Mixer dialog box are checked.

Channel Mixer	
Output Channel: Gray	OK
Source Channels	Cancel
Red: +100 %	Load...
Green: 0 %	Save...
Blue: 0 %	☑ Preview
Constant: 0 %	
☑ Monochrome	

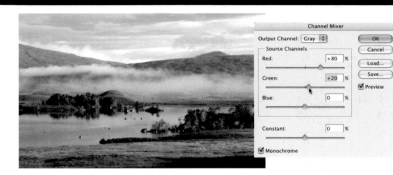

4 We can now adjust the individual channels to control the appearance of the final black-and-white image. It's preferable that the combined channel values add up to 100%, although this rule can be broken for extra impact and contrast. With this in mind, adjust each channel to produce significantly different effects. Try these settings first: Red 80%, Green 20%, Blue 0%. This simulates the effect of a Red filter used in traditional black-and-white photography. Click OK.

Tip

TWEAKING LEVELS

When the black-and-white conversion is completed, it's still possible to tweak the intensity and contrast a little more using Levels. Do this with an adjustment layer (Layer > New Adjustment Layer > Levels) so that adjustments can be made without permanently affecting the original image layer. In the Levels dialog box, lighten the Highlights by dragging the White Point marker beneath the histogram to the left, and darken the shadows by dragging the Black Point marker to the right.

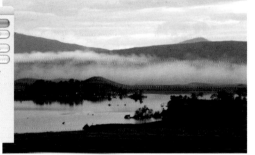

5 Double-click the adjustment layer again, and change the values to Red 20%, Green 0%, Blue 80%. This gives some real impact to the darkest tones in the image, and creates an altogether more low-key appearance.

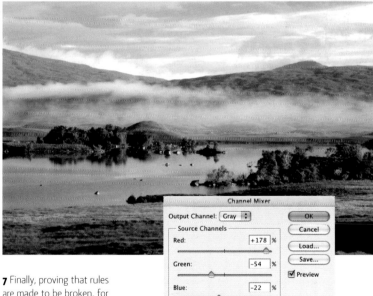

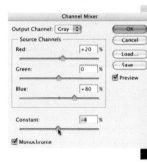

6 Finer adjustments to the overall tonal depth of the grayscale image can be made using the Constant slider. Very small changes to its value can have a pronounced effect on the entire image, so take care when using it. Negative values darken the entire image, while positive values lighten it.

7 Finally, proving that rules are made to be broken, for the final image I've settled on Red 178%, Green -54%, Blue -22%. These channel proportions offer an attractive balance of rich darks and bright highlights, with lots of tonal depth. The precise settings for any image are largely a matter of personal taste, and are most effective when they reflect the overall mood of the picture.

Selective coloring

Color has great power when it comes to conveying emotion and attracting attention. This power is multiplied exponentially when color is used as an accent in an otherwise monochrome image. By using selective coloring, we can draw the viewer's eye to the key areas of an image, with the colored areas adopting a jewel-like quality amid an expanse of gray.

The effect ranges from the subtle to the extreme. We can tint an image with just a hint of color, or apply an exciting splash of color to a specific area. Layer masks are an essential tool here, offering us the ability to restore color to the area of our choice, which can be controlled and restrained with the accuracy only a brush can provide.

1 The first step is to duplicate the background layer by dragging it to the new layer icon in the Layers palette or hitting Ctrl/Cmd+J.

2 Since we want most of the image to be monochrome, on this duplicate layer go to **Image > Adjustments > Desaturate** (Ctrl/Cmd+Shift+U). To add to the effect, give this monochrome layer a subtle blue tint. Go to **Image > Adjustment > Hue and Saturation**. Check the Colorize box, and move the Hue slider to 221, and the Saturation slider to 12.

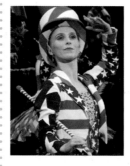

3 Now we're going to add a layer mask to the monochrome layer, which we'll use to manually restore color to parts of the image. Go to **Layer > Layer Mask > Reveal All**.

4 Check the Layers palette to be sure that the layer mask thumbnail is highlighted, which means that we're working on the layer mask, not the layer itself. Set the foreground color to black and select the Brush tool. Click in the Brush Picker and select a hard round brush. Hit F5 to display the Brush Options and ensure that Shape Dynamics is unchecked.

Tip

LAYER MASK OR ACTUAL IMAGE LAYER?

It's very important when working with layer masks to make sure that you're painting on the mask and not on the associated image layer. There are three ways to check this:

1. Check for a bold outline around the thumbnail for the layer mask in the Layers palette.
2. Check for the mask symbol in the margin of the Layers palette (PC only). When you're working on the image layer, a Brush symbol will appear, but when you're painting on a mask, it will be replaced by a small rectangle with a circle at its center.
3. Since masks operate on a purely grayscale principle, when you're working on a layer mask, your foreground/background color swatches will always be white, black, or gray.

24

5 Paint over all of the blue and red areas on the coat and hat with black. This will hide these areas of the monochrome layer, thus revealing the colors on the background layer underneath. We can adjust the size of the brush as we go with the square bracket keys on the keyboard. Zoom into the image with the Zoom tool (Z) to ensure accuracy.

6 Accuracy is all-important here, so take the time to follow the edges of the colored sections very carefully. If you accidentally paint over any other part of the image, simply swap your foreground/background colors and paint over it again with white instead of black. Remember, when working on layer masks, black conceals and white reveals. Continue to paint over all of the red and blue sections.

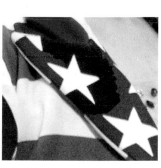

7 Only mask out the areas of this layer that cover the red and blue sections of the costume, leaving the white areas as they are.

8 As we paint, the black areas will appear on the associated layer mask. We can check the mask by holding down the Alt/Opt key and clicking the layer mask thumbnail. This enables the actual mask to be seen in isolation.

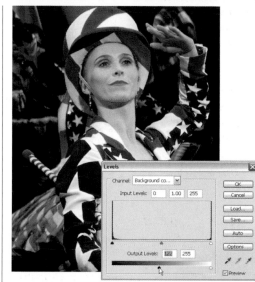

9 We can control how vividly the colors show through the mask. Working on the mask itself, go to **Image > Adjustments > Levels**. By dragging the Black Point marker under the Output Levels bar to the right, the black tones within the layer mask are turned to gray. Where black on a layer mask is completely transparent, gray tones are only semi-transparent, which makes the revealed colors in the image layer more subtle. We can control just how subtle they are by adjusting the luminosity of the gray color on the layer mask.

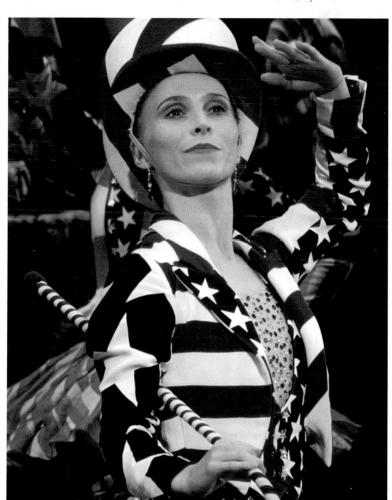

Tone separations

"Soot and Snow." That's what this effect was called in the days of wet-process photography. The phrase refers to the extremes of high-contrast black and white, where all that remains of a monochrome image are the darkest darks and the lightest lights. The effect may be familiar, but used wisely it still has the potential to create some truly arresting images.

Boiling down an image to its bare essentials tonally also reduces it to its essence graphically. A creatively lit figure or portrait can be distilled into a few essential contours, taking on a hand-drawn—and sometimes even abstract—effect. Used alone or as an element in a more complex photomontage, tone separation still has a certain charm.

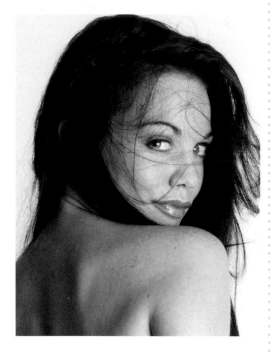

1 To achieve the best results with this technique, it's important to begin with the right kind of image. The ideal candidate is a subject shot against a plain white background, as it already contains the element of contrast we're seeking to exaggerate.

2 Duplicate the background layer by hitting Ctrl/Cmd+J on the keyboard. On the duplicate layer go to **Image > Adjustments > Levels** to make the initial tonal adjustments. To increase the contrast, grab the White Point marker below the histogram and drag it left until the Output Levels value reads 167. Now drag the Black Point slider right to a value of 9.

3 As we want a monochrome image, go to **Image > Adjustments > Desaturate** (Ctrl/Cmd+Shift+U). Flatten the layers in the image using **Layer > Flatten Image**.

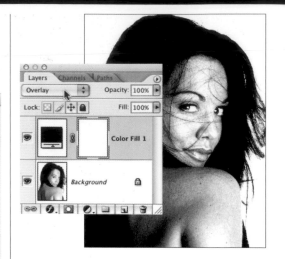

4 Hit D on the keyboard to revert to default foreground/background colors. To unify the tones in the image, click on the "Create new fill or adjustment layer" icon at the base of the Layers palette, and choose Solid Color. Click OK in the Fill Layer color picker to OK black as the fill color. Set the blending mode for this layer to Overlay.

5 Return to the background layer and go to **Image > Adjustments > Brightness and Contrast**. Grab the Contrast slider and drag it up to a value of 63. This will give the remaining dark areas plenty of impact.

Tip

CHOOSING COLORS ON SOLID COLOR ADJUSTMENT LAYERS
As soon as you select Solid Color from the adjustment layer drop-down, the Color Picker opens. In the Color Picker itself, choose the hue you want from the vertical spectrum bar, and then select the exact shade (a combination of saturation and brightness) by clicking in the large Color Picker square. The shade is chosen by a simple click within the Picker.

26

6 Now we need to intensify some of the dark areas even further. Choose the Burn tool from the Toolbar and set the Exposure to 92% in the Options bar. Set the Range to Shadows. Use this tool over the eyes and lips. Also, increase the size of the tool with the square bracket keys on the keyboard and use it over the shadows that fall across the model's back.

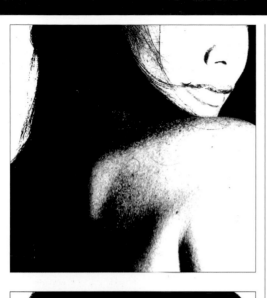

7 We need to clean up a few of the white areas in the image. Choose the Dodge tool from the Toolbar. Set the Exposure to 100% and the Range to Highlights. Use the tool to clean up the white areas. Remove any remnants of stray hairs and blemishes on the face.

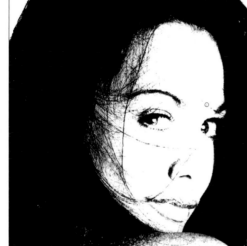

8 We are not limited to having black as the main tonal color within the image. By adding another Solid Fill adjustment layer and choosing an alternative color from the picker, we can change the darker tone within the image to any color we choose.

9 Alternatively, we can change the white background color. Simply add another Solid Color adjustment layer and set the layer's blending mode to Darken.

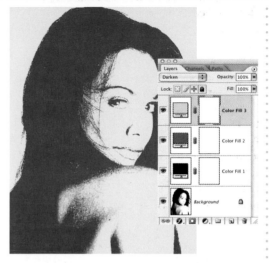

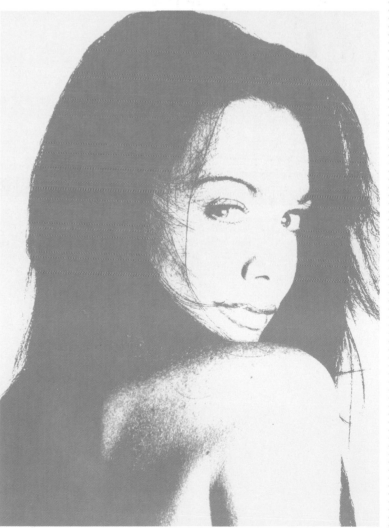

GRAPHIC ART EFFECTS

Art Nouveau

Warhol screen-print

Watercolor

Oil painting

Pencil sketch

Pen-and-ink drawing

Woodcut and linocut

Art Nouveau

In Paris in the late 1880s, Art Nouveau was king. As a style, it is the very essence of all that's best in the decorative arts. To evoke the flavor of Art Nouveau in Photoshop, we can combine vector shapes with raster pixels. By using the much-maligned—and often dreaded—Pen tool, we can create a framework of lines to build upon. With the Pen tool, Paths can be drawn and stroked with pressure-sensitive brushes, creating the calligraphic elegance that the Art Nouveau style requires.

Layer Styles help to emboss parts of the image, giving the finished piece a decorative quality reminiscent of an illuminated manuscript. Voilá: Art Nouveau—with a digital-imaging twist!

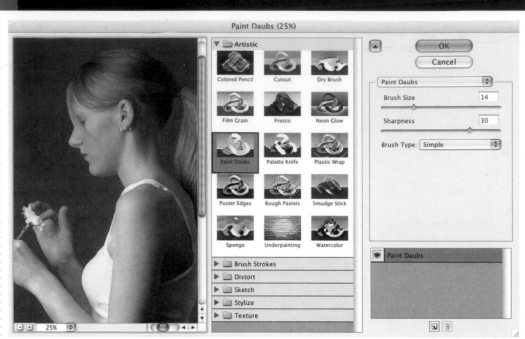

1 With the original image open in Photoshop, go to **Filter > Artistic > Paint Daubs**. Use Brush Size 14, Sharpness 30, Brush Type Simple. This will simplify the tones in the image.

2 Now, isolate the figure from the background. Double-click the background layer to make it editable and rename it "Figure." Then hit Q on the keyboard to enter Quick Mask mode. Choose the Brush tool, and select a hard round brush from the Brush Picker. Using black as the foreground color, paint carefully over the entire figure. Remember to use the square bracket keys to alter the size of the brush, and if you make a mistake, hit the X key to change the foreground color to white to paint out the mask. Zoom right into the flower, and with a very fine brush, mask it out also.

3 Make sure to cover every part of the figure with the mask. Don't be too concerned about following the exact shape of the ponytail in the hair as this will be fine-tuned later. When the mask is complete, hit Q again to exit Quick Mask to generate the selection. Now delete the background. Depending on how the Quick Mask preference is set, either hit the Backspace key to delete the background or go to **Select > Inverse** (Ctrl/Cmd+Shift+I) to select the background, and then hit the Backspace key.

4 Save this selection using **Select > Save Selection**, and name it "Figure."

5 Hit Ctrl/Cmd+D to deselect. Add a new layer to the image (Ctrl/Cmd+Shift+N), name it "White," and go to **Edit** > **Fill** > **Use: White**. Then grab the Figure layer in the Layers palette and drag it above the White layer.

6 Add another new layer, and name it "Hair." Select the Pen tool from the Toolbar, and check to see that the Paths icon and Add To Path Area are active in the Options bar. Now, draw a path to form the decorative hair. Click with the Pen tool on the narrowest part of the ponytail nearest the girl's head. For illustrative purposes, I've added a simple drop shadow layer style to lift the figure from the background.

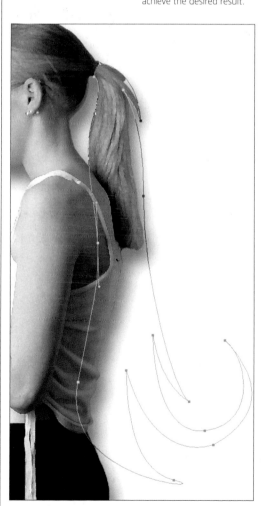

7 To draw the curved paths for the hair, click and drag with the Pen tool. As we drag each curve, direction handles will appear against each curved path section. These are Bézier curves, and they can be adjusted by holding down the Alt/Opt key and moving each handle with the tool. The shape of this main hair section can be as simple or as complicated as you like, but should be made up of curves to achieve the desired result.

8 When we need a dramatic change of direction or a sharp point in the path, hold down the Alt/Opt key while clicking the previously plotted endpoint on the path. Work around the entire hair shape, closing the completed path by clicking again on the starting point.

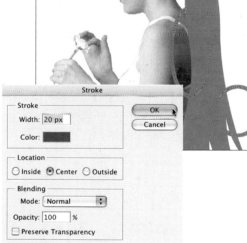

9 Right-click/Ctrl-click inside the completed path and choose Make Selection, choose a Feather radius of 1 pixel. Now click on the foreground color swatch to open the Color Picker. Select a light tan color and fill the selection using the Paint Bucket tool.

10 Working on the hair layer, choose the Elliptical Marquee tool. Make sure that Add To Selection is active in the Options bar. Then drag a number of elliptical selections of varying sizes over the hair. Using the same foreground color, go to **Edit** > **Stroke** choosing Center for Location and using a pixel width of 20. Deselect (Ctrl/Cmd+D) and drag a few smaller ellipses, stroking with a larger pixel width.

31

Art Nouveau continued

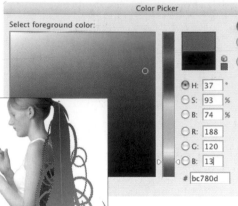

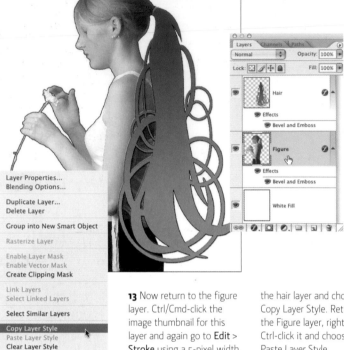

11 Use the Eyedropper tool to sample the darkest shade from the hair on the head. Then click on the background color swatch and choose a deep russet gold. Ctrl/Cmd-click the thumbnail for the Hair layer to generate a selection. Select the Gradient tool from the Toolbar, choose Linear Gradient, and click in the Gradient Picker to select Foreground To Background. Now click and drag a gradient from top to bottom over the hair shape.

13 Now return to the figure layer. Ctrl/Cmd-click the image thumbnail for this layer and again go to **Edit** > **Stroke** using a 5-pixel width. Next right-click/Ctrl-click the hair layer and choose Copy Layer Style. Return to the Figure layer, right-click/ Ctrl-click it and choose Paste Layer Style.

14 Still on the Figure layer, go to **Layer** > **New Adjustment Layer** > **Gradient Map**. Click on the arrow next to the Gradient Used For Grayscale Mapping box and choose Blue, Red, Yellow from the gradient swatches. Set the blending mode for this layer to Color, and reduce the opacity to 27%. This extra coloration helps to lessen the photographic qualities of the image and to blend it better with the new hair.

12 With the selection still active, hit D to revert to default colors and go to **Edit** > **Stroke**, using a Stroke Width of 5 pixels. This will add an outline to the hair. Now go to **Layer** > **Layer Style** > **Bevel and Emboss**. Use these settings: Style: Emboss, Technique: Chisel Hard, Depth: 100%, Size: 5.

15 We'll add some line work to the image. Add a new layer (Ctrl/Cmd+Shift+N), name it "Line Work," and ensure that black is the foreground color. Click on the Brush tool and choose a small, hard-edged brush from the picker. Then select the Pen tool, and click on the tab at the top of the Layers palette to reveal the Paths palette. Draw a single curved path, following one of the edges of the hair.

32

16 Right-click (or Ctrl-click) this Work Path in the Paths palette, and select Stroke Path. Choose Brush for the Tool, making sure that Simulate Pressure is checked. After stroking the path, click in a blank area of the Paths palette.

17 Add more paths, stroking each before drawing the next. Add as many as you like, ensuring they follow the shapes in the image.

18 After clicking on the white-filled layer, add a new layer and choose the Custom Shape tool by clicking and holding on the Shape tool in the Toolbar. Ensure that the Fill Pixels option is selected in the Options bar in the upper left corner. Click on the Shape Picker to reveal shape thumbnails, then click on the right-pointing arrow to get more options. Choose All (clicking OK at the warning dialog), and scroll through the thumbnails to locate Leaf Ornament 1.

20 Finally, double-click the Bevel and Emboss effects panel attached to the main figure layer. In the Layer Styles dialog box, click the Drop Shadow panel. Set the Distance slider to 57 and the Size to 106. Repeat this procedure for the hair layer. For a final touch, click on the leaf ornament layer, then select the Rectangular Marquee tool. Draw a border around the image. Go to **Edit > Stroke** and choose a bright red color. Set pixel width to 5 and Location: Inside. Click OK.

19 Choose a suitable foreground color and click and drag with the tool to create a large motif behind the figure. Move this motif into place with the Move tool (V).

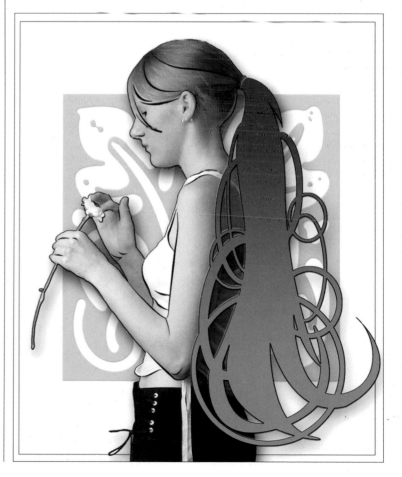

Warhol screen-print

Andy Warhol's silkscreen prints are recognized worldwide, and epitomize the entire Pop Art style. In this example, we'll get into the very essence of Warhol's images, most famously evident in the iconic Campbell's soup can images. But we can update the technique with our own digital twist, using Photoshop.

There are a couple of Photoshop filters that are invaluable here. The Cutout filter is a great way to simplify and break up the tones in the image, very much a characteristic of screen printing, while clever use of the Glowing Edges filter provides some solid lines for definition.

In essence, we're paying homage to a great 20th-century artist—in a 21st-century fashion.

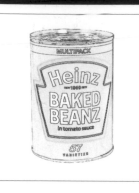

1 Before we begin to simulate the screen print effect, isolate the can from its background. Select the Magic Wand tool from the Toolbar and set the Tolerance to 30 in the Options bar. Ensure that Anti-Aliased and Contiguous are both checked. Click anywhere in the white surrounding the can to generate a selection. Invert the selection using **Select > Inverse** (Ctrl/Cmd+Shift+I) so that the can itself is selected.

2 With the selection active, go to Edit > **Copy** (Ctrl/Cmd+C) and then to **Edit > Paste** (Ctrl/Cmd+V) to paste a copy of the can on a separate layer. Name this "Can layer." Duplicate this new layer by going to **Layer > Duplicate Layer** (Ctrl/Cmd+J), and name the duplicate "Glowing Edges."

3 To begin the screen-print effect, we need to establish a bold outline. With the Glowing Edges layer selected, go to **Filter > Stylize > Glowing Edges**. Use Edge Width 2, Edge Brightness 13 and Smoothness 5. Click OK.

4 Go to **Image > Adjustments > Desaturate** (Ctrl/Cmd+Shift+U) followed by **Image > Adjustments > Invert** (Ctrl/Cmd+I) so that we have a monochrome line drawing of the can. Set the blending mode for this layer to Multiply so that the original can image shows through the drawing.

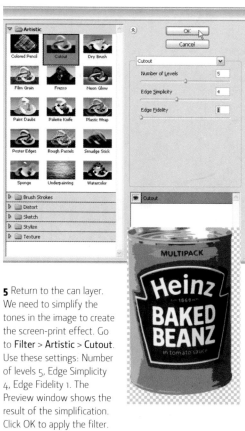

5 Return to the can layer. We need to simplify the tones in the image to create the screen-print effect. Go to **Filter > Artistic > Cutout**. Use these settings: Number of levels 5, Edge Simplicity 4, Edge Fidelity 1. The Preview window shows the result of the simplification. Click OK to apply the filter.

6 Return to the Glowing Edges layer and use the Eraser tool to erase this layer over just the small lettering on the label.

7 To create an image reminiscent of Warhol, we need to adjust the colors of the can. Return to the can layer and go to **Image > Adjustments > Hue and Saturation**. Check the Preview box, grab the Hue slider, and slide it all the way to the left. The colors in the image change as we move the slider. To increase the vibrancy of the colors, pull the Saturation slider to the right until the value reads about 75.

8 Click on the top Glowing Edges layer and go to **Layer > Merge Down** (Ctrl/Cmd+E) to merge the can and drawing layers.

9 Now enlarge the canvas so that more images can be added. Ensure that the background color is set to white and go to **Image > Canvas Size**. In the dialog box, change the width units box to percent and enter 100 in the Width and Height boxes. Click the top left square in the Anchor plan and click OK

10 Make three duplicate copies of the completed can layer by repeatedly dragging it to the New Layer icon in the Layers palette (or hit Ctrl/Cmd+J three times). Click on each layer in turn and use the Move tool (V) to position the four cans around the canvas. See tip box for how to align layers.

Tip

ALIGNING LAYERS
To perfectly align the cans, use the Align layers command. We can link layers by selecting them (with Shift+click) and then clicking the Link layers icon at the bottom left of the Layers palette. To link the two layers containing the cans on the left- or right-hand side of the image, go to Layer > Align > Vertical

Centers. To link the layers containing the cans at the top or bottom of the image, go to Layer > Align > Horizontal Centers.

11 Now we'll alter the colors of the additional three cans. To do this, on each layer in turn go to **Image > Adjustments > Hue and Saturation** and adjust the Hue slider as in step 6, choosing a different hue for each additional can. Adjust the Saturation slider as necessary.

12 Finally, add a new layer at the bottom of the stack and make a selection with the Rectangular Marquee tool to cover a quarter of the total area behind one can. Fill this selection with a color of your choice using **Edit > Fill**. Move the selection to the other quarters by dragging and filling each time with a different color.

Watercolor

Although Photoshop includes filters and effects rather optimistically labeled Watercolor, after the first few attempts to use them to produce a convincing fine art image, their shortcomings become all too apparent.

In fact, the program does have the power to enable us to mimic real watercolor paintings, but success relies on good technique rather than a simple one-click process.

Although the techniques in this example are relatively basic—manipulating image layers and adding some subtle brushwork—the results are deceptively sophisticated.

A point worth noting here is that a pressure-sensitive stylus and pad is virtually essential when it comes to expressive and effective use of brushes. Using Brush Options, a brush can be set to respond directly to the pressure applied by the stylus. As a result, extremely subtle variations in the opacity and density of the brushstrokes can be achieved.

1 Duplicate the background layer (Ctrl/Cmd+J). To prepare the image for the watercolor effect, go to **Filter > Blur > Smart Blur**. This will simplify the tones and the detail in the image. Use these settings: Radius 14.1, Threshold 68.4, Quality High, Mode Normal.

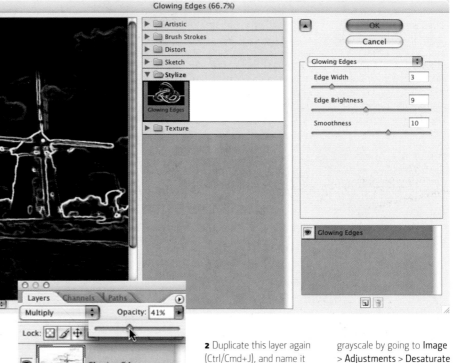

2 Duplicate this layer again (Ctrl/Cmd+J), and name it "Glowing Edges." To create the effect of an initial line drawing, go to **Filter > Stylize > Glowing Edges**. Use: Width 3, Brightness 9 and Smoothness 10. This layer needs to be inverted so there are dark lines on a light base. Go to **Image > Adjustments > Invert** (Ctrl/Cmd+I). Finally, desaturate the line work to make it grayscale by going to **Image > Adjustments > Desaturate** (Ctrl/Cmd+Shift+U). Set this layer's blending mode to Multiply, reducing the opacity to 41%.

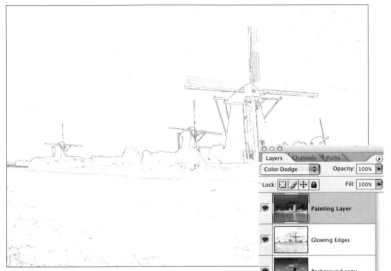

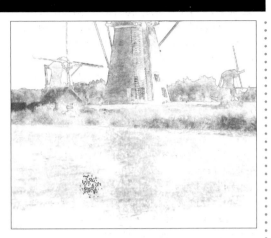

3 Duplicate the first background copy layer that we applied Smart Blur to, name it "Painting Layer," and drag it to the top of the layer stack. Go to **Image** > **Adjustments** > **Invert** (Ctrl/ Cmd+I) and set the blending mode for this layer to Color

Dodge. The image will turn white at this stage, which is exactly what we need. This will be our blank canvas. Paint onto it with black, which, because of its blending mode, will reveal the colors in the image.

4 Select the Brush tool and click in the Brush Picker. To make sure that you are using the default brush set, click the small, right-pointing arrow and choose Reset Brushes. Next, scroll down the brush thumbnails and choose Dry Brush. If you are using a graphics tablet, hit

F5 to display the Brush Options. Click in the Other Dynamics panel, and for Opacity Jitter, choose Pressure in the Control box.

5 Hit D to ensure that the foreground color is black. Paint with this brush at a large size over the main central area of the image at an opacity of about 60%. Leave plenty of plain white around the edges of the picture. Gradually build up the depth of color by painting over certain areas more than once. To give the impression of real watercolor, it's important to leave small areas of white here and there.

6 Click in the Brush Picker again, click the right-pointing arrow, and now choose Wet Media Brushes. Select Watercolor Textured Surface from the brush thumbnails. Use the Zoom tool to zoom into the main windmill in the image. Paint with this brush (using black) into the windmill and surrounding areas. Use short, random strokes that follow the contours and shapes of the components of the image.

7 Use this brush to paint over the rest of the land in the image. Use short, expressive strokes. When you paint over the grass and the bushes, try to follow the direction of the grass and plant growth and use directional strokes to define the image. Gradually build up color by painting over some areas again with black at low opacity.

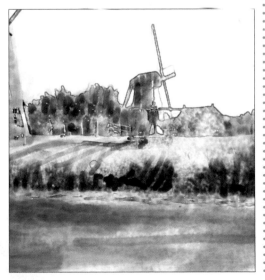

37

Watercolor continued

8 Increase the size of the brush using the right-hand square bracket, and paint large, loose strokes into the sky and water. Don't try to follow the details of the clouds or ripples in the water, just add some interest and movement with these strokes. This will give a real feeling of pure watercolor.

9 Often, watercolors are painted on slightly off-white paper, so let's establish that next. Go to **Layer > New Fill Layer > Solid Color** and click OK. When the Color Picker appears, choose a very light straw color for the fill. Click OK and set this layer's blending mode to Linear Burn, opacity 31%. Paint into this layer using black to hide it here and there, exposing the white beneath.

10 To add a subtle paper texture, go to **Layer > New Fill Layer > Pattern** and click OK. Click the downward-pointing arrow in the Pattern Picker display and then the right-pointing arrow next to the pattern swatch to bring up the Pattern Picker itself, and choose Artist Surfaces. Choose Watercolor from the swatches. Increase the scale to 573 and click OK. Drag this layer below the Color fill layer and set its blending mode to Multiply with an opacity of 76%.

11 To give the impression of broad, soft washes of color, return to the background copy layer and choose the Eyedropper tool. Click with the tool in the blue sky. Now, go to **Select > Color Range**, set Selection Preview to Black Matte and use a Fuzziness setting of 61, so that just some of the blue areas in the sky and water are selected. Hit OK.

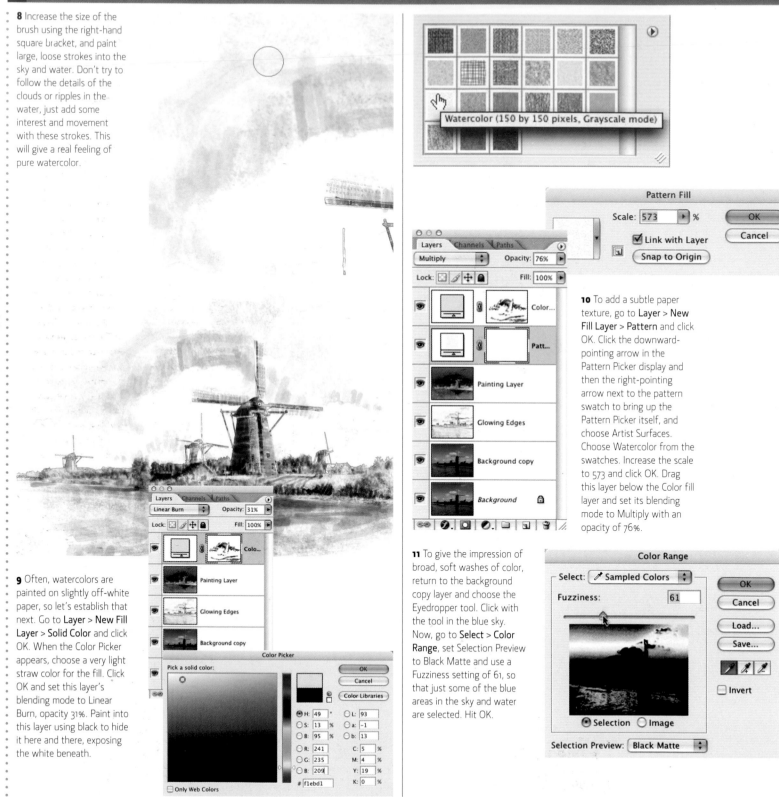

12 Go to **Edit** > **Copy** (Ctrl/Cmd+C), **Edit** > **Paste** (Ctrl/Cmd+V). Drag this newly pasted blue layer up so that it sits directly below the Pattern Fill layer. Go to **Filter** > **Blur** > **Motion Blur**. Use these settings: Angle 90, Distance 283. Set this layer to Darken blending mode, opacity 60%.

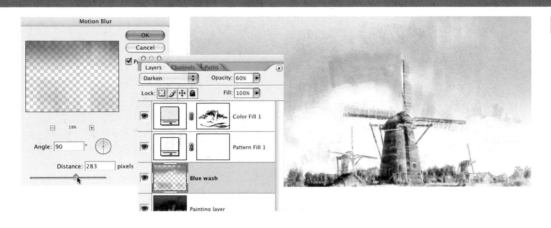

Tip

MAKING MARKS
Although this technique results in a convincing painterly effect, you really don't need to be an accomplished artist to successfully create it. All we're actually doing here is making simple marks with the brush using black on the Color Dodge layer. Due to the blending mode of this layer, the black marks allow the colors on the underlying layer to show through at various opacities. Because of the special qualities of the brushes used, the black marks on the layer have the effect and texture of real watercolor on paper. It's important to ensure that the marks we make on this layer are energetic and lively. As a general rule, short dabs work better than long strokes.

13 To complete the image, duplicate the background copy layer again, naming it "Watercolor Filter," and drag this copy to the top of the layer stack. We'll emphasize the overall effect by using Photoshop's Watercolor filter very subtly. Go to **Filter** > **Artistic** > **Watercolor**. Use: Brush Detail 12, Shadow Intensity 0, Texture 3. Click OK to apply the filter. Finally, set this layer's blending mode to Luminosity, and the opacity to 27% so that it just adds a touch of emphasis to the painting.

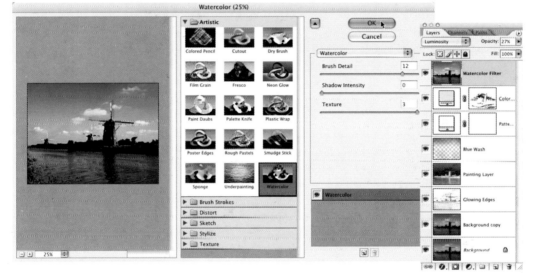

14 Return to the Painting layer and choose the Brush tool. Click in the Brush Picker, selecting the Watercolor Heavy Loaded brush. Hit D on the keyboard to revert to default colors. Using black, paint some small strokes throughout the center of interest in the image. This brush produces distinct, sharp accents that will help to direct the viewer's attention.

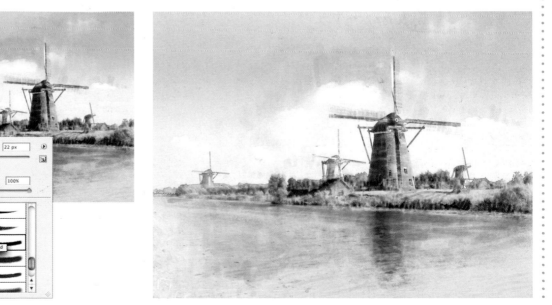

39

Oil painting

There are many filters out there that promise to transform digital photographs into oil paintings, but it has to be said that most fail miserably. To create a truly realistic oil painting effect we need to be a little more inventive. One of the most important characteristics of an oil painting is the contrast of thin areas of paint set against areas of thick, solid paint or impasto. Another vitally important factor is texture. Oil paintings have a surface quality that is unique to the medium itself, and for the effect to be convincing we need to mimic this accurately. Fortunately, Photoshop has a selection of brushes that are made for this very purpose. These brushes can apply color and convincing textures at the same time. For the thick impasto effect we can employ a layer style that will give the brushstroke a subtle 3D quality.

Remember, this project will be far more successful if a pressure-sensitive graphics tablet is used, as the brushes we're going to use have properties that respond directly to stylus pressure.

1 To begin the painting, make a toned canvas layer for the final image to be "painted" onto. With the start image open, add a new layer (Ctrl/Cmd+Shift+N), naming the layer "Canvas." Choose a warm gray for the foreground color and go to **Edit > Fill > Use Foreground color**. We'll add a canvas texture to this background a little later.

2 We need to create a rough under-drawing that will form a framework for the painting. Click on the background layer and duplicate it using Ctrl/Cmd+J. Drag this duplicate layer to the top of the layer stack. Now go to **Filter > Stylize > Glowing Edges**. Use these settings: Edge Width: 5, Edge Brightness: 13, Smoothness: 11. Remove the color from this layer using **Image > Adjustments > Desaturate** (Ctrl/Cmd+Shift+U) and invert the layer with **Image > Adjustments > Invert** (Ctrl/Cmd+I). Set the blending mode for this layer to Multiply, opacity to 57%.

3 Duplicate the background layer again (with Ctrl/Cmd+J), dragging the duplicate to the top of the layer stack. Increase the color saturation using **Image > Adjustments > Hue and Saturation**, dragging the Saturation slider up to 33.

6 Hit F5 to display the Brush Options. Click the Texture category and increase the Texture Scale to 85%. Choose Shape Dynamics, setting the Minimum Diameter to 65%. Finally, if using a graphics tablet, choose Other Dynamics and set Opacity Jitter Control to Pen Pressure.

4 To lose some of the detail in the image and begin to create a painterly effect, go to **Filter** > **Artistic** > **Palette Knife**. Use 12 for Stroke Size, 2 for Stroke Detail, and 10 for Softness. Click OK to apply the filter. Set the blending mode for this layer to Hard Light.

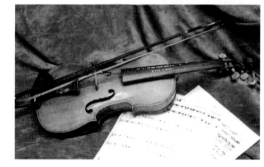

5 Hide this layer with a mask using **Layer** > **Layer Mask** > **Hide All**. We need to set up the properties of a particular brush, so choose the Brush tool and click in the Brush Picker. Hit the right-pointing arrow in the Picker, select Wet Media Brushes, and choose Brush Light Texture Medium Tip from the brush thumbnails.

7 Select white as the foreground color. Working on the layer mask, begin to paint over the image. Make sure to leave some gaps here and there, allowing the canvas to show through the painted areas. Use the brush at varying sizes to introduce some interest.

8 Traditionally in an oil painting, the dark areas are painted thinly and the light areas are painted with thick paint, or impasto, so bear this in mind as you continue to paint into the image, overlaying more brushstrokes in the light areas.

Oil painting continued

9 As you paint, you'll see that because we've chosen a brush that carries texture with its stroke, you begin to create a convincing "paint on canvas" effect with the brushstrokes. At this stage, don't worry about painting over the fabric that the objects are lying on, just concentrate on the violin and sheet music.

10 As you get toward the outside edges of the painting, make your brushstrokes far less opaque and more sketchy. Control the opacity of the Brush either using the slider in the Options bar or, if you're using a graphics tablet, by the pressure applied to the stylus.

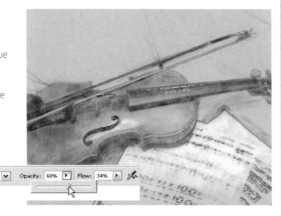

42

12 Click on the layer mask for this layer in the Layers palette and fill it with black using **Edit > Fill > Use: Black**. This will completely hide the image layer, ready for some more painting.

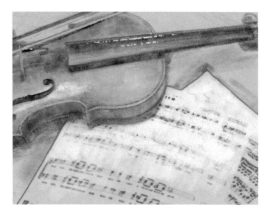

13 Return to the Brush tool and continue to paint with white. Remember to make sure that you are painting on the Layer Mask and not the actual image layer by checking for a bold outline around the thumbnail for the mask in the Layers palette. Concentrate on painting mainly into the lighter areas in the image with the brush at a fairly small size. As you paint, you'll see the effect of thick paint standing on the surface of the canvas begin to develop.

14 Change brushes to add a few more deft strokes of impasto that will really add to the oil painting effect. Click in the Brush Picker and choose Oil Medium To Large Tip. In Brush Options, select Shape Dynamics and set Opacity Jitter Control to Pen Pressure. Next, choose Shape Dynamics and set Minimum Diameter to 75%. Again, painting with white, add a few stokes here and there with this brush.

11 Now duplicate this main Painting layer, complete with Layer Mask, by going to **Layer > Duplicate Layer**. To give the impression of thick paint on the layer, add a Layer Style. Go to **Layer > Layer Style > Bevel and** Emboss. For Style choose Emboss, and increase the Depth slide to 81.

15 Now right-click/Ctrl-click each layer mask in turn, choosing Apply Layer Mask on both. This will apply the mask to the image layer, maintaining the transparency values from the masks. Click on the topmost painting layer and go to **Layer > Merge Down** (Ctrl/Cmd+E) to merge the two painting layers together.

16 Select the Smudge tool from the Toolbar. Choose the Oil Medium To Large Tip brush again from the Brush Picker. Bring up the Brush Options and in Shape Dynamics set Minimum Diameter to 75%. If using a graphics tablet, go to the Other Dynamics category and set Strength Jitter to Pen Pressure. Now, using this tool on the Palette Knife layer, gently smudge parts of the image, paying special attention to smudging edges here and there. This will give the impression of some nice loose brushwork.

17 To complete the painting, we need to apply a canvas texture to the Canvas layer. Click on the Canvas layer in the Layers palette and go to **Filter > Texture > Texturizer**. In the Texturizer dialog box, choose Canvas for Texture, 176% for Scaling, 10 for Relief, and Top Left for Light Direction. Click OK to apply the texture. To finish, flatten the image with **Layer > Flatten Image** and save.

Tip

PRINTING PERFECTION! To add the perfect finishing touch to our "oil painting," try printing the finished image onto canvas-textured media. There are many manufacturers out there that produce canvas-type inkjet papers, and some real artists' canvas can be used in a normal inkjet printer. The advantage to using this is that the subtle canvas textures we've added using Photoshop's special brushes are enhanced by the physical surface texture of the canvas.

It's worth making a test print first, to see if printing on the canvas paper produces any unwanted color shifts. Compensate for this by adjusting the Hue/Saturation in Photoshop before making the final print (it may take a few test prints to get it just right). Remember to always follow the manufacturer's instructions regarding media-type settings for your printer.

43

Pencil sketch

Ask any artist and they'll tell you that all the tubes of paint in the world cannot replace the simple pencil when it comes to artistic potential. Through the centuries, the litmus test of an artist's ability was demonstrated best through the medium of drawing. In days of yore, student painters spent years drawing with graphite to hone their skills. The so-called "Sketch Filters" in Photoshop consistently yield very disappointing results; re-creating the quintessential sketch demands a little more inventiveness and an approach that mimics traditional techniques.

Pencil sketches work especially well when very soft leaded pencils are used on a tinted paper, with a few touches of white chalk here and there to heighten the tones. This is what we'll produce here, digitally. Don't worry if your drawing abilities aren't up to snuff, all that's required here is the ability to scribble!

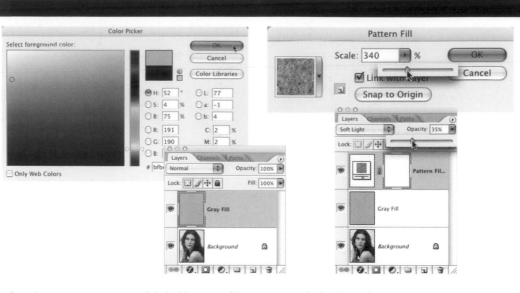

1 Open the start image in Photoshop. Go to **Layer > New Fill Layer > Solid Color**, call it "Gray Fill," and click OK. In the Color Picker, choose a light gray.

2 Click the "Create new fill or adjustment layer" icon at the base of the Layers palette and choose Pattern from the list. Click in the Pattern Swatch in the dialog box, hit the right-pointing arrow, and select Grayscale Paper. Choose Fibers 1 from the swatch. Increase the Pattern Scale to 340% and click OK. Set this layer to Soft Light, and 35% opacity.

3 Right-click/Ctrl-click the background layer and choose Duplicate Layer, calling the layer "Glowing Edges." Drag this new layer to the top of the stack and go to **Filter > Stylize > Glowing Edges**. Use these values: Edge Width 3, Edge Brightness 11, Smoothness 10.

4 Invert the Glowing Edges layer using **Image > Adjustments > Invert** (Ctrl/Cmd+I). This layer only needs to be black and white, so go to **Image > Adjustments > Desaturate** (Ctrl/Cmd+Shift+U). Set the layer's blending mode to Multiply with an opacity of 15%.

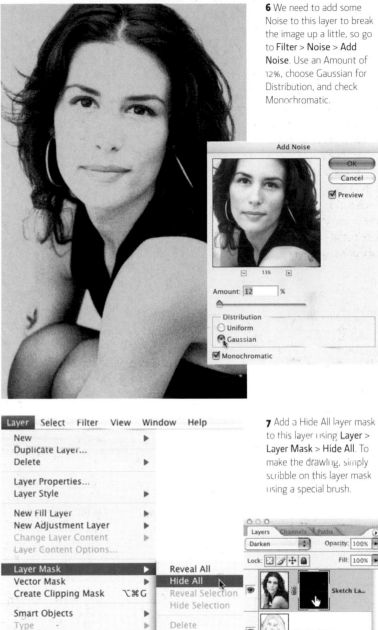

6 We need to add some Noise to this layer to break the image up a little, so go to **Filter > Noise > Add Noise**. Use an Amount of 12%, choose Gaussian for Distribution, and check Monochromatic.

5 Duplicate the background layer again, calling it "Sketch Layer," and drag this duplicate to the top of the stack. Desaturate this layer using **Image > Adjustments > Desaturate** (Ctrl/Cmd+Shift+U). To use the layer as a base for the drawing, increase the contrast a little, by going to **Image > Adjustments > Brightness and Contrast**. Drag the Contrast slider to the right to a value of 22. Now set the layer blending mode to Darken and leave the opacity set to 100%.

7 Add a Hide All layer mask to this layer using **Layer > Layer Mask > Hide All**. To make the drawing, simply scribble on this layer mask using a special brush.

Pencil sketch continued

8 Select the Brush tool and click in the Brush Picker. Click the right-pointing arrow in the Picker and choose Dry Media Brushes. Scroll down the thumbnails and double-click Pastel on Charcoal Paper.

9 Hit F5 on the keyboard to display the Brush Options. Click the Other Dynamics panel and set the Opacity Jitter Control box to Pen Pressure. Click Shape Dynamics and set the Size Jitter to Pen Pressure. Set Minimum Diameter to 70%. Remember, if you are not using a graphics tablet, you must control the opacity of the Brush using the Opacity slider in the Options bar.

10 Be sure that the foreground color swatch is white. In the Options bar, increase the size of the brush to between 20 and 25 pixels. Now begin to scribble onto the Sketch Layer's layer mask. At first, just concentrate on the main facial features within the image. Use just a little pressure on the stylus, or a very low opacity for the brush. Scribble loosely over all of the required parts of the image, changing direction often to create a hand-shaded look.

11 Use plenty of cross-hatch scribble where the strokes overlap in opposite directions. Remember, there is no actual drawing ability whatsoever required here, we are simply scribbling to reveal the layer lying beneath the Layer mask.

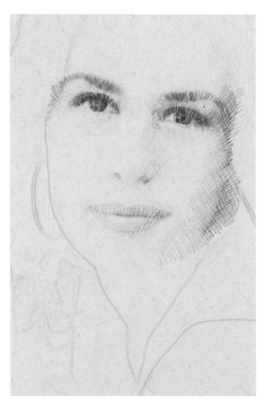

46

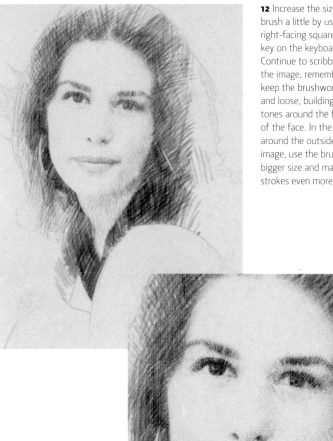

12 Increase the size of the brush a little by using the right-facing square bracket key on the keyboard. Continue to scribble over the image, remembering to keep the brushwork nice and loose, building up the tones around the features of the face. In the hair, and around the outside of the image, use the brush at a bigger size and make the strokes even more sketchy.

Tip

FEEL THE PRESSURE!

In exercises such as this, using a pressure-sensitive graphics tablet has huge advantages over using a mouse. Many of the special brushes in Photoshop, such as the one we're using here, have characteristics that can be set to respond directly to pressure. Although this exercise can be completed with a conventional mouse, the opacity of the brush has to be controlled manually in the Options bar. When using a graphics tablet we can simply apply more pressure to the stylus to create darker strokes. Graphics tablets are relatively cheap nowadays, and stunning results can be achieved with even the most inexpensive models.

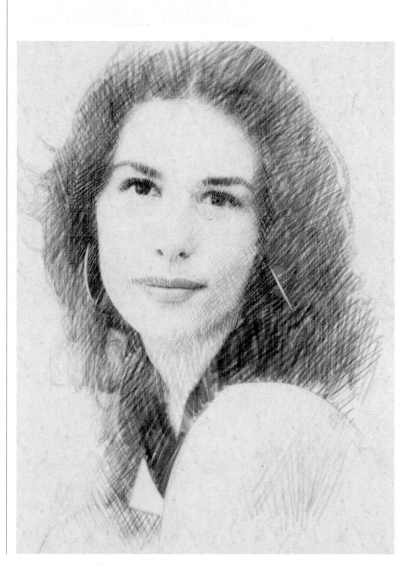

13 Finally, reduce the size of the brush again and use it with white at full opacity to scribble more into the main features, adding some really dark strokes.

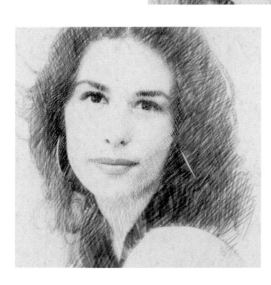

47

Pen-and-ink drawing

Pen-and-ink drawings have a charm all of their own. There is a certain crispness and clarity to a pen drawing that can't be achieved in any other way. As a technique, it's quite a challenge to replicate in Photoshop, although by no means impossible. Pen drawings rely on the density of hatched lines to create varying tones within an image, and, where the individual lines are black in color, the viewer's eye interprets different densities of hatching as various shades of gray.

Pen drawings evoke an antique "old world" feeling. The technique seems especially suited to architectural subjects.

To create the pen-and-ink effect, we'll use Photoshop's Graphic Pen filter. This filter has to be used with care, as it's a stock effect, which, when used on a single layer, does not produce a satisfactory result. However, combining a number of layers with different settings will replicate the technique employed by artists, who use pen strokes at different angles.

48

1 To use the Graphic Pen filter effectively, the background color must be set to white, so be sure that this is done before we start (hit D on the keyboard or click on the black and white color swatches near the bottom of the Toolbar).

2 Start by making four copies of the background layer (hit Ctrl/Cmd+J four times). Click on the topmost duplicate layer and rename it "Pen layer." Then go to **Filter > Sketch > Graphic Pen**, and enter these settings: Stroke Length: 13, Light/Dark Balance: 8, and select Right Diagonal for Direction.

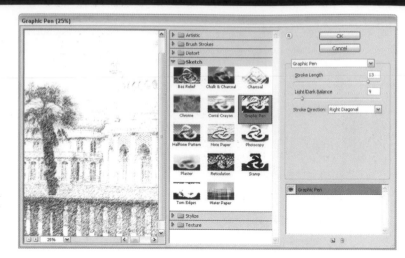

Tip

PAPER TEXTURE

To add a little extra realism to the Pen Drawing, try adding a subtle paper texture to the finished image. After the drawing is completed, go to Layer > New Fill Layer > Pattern. Click in the small pattern swatch and load Artist Surfaces using the small right pointing arrow. Choose a texture from the swatches and increase the Scale to at least 300%. Set this pattern layer to Soft Light blending mode.

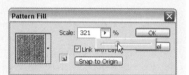

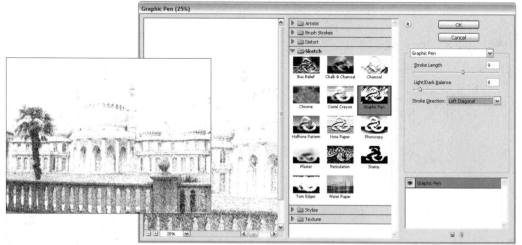

3 To sharpen the pen strokes on this layer, apply **Filter > Sharpen > Sharpen Edges** twice. Then drag one of the remaining background copies to the top of the layer stack

and rename it "Darken 1." Go to **Filter > Sketch > Graphic Pen**, but this time use: Stroke Length: 9, Light/Dark Balance: 8, and choose Left Diagonal for

Direction. Set the layer blending mode to Darken, allowing the underlying layer to show through.

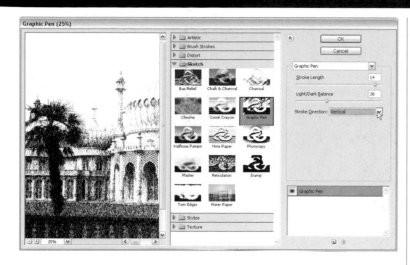

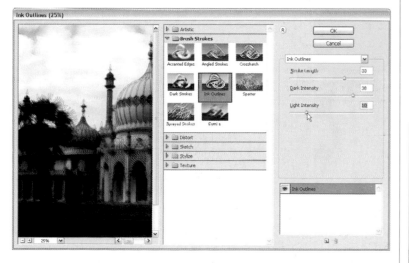

4 Drag another of the background copies to the top of the stack and name it "Darken 2." Click on the layer, then go to **Image > Adjustments > Brightness and Contrast**. To create a more subtle effect, reduce the contrast by pulling the Contrast slider to the left, setting it at -20. Go to **Filter > Sketch > Graphic Pen**, and apply: Stroke Length: 14, Light/Dark Balance: 36, and Direction: Vertical. Set the blending mode to Darken, with an opacity of 75%.

6 The pen-and-ink drawing is complete at this stage, but we might want to add some subtle watercolor wash effects to the image. To do this, duplicate the background layer, and drag it to the top of the layer stack. Go to **Filter > Blur > Gaussian Blur**, with a radius of 30. Set the layer blend mode to Color.

5 Add some loosely drawn outlines by dragging the remaining background copy to the top of the stack. Rename it "Ink layer." Go to **Filter > Brush Strokes > Ink Outlines**, and apply these settings: Stroke Length: 33, Dark Intensity: 38, and Light Intensity: 10. To remove color from this layer, desaturate it using **Image > Adjustments > Desaturate** (Ctrl/Cmd+ Shift+U). Set the layer blending mode to Hard Light, with opacity of 54%.

Woodcut and linocut

Making prints from a woodcut, a wooden printing block created by gouging a design into a wooden block, is a technique that dates back to the earliest days of printing.

Essentially, the design on the block is carved into the wood in reverse. When the block is inked with a flat roller, the areas that have been carved don't pick up any ink, while the areas that haven't been carved do. When printed, only the uncarved areas leave an impression. There are a few Photoshop techniques that can be found on the Internet for simulating this printing technique, but here we'll use one that involves using vector paths, which produce the sharp lines and fills ideally suited to this effect.

So, digital wood chisels at the ready, we're about to create a woodcut print...

1 To create the woodcut effect, we need first to dramatically simplify the start images in various stages. Begin by copying the background layer (Ctrl/Cmd+J).

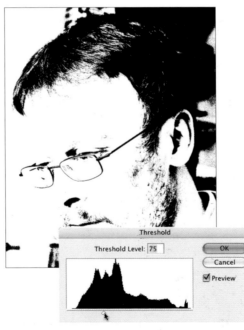

2 On this duplicate layer, go to **Image** > **Adjustments** > **Threshold**. Drag the pointer to the left to a Threshold value of 75 and click OK. It's immediately apparent how much this simplifies the image tones.

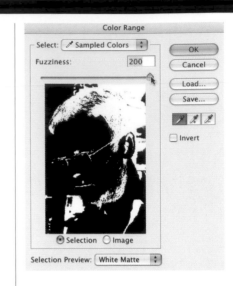

3 Now hit D on the keyboard to revert to default black/white swatch colors. Go to **Select** > **Color Range** and drag the Fuzziness slider up to a maximum of 200. This will select just the blacks in the image.

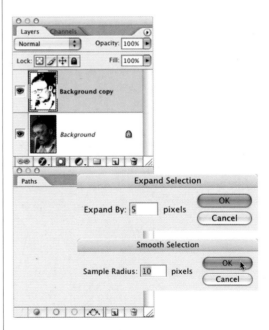

4 Go to **Select** > **Modify** > **Expand**, using a value of 5 pixels. Now simplify with **Select** > **Modify** > **Smooth**. For Sample Radius, enter 10 pixels. Now, click on the Paths palette and drag this palette out into the workspace.

5 At the base of the Path palette, click on the "Make work path from selection" icon. Wait while Photoshop converts the Selection into a Path. Now go to **Edit > Fill**, choosing White for Contents to fill the duplicate layer with white, leaving just the Path visible.

6 Add a new layer to the image (Ctrl/Cmd+Shift+N) Return to the Paths palette, and right-click/Ctrl-click the Work Path and choose Fill Path. From the Fill Path dialog box, choose Black for Contents. This filled layer will form the base of the woodcut. Before moving on, rename the Work Path "Path 1" and click in a blank area of the palette to deselect it.

7 Click on the background layer and copy it (Ctrl/Cmd+J). Drag this duplicate layer to the top of the layer stack. Go to **Filter > Blur > Smart Blur**. Use a Radius of 73 and a Threshold of 40. Choose Quality: High, Mode: Normal, and click OK.

8 Now go to **Filter > Other > High Pass**. Use a Radius here of 5.2 pixels. Go to **Image > Adjustments > Threshold**, and choose a Threshold value of 124.

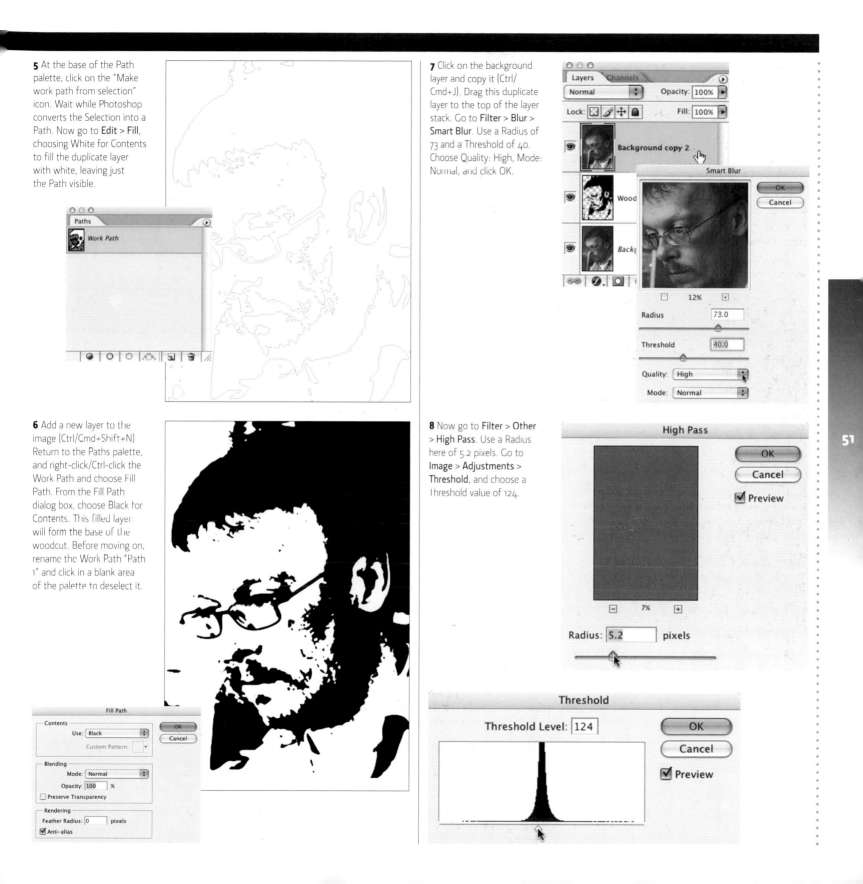

51

GRAPHIC ART EFFECTS

9 Select **Image > Adjustments > Invert** (Ctrl/Cmd+I), and then hit X on the keyboard to swap the foreground and background colors so white is foreground. Go to **Select > Color Range**, again using a Fuzziness of 200. Now, again go to **Select > Modify > Smooth**

using a Sample Radius of 5 pixels. Return to the Paths palette, and choose the "Make work path from selection" icon again and name this "Path 2." Grab this duplicate layer in the Layers palette and drag it to the trash can.

10 Add a new layer to the image (Ctrl/Cmd+Shift+N). Now right-click/Ctrl-click Path 2 in the Paths palette and choose Fill Path. Choose

50% Gray from the Contents box in the Fill Path dialog box. This will add a little detail to the woodcut image. Click off the Work Path.

11 Duplicate the background layer for a final time, dragging it to the top of the stack. We need to use a different technique here to add a little

detail to the image. Go to **Filter > Stylize > Glowing Edges**. Use: Edge Width 6, Edge Brightness 11, Smoothness 14.

12 Return to **Image > Adjustments > Threshold**, choosing a Threshold level of 107. Be sure that the foreground color is white. Now go to **Select > Color Range**, again using a maximum Fuzziness value of 200. Now go to **Select > Modify > Smooth** using a Sample Radius of 5.

52

Tip

WOODCUT PRINT ON COLORED GROUND

It's easy to recreate the effect of the final woodcut printed on a colored paper. When the image is completed, with the layers still intact, click on the Woodcut 1 layer and go to Layer > New Fill Layer > Solid Color. Choose a color for the ground from the picker, and then simply set the blending mode for the Color Fill layer to Linear Burn in the Layers palette.

If you want to print the image directly onto colored paper, then you will first need to delete the background layer (converting it into a normal layer first by double-clicking it). Depending on the color of the paper that you're printing onto, you may also want to delete the colored layer, leaving just the black and gray layers.

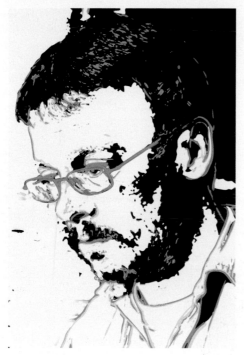

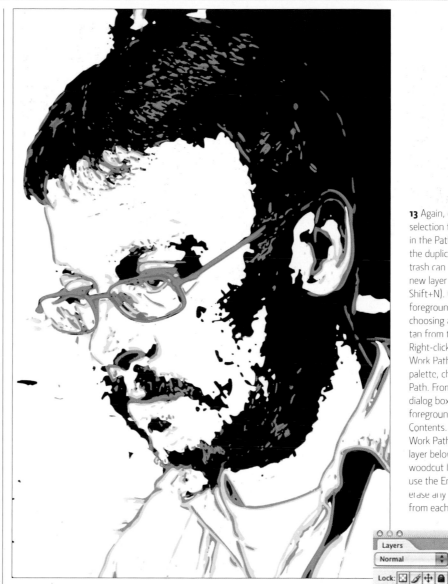

13 Again, convert the selection to a Work Path in the Paths palette. Drag the duplicate layer to the trash can and add a final new layer (Ctrl/Cmd+Shift+N). Click the foreground color swatch choosing a light orange/tan from the Color Picker. Right-click/Ctrl-click the Work Path in the Paths palette, choosing Fill Path. From the Fill Path dialog box, choose foreground color for Contents. Click off the Work Path and drag this layer below the gray-filled woodcut layer. Finally, use the Eraser tool to erase any unwanted parts from each layer.

LIGHTING EFFECTS

Adding rays of light

ight is the essence of photography—and it's also the photographer's most effective tool for creating unique images with power and romance that set them apart from ordinary snapshots. Unfortunately, time and nature are not always on our side when it comes to this most alchemic photographic ingredient. But all is not lost: armed with Photoshop, we can add stunning lighting effects even after the fact. To simulate the subtle and mysterious qualities of light, gradients and layer masks are our greatest allies.

In this example, we'll use gradients to recreate the effect of light passing through a stained-glass window. Using different gradients on separate layers with various blending mode settings, we can simulate the effect of dissipating light beams with great authenticity. By making selections for each beam of light with the Polygon Lasso tool, we can accurately restrict the gradient fills and then lightly blur the edges. We can then adjust the direction of each light beam layer by using Transform. Photographs need never be hampered by dull, gray days again.

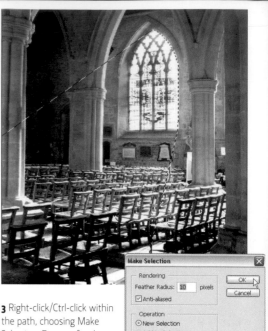

1 Begin by adding an overall shaft of light that will serve as the foundation for the final lighting effect. Add a new layer (Ctrl/Cmd+ Shift+N), call it "Main Beam," and then select the Pen tool. Draw a large wedge-shaped path from the very top of the window, radiating out over to the left side of the image.

2 The path should encompass the entire bottom left-hand corner of the image. Click again with the tool at each corner of the shape. Click again at the bottom right of the window, and again where the top curve begins. Now return to the starting point, clicking and dragging to follow the curve.

3 Right-click/Ctrl-click within the path, choosing Make Selection. Enter 10 for the Feather Radius in the dialog box and hit OK.

4 Choose a very pale yellow from the Color palette (accessed under Window if it's not already open) and choose the Gradient tool. Click in the Gradient Picker and choose Foreground to Transparent. Select Linear Gradient in the Options bar, and drag a gradient from the top of the window down to the bottom left-hand corner. Hit Ctrl/Cmd+D to deselect.

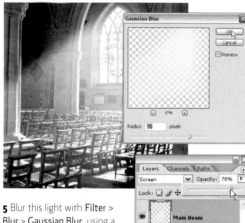

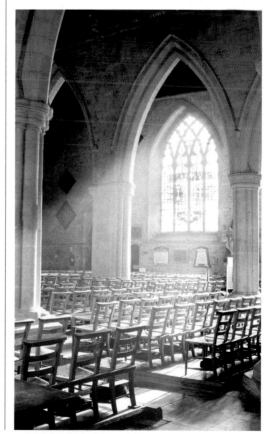

5 Blur this light with **Filter > Blur > Gaussian Blur**, using a Blur Radius of 76 pixels. Set the layer blending mode to Screen and reduce the layer opacity to 78%.

7 Soften the edges of the beam with a Gaussian Blur at a radius setting of 90 pixels (**Filter > Blur > Gaussian Blur**). Change the blending mode for this layer to Vivid Light, and reduce the opacity to create a subtle, convincing effect.

9 To give the effect of the light being filtered by airborne particles, return to the Main Beam layer and go to **Filter > Noise > Add Noise**. Select Gaussian for Distribution and use an Amount of 20%.

10 We can adjust the exact hue of each light beam by clicking on it in the Layers palette and going to **Image > Adjustments > Hue/Saturation**. Use the Hue slider to modify the color and increase or decrease the brightness using the Lightness slider.

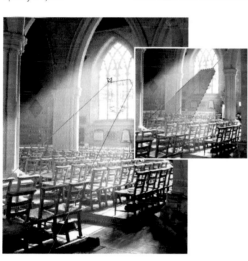

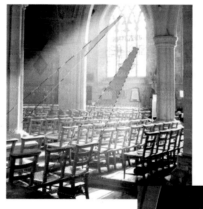

6 To heighten the effect, we now need to add some colored light beams. Create a new layer called "Colored Beams." Choose the Polygon Lasso tool and draw a thin light beam, radiating from the main red glass in the window. Ensure that the direction matches the previous beam. Choose a vivid pink and click the Gradient tool again. Drag the gradient over the length of the selection.

8 Add two thinner light rays with the Polygon Lasso on a separate layer. Fill these with a Blue to Transparent gradient, and blur by the same method. Set this layer to Multiply and reduce the opacity.

Tip

POLYGON LASSO: FINISH AT THE START!

Remember, when using the Polygon Lasso tool to make a selection, you need to close the selection by returning to your starting point. As you return to the point where you made your first click with the tool, a tiny circle will appear by the side of the mouse pointer, indicating that you're about to complete the selection.

Simulating studio lighting

High-quality panoramic studio shots can be tricky to pull off when all that's available is a studio the size of a broom closet. However, with a little skill and imagination, it's possible to build a virtual studio around a model—and even add realistic studio lighting—with Photoshop. The key to this technique is the powerful Lighting Effects filter. Just follow these steps and the restrictive walls of that studio will soon fall away!

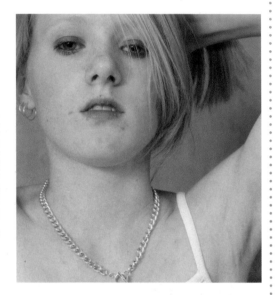

Lighting Effects

Style: Default

Save... Delete

OK Cancel

Light type: Spotlight

☑ On

Intensity: Negative 35 Full

Focus: Narrow 69 Wide

Properties:

Gloss: Matte 0 Shiny

Material: Plastic 69 Metallic

Exposure: Under 0 Over

Ambience: Negative 8 Positive

Texture Channel: None

☑ White is high

Height: Flat 50 Mountainous

☑ Preview 🔆 🗑

LIGHTING EFFECTS FILTER:
The majority of adjustments within the filter dialog box take place within the preview window. First, make sure that the Preview box is checked, so we can gauge the results as we make adjustments. The circle with the handles around it defines the pool of light itself, with the highest concentration of light along the axis line bisecting the pool. The light itself can be moved by clicking and dragging the central spot in the light. Pull on the outer handles of the light to widen the pool of light, and use the handles aligned with the axis to control the range of the light. The Light Type and Properties sliders control the intensity of the light and the material effects it has on the subject.

Tip

EDIT > TRANSFORM Distort transformations can be difficult at first. Try to identify which handles around the box need to be moved to achieve the desired shape, and if you're not happy, hit the stop sign next to the checkmark in the Options bar and try again.

1 Open the main backdrop image, for which we'll be using a close-up. Using the Crop tool, crop from the top of the image to just below the lower lip.

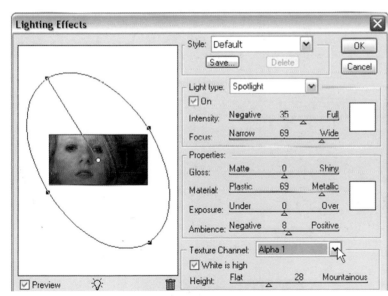

2 To add the texture to the image, open the Channels palette and click the "Create new channel" icon at the base of the palette. Reset the color swatch to default (D). Now go to **Filter > Render > Clouds**. This channel will be used for the lighting texture.

3 In the Channels palette, click back onto the RGB channel before returning to the Layers tab. Now, go to **Filter > Render > Lighting Effects**. Spread the light in the preview box over the entire image, and set the height slider to 28. From the texture channel box, choose Alpha 1 for the channel to be used.

4 Go to **Image > Canvas Size** and increase the canvas size by 30% downward (click the top center in the Anchor box). At the bottom of the Toolbar, choose a deep red for the background color and a lighter shade for the foreground by clicking the respective swatches.

5 Add a new layer (Ctrl/Cmd+Shift+N), call it "Floor," and select the Rectangular Marquee tool. Drag a selection over the entire white portion at the bottom of the image. Click on the Gradient tool, choose Foreground to Background from the Gradient Picker, and drag the tool over the selection from left to right.

6 Add some Noise to this layer (**Filter > Noise > Add Noise**). Check the Monochromatic box and use a value of 13%. Press Ctrl/Cmd+D to deselect.

7 To add the wooden bar at the base of the backdrop, add another new layer (Ctrl/Cmd+ Shift+N) and call it "Bar." With the Rectangular Marquee tool, drag a long thin selection along the base of the backdrop across the entire width of the image. Choose light brown/dark brown for the background and foreground colors respectively, and click on the Gradient tool. Drag a gradient vertically across the selection. Finally, add some noise (**Filter > Noise > Add Noise**) and choose **Filter > Blur > Blur More**.

59

Simulating studio lighting continued

8 Add another new layer for the ropes. Choose the Pen tool from the Toolbar and click the start point at the top of the image. To create subtle curves in the path, click and pull the Pen tool slightly on the subsequent points. Choose an off-white color for foreground and click the Paths palette tab.

9 Select the Brush tool and choose a small, hard brush. Right-click/Ctrl-click the New Work Path in the Paths palette and choose Stroke Path, selecting Brush as the tool, and ensuring Simulate Pressure is checked. Click OK. Click away from the Work Path before returning to the Layers palette.

10 Go to **Filter > Blur > Blur More** and duplicate the Rope layer twice (Ctrl/Cmd+J). Move these new layers into position at intervals further along the backdrop. On the middle Rope layer, go to **Edit > Transform > Flip Horizontal**. Now, select these three layers and go to **Layer > Merge Layers**. Click on the Brush tool and join these ropes with a loose line. Add a couple of knots where the ropes join this line.

11 Finally on this layer, add a shadow to the ropes by clicking the Layer Styles button at the base of the Layers palette and choosing Drop Shadow. In the following dialog box, place the cross in the light direction indicator at 11 o'clock, and set the size slider at a medium value to soften the shadow. Move the distance slider until there appears to be a little distance between the ropes and the backdrop.

12 To add the figure, open the image of the girl sitting, click on the Move tool, and drag this image into the main composition. Use the bounding box corners to resize the image if necessary; remember to hold down the Shift key to retain the correct proportions.

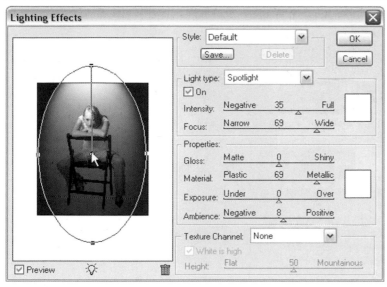

Lighting Effects

Style: Default

Save... Delete

OK

Cancel

Light type: Spotlight

☑ On

Intensity: Negative — 35 — Full

Focus: Narrow — 69 — Wide

Properties:

Gloss: Matte — 0 — Shiny

Material: Plastic — 69 — Metallic

Exposure: Under — 0 — Over

Ambience: Negative — 8 — Positive

Texture Channel: None

☑ White is high

Height: Flat — 50 — Mountainous

☑ Preview

16 Set the layer blending mode for this layer to Multiply, lower the opacity, and drag the layer in the Layers palette so that it sits below the layer containing the sitting figure. Add some blur to the Shadow layer by going to **Filter > Blur > Gaussian Blur**. Finally, duplicate this layer (Ctrl/Cmd+J), go to **Edit > Transform > Distort**, and skew this new layer in the other direction. Again, make sure this layer sits below the main figure in the layer stack.

Gaussian Blur

OK

Cancel

☑ Preview

— 8% +

Radius: 15.8 pixels

17 To add the image on the floor, open the image and drag it into the main composition. Go to **Edit > Transform > Distort** and skew the image as before. Adjust the corner handles to achieve the desired effect.

13 The figure now needs to be lit to blend into the surrounding environment. Go to **Filter > Render > Lighting Effects**. Using the default spotlight, drag the main center of the light to sit mid-body on the figure. Refer to the screenshot and expand the light circle so that it envelops the entire upper half of the figure.

Experiment with different settings for the various sliders to achieve the effect of light concentrated on the upper half of the body.

Fill

Contents

Use: Black

OK

Cancel

☐ Custom Pattern:

Blending

Mode: Normal

Opacity: 100 %

☐ Preserve Transparency

61

14 Make the shadows by transforming and blurring a silhouette of the seated figure. Copy the sitting Figure layer, then Ctrl/Cmd-click the duplicate sitting Figure layer thumbnail to make a selection from its transparency. Fill this selection with black by going to **Edit > Fill > Use: Black**. This Shadow layer now needs to be transformed and skewed so that it is cast away from, and behind, the figure. Hit Ctrl/Cmd+D to deselect.

15 On this Shadow layer, go to **Edit > Transform > Distort**. The distort box has handles around it which can be dragged with the mouse pointer to distort the layer. Click and drag on the top center handle and drag to the right to skew the shadow, and adjust the corner handles to create the effect of perspective. Ensure that the shadow of the front feet on the chair line up with the actual chair legs on the image layer. Hit the Commit checkmark.

Layers | Channels | Paths

Normal — Opacity: 100%

Lock: ☐ ✎ ✛ 🔒 Fill: 100%

👁 Layer 1

👁 Figure

👁 Ropes

• Effects

• Drop Shadow

👁 Bar

👁 Floor

👁 Background

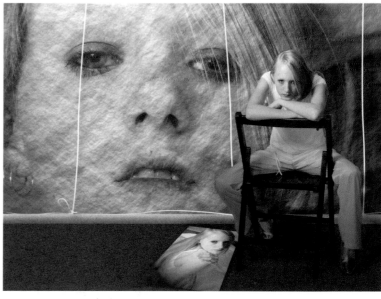

18 Move the image into place and go to **Filter > Render > Lighting Effects**. Position the light so that it illuminates only half of the image. Finally, click the Layer Styles button at the base of the Layers palette and apply a drop shadow to this layer.

Creating a neon sign

If all forms of lighting and illumination, neon is arguably the most evocative. The result of applying an electrical charge to a tube filled with the inert gas, neon, is a light that glows with vibrancy and color. The effect of these lights, synonymous with night clubs, late-night cafés, and the famous gambling strips of Las Vegas, is relatively easy to recreate in Photoshop.

Many tutorials tell us that this can be done using the Glow family of Layer Styles, and while this is true to some extent, the effects produced with those techniques tend to lack subtlety. Here, we're going to use a less automated method, but one that produces far more realistic results.

Key to the technique is the Type tool. With this tool, we can establish the framework for the individual letters and generate pixel-accurate selections that can then be stroked with color. The Gaussian Blur filter is called into service to supply the glow around the tubes of light, and we'll also tailor the perspective of the newly created sign with the Transform function to seamlessly fit it into the image.

Once the essentials of the technique have been mastered, the potential for creating custom neon elements to add to digital photographs is almost limitless.

62

1 Open the nighttime street image and add a new layer (Ctrl/Cmd+Shift+N). Select the Rectangular Marquee tool and drag a rectangle roughly the same size as the empty space above the doorway. Now fill this selection with white using **Edit > Fill > Use: White**. Hit Ctrl/Cmd+D to deselect.

2 Select the Horizontal Type tool and choose Arial Black from the Font Picker. Click in the white rectangle and type "CELLAR BAR." Highlight the words, and then, in the Options bar, increase the size of the type to fit the height of the white panel. Hit the Commit checkmark.

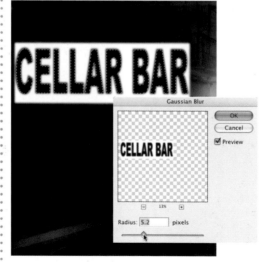

3 Right-click/Ctrl-click the Type layer (not the thumbnail) in the Layers palette and choose Rasterize Type. Now go to **Edit > Transform > Scale** and use the handles at each end of the bounding box to fit the words to the white panel. Again, hit the checkmark in the Options bar when this is done.

4 Go to **Layer > Merge Down**. We need to blur the lettering slightly to achieve rounded corners, so go to **Filter > Blur > Gaussian Blur**, using a Radius of 5.2 pixels. Choose the Magic Wand and select Add To Selection from the Options bar. Click within each of the letters.

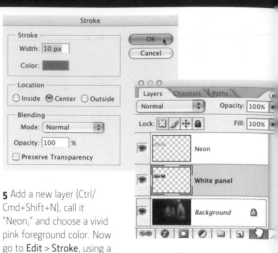

5 Add a new layer (Ctrl/Cmd+Shift+N), call it "Neon," and choose a vivid pink foreground color. Now go to **Edit > Stroke**, using a stroke width of 10 pixels, and choosing Center for Location. We can now drag the black-and-white layer to the trash can in the Layers palette.

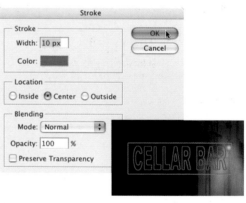

6 Choose the Rectangular Marquee tool and drag a selection around the lettering to form an outer border. Choose a bright orange color for the foreground and go to **Edit > Stroke**, using the same settings as before. Hit Ctrl/Cmd+D to deselect.

7 To fit the sign to the space above the door, go to **Edit > Transform > Distort**. Pull the corner handles on the bounding box around the lettering into the corners of the space. Take the time to match the perspective by careful adjustment of each handle.

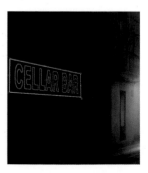

8 Use the Eraser tool to create small breaks in each letter. Ensure that these breaks have rounded ends to add to the realism of the neon tube effect. Now choose the Brush tool and paint in the small prongs at right angles to these breaks in the lettering. Use a very small, hard brush and sample the color of the lettering with the Eyedropper tool. Repeat the same procedure in the border.

9 Ctrl/Cmd-click the Neon layer thumbnail in the Layers palette to select it, go to **Select > Modify > Contract**, and use a value of 2 pixels.

10 Add a new layer (Ctrl/Cmd+Shift+N), call it "Highlights," and use the Brush tool to paint white into the selection to create a highlight on the lettering.

- Blur this a little with **Filter > Blur > Gaussian Blur** using a very small Blur Radius. Set this layer's blending mode to Screen, reducing the opacity to 85%.

Tip

TRANSFORM COMMAND
To fit the sign to the available space, we've used the Transform > Distort command. Although Photoshop has a Perspective Transform command, the Distort variant allows us greater flexibility. Within the Transform function, you will see a bounding box surrounding the element on the layer. The element can be distorted geometrically by dragging the "handles" distributed around this box. You can skew the lettering by using the central handles on the top and bottom of the box.

11 To create the neon glow, click the Neon layer and duplicate it (Ctrl/Cmd+J). Now blur this layer with **Filter > Blur > Gaussian Blur**, using a Radius of 13.7. Duplicate this blurred layer and set both of the blurred layers' blending modes to Screen. We can duplicate this layer a few more times to increase the glow amount.

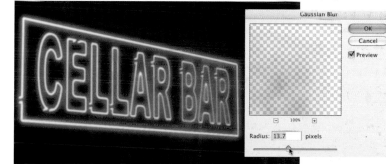

12 To finish, choose the Brush tool and a soft brush. Brush some of the lettering color at very low opacity along the top edge of the porch to indicate reflected glow.

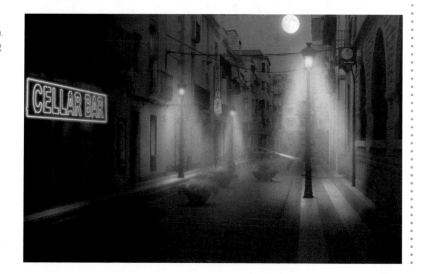

63

Creating a star-filled sky

Sometimes, a really good nighttime shot will be missing one vital component—the celestial majesty of a star-filled sky. Sadly, a cloudless night sky is not something that can always be relied on, but with the power of Photoshop at our fingertips, this is easily remedied.

The basic building blocks for the randomly placed stars are supplied by the Noise filter. This gives a random scattering of light-toned pixels that can be blurred and clumped together to create the starfield. We'll then add a simple moon and use a few basic layer blending modes to recreate that classic starry, starry night.

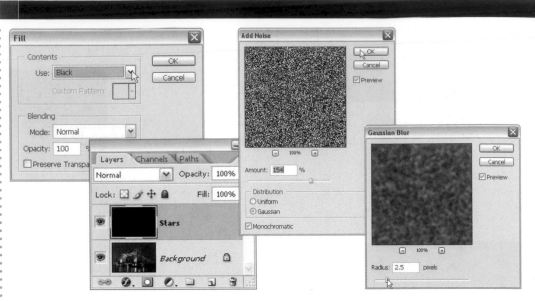

1 Open an appropriate nighttime image. Begin by adding a layer for the main collection of stars (Ctrl/Cmd+Shift+N), call it "Stars," and fill it with black using **Edit > Fill > Use: Black**.

2 Now we'll apply some noise to this layer to create the foundation for the stars. Go to **Filter > Noise > Add Noise**. A fairly high level of noise is needed here, so drag the Amount slider up to 154%. Select Gaussian for Distribution and check the Monochrome box. Click OK to apply the noise. We need to blur this noise layer a little, so go to **Filter > Blur > Gaussian Blur**. Use a small value of about 2.5 pixels.

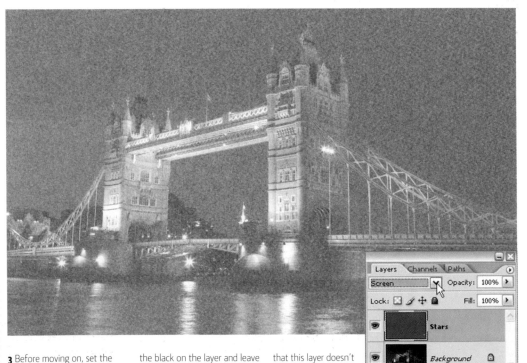

3 Before moving on, set the blending mode for the Stars layer to Screen. This will hide the black on the layer and leave just the white noise showing over the image. Don't worry that this layer doesn't look much like stars at the moment.

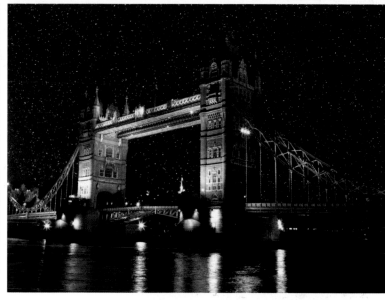

4 With the Stars layer still active, go to **Image > Adjustments > Threshold**. At the default Threshold value of 128, the stars already look pretty realistic, but we can modify the setting to fine-tune the density of the stars. By dragging the Threshold to the left (lowering the Threshold value), we can increase the density of the stars. Dragging it to the right decreases the number of stars. Here I've settled on a value of 123. Click OK.

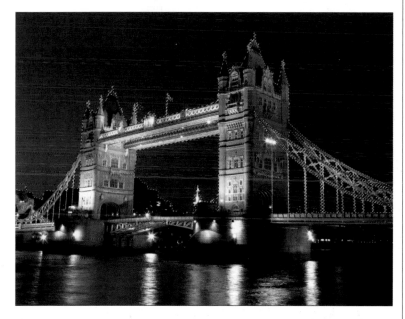

6 Now click again on the Stars layer and click the "Add layer mask" icon at the base of the Layers palette to mask out the stars over the buildings. Click the Stars layer visibility eye to see the result.

5 At this stage we need to add a Layer Mask to the Stars layer so that the stars are only visible in the sky, and not over the buildings. Hide the Stars layer temporarily by clicking its visibility eye and return to the background layer. Choose the Eyedropper tool, and click anywhere in the dark blue of the sky. Go to **Select > Color Range** and drag the Fuzziness slider to 67 to select only the sky. Click OK.

Tip

STARBURST BRUSH

Photoshop has a special brush that is useful for starfields. Using the Brush tool, click in the Brush Picker and choose the right-pointing arrow. Load the Assorted Brushes set from the list. Scroll down the Brush thumbnails and choose Starburst Small. You can now use this brush, with a very light yellow color, on the Extra Stars layer to add a touch of starlight twinkle!

65

Creating a star-filled sky continued

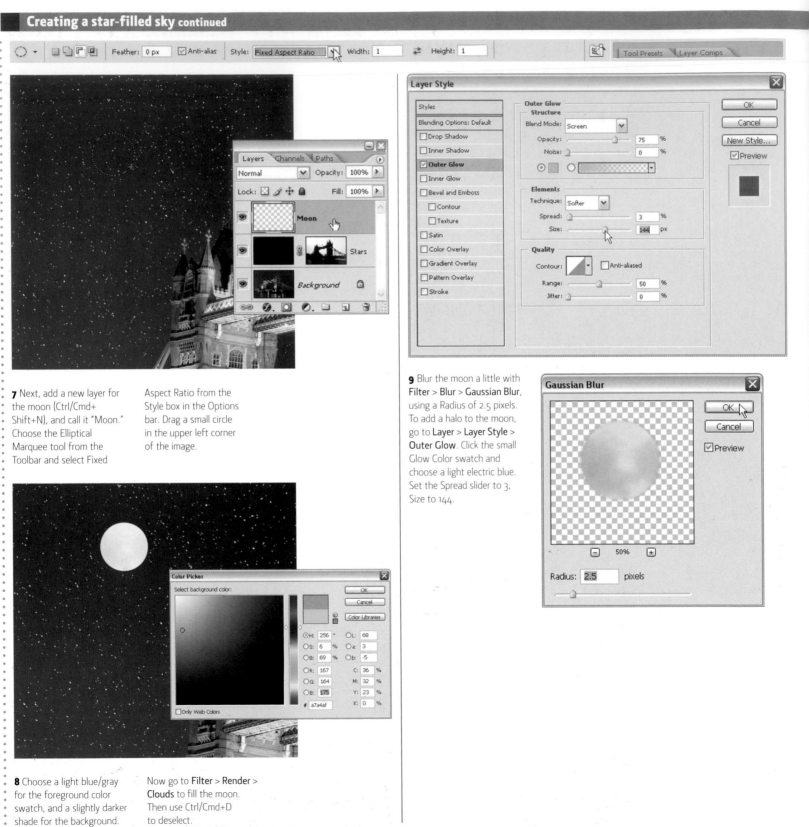

7 Next, add a new layer for the moon (Ctrl/Cmd+ Shift+N), and call it "Moon." Choose the Elliptical Marquee tool from the Toolbar and select Fixed Aspect Ratio from the Style box in the Options bar. Drag a small circle in the upper left corner of the image.

8 Choose a light blue/gray for the foreground color swatch, and a slightly darker shade for the background. Now go to **Filter > Render > Clouds** to fill the moon. Then use Ctrl/Cmd+D to deselect.

9 Blur the moon a little with **Filter > Blur > Gaussian Blur**, using a Radius of 2.5 pixels. To add a halo to the moon, go to **Layer > Layer Style > Outer Glow**. Click the small Glow Color swatch and choose a light electric blue. Set the Spread slider to 3, Size to 144.

10 Add another layer for some more stars, which we're going to add manually with a brush. Click on the Brush tool, and select a soft, 17-pixel brush from the Brush Picker. Choose a very light violet color for foreground, and with single clicks add a few softer, bigger stars here and there throughout the sky. Change the color to light yellow and add a few more stars. Blur these stars a little using Gaussian Blur and set the layer blending mode to Screen.

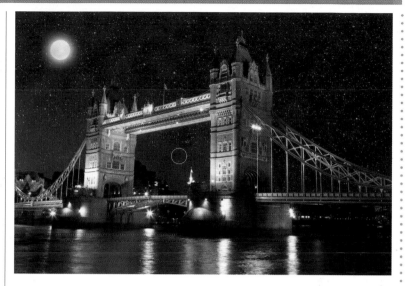

12 Finally, we can use the Eraser tool on the Stars layer to remove a few of the stars near the horizon, and on the Clouds layer to restrict the clouds to the area around the moon.

11 Finally, add some very subtle clouds to the image. Create a final new layer, and call it "Clouds." Choose a vivid light blue for foreground and black for background. Fill this layer using **Filter** > **Render** > **Clouds**. Blur the layer with **Filter** > **Blur** > **Gaussian Blur**, using a Radius of 34. Set the layer's blending mode to Soft Light, and the opacity to 42%.

Adding fire and flames

It's a natural phenomenon that has fascinated mankind since time immemorial. Fire! There are a few, sadly rather expensive plug-ins that can be used with Photoshop to recreate fire and flames, but here we'll look at a technique using Photoshop exclusively, without any add-ons.

The most difficult aspect of fire to recreate is its essentially random quality. For this we'll use the Clouds filter as a starting point, which has a great degree of randomness built in. Color is all-important when it comes to fire, so we'll use a customized Gradient Map to add this vital component.

So, fire up Photoshop, and feel the heat!

1 We first need to isolate the saxophone from its background. Hit Q on the keyboard to enter Quick Mask mode. Select the Brush tool and paint with black over the entire saxophone, taking care to follow the edges precisely. This will result in the entire object being covered with the red Quick Mask. Now hit Q again to exit the mode and generate a selection.

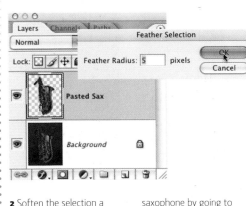

2 Soften the selection a little with **Select > Feather**, using a Feather Radius of 5 pixels. Now copy and paste a duplicate of the saxophone by going to **Edit > Copy** (Ctrl/Cmd+C) followed by **Edit > Paste** (Ctrl/Cmd+V).

3 Add a new layer (Ctrl/Cmd+Shift+N) for the first fire layer. Hit D on the keyboard to reset the swatch colors to default foreground/background colors and go to **Filter > Render > Clouds**. This will fill the layer with a random Clouds fill, which is a good basis for the fire effect.

4 To make this layer look a little more like raging fire, go to **Filter > Render > Difference Clouds**. This action needs to be repeated two or three times. To reapply this filter, simply return to the Filter menu and Difference Clouds will be the first entry (or hit Ctrl/Cmd+F). In the screenshot, the filter has been applied three times.

5 To color the fire, go to **Layer > New Adjustment Layer > Gradient Map**. OK the next dialog box. In the Gradient Map dialog box, click in the Gradient swatch to invoke the Gradient Editor. Double-click the left-hand color stop below the gradient ramp and choose a rich dark brown from the picker. Next, double-click the right-hand color stop and choose a bright yellow. Click on the midpoint color stop between these two, then click off to add another color stop, choosing a vivid red by clicking in the color swatch. Grab each stop in turn, moving them roughly into the positions shown in the screenshot. Click OK. The layer will now look much more like fire.

6 Go to **Layer > Merge Down** to merge this Gradient Map layer with the clouds layer. Now zoom out of the image a little and go to **Edit > Transform > Scale**. Grab the top handle on the Transform bounding box and drag it upward, stretching the flames layer.

Click the commit checkmark in the Options bar to apply the transformation. Click on the Crop tool, select the entire image, and apply the crop. This deletes the invisible stretched flames.

7 Change the blending mode for this Fire layer to Screen. Blur the fire a little using **Filter > Blur > Motion Blur**. Choose an Angle of 90 degrees and a Distance of 50 pixels.

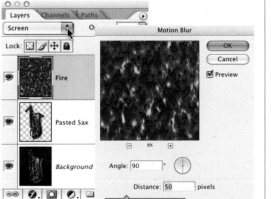

8 Add a layer mask to the fire layer using **Layer > Layer Mask > Reveal All**. Choose the Brush tool again and select a soft-edged, round brush from the Brush Picker. Increase the size of the brush with the right-facing bracket key (]) on the keyboard and paint out the top of the flames with black, varying the opacity as we go. Painting black onto the mask will hide this area of flames. After masking, right-click/Ctrl-click the thumbnail for the layer mask and choose Apply Layer Mask.

9 To make the flames appear to lick around the saxophone, use the Liquify command. Go to **Filter > Liquify**. Although the Liquify dialog box looks very complicated, we'll use it here in a very simple way. Choose the Turbulence tool from the tools on the left, and set the Turbulence jitter slider to 64%. Use the brush at a fairly large size to drag a few flame tips upward. Just click and drag on the flame tips. Click OK to apply the Liquify results.

Adding fire and flames continued

10 For more impact, add a major league fireball behind the saxophone. Click on the original background layer and add a new layer (Ctrl/Cmd+Shift+N), naming it "Fireball." Choose the Lasso tool from the Toolbar and draw an irregular-shaped selection in the top two-thirds of the canvas. Choose red as the foreground color and bright yellow for background. Now go to **Filter > Render > Clouds**.

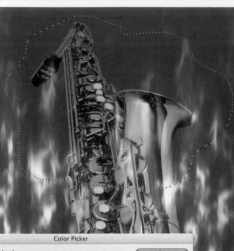

11 Hit Ctrl/Cmd+D to deselect, then blur this shape using **Filter > Blur > Gaussian Blur**. Use a Blur Radius of 55 pixels.

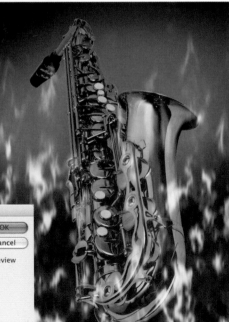

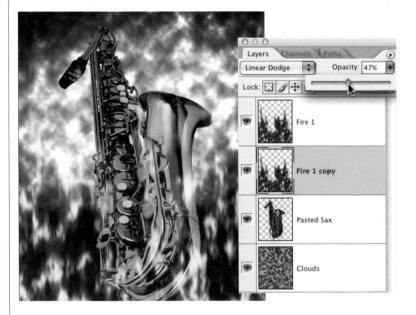

12 Now add some turbulence to the fireball. Create another new layer (Ctrl/Cmd+Shift+N) and hit D on the keyboard to revert to default black/white colors. Return to **Filter > Render > Clouds** and apply the filter. Set the blending mode for this layer to Color Dodge.

13 Click on the Fire layer and duplicate it (Ctrl/Cmd+J). Drag this second fire layer below the first in the Layers palette and go to **Filter > Blur > Motion Blur**. Use an Angle of 90 degrees and a Distance of 460 pixels. Set the blending mode for this layer to Linear Dodge and reduce the opacity to 47%.

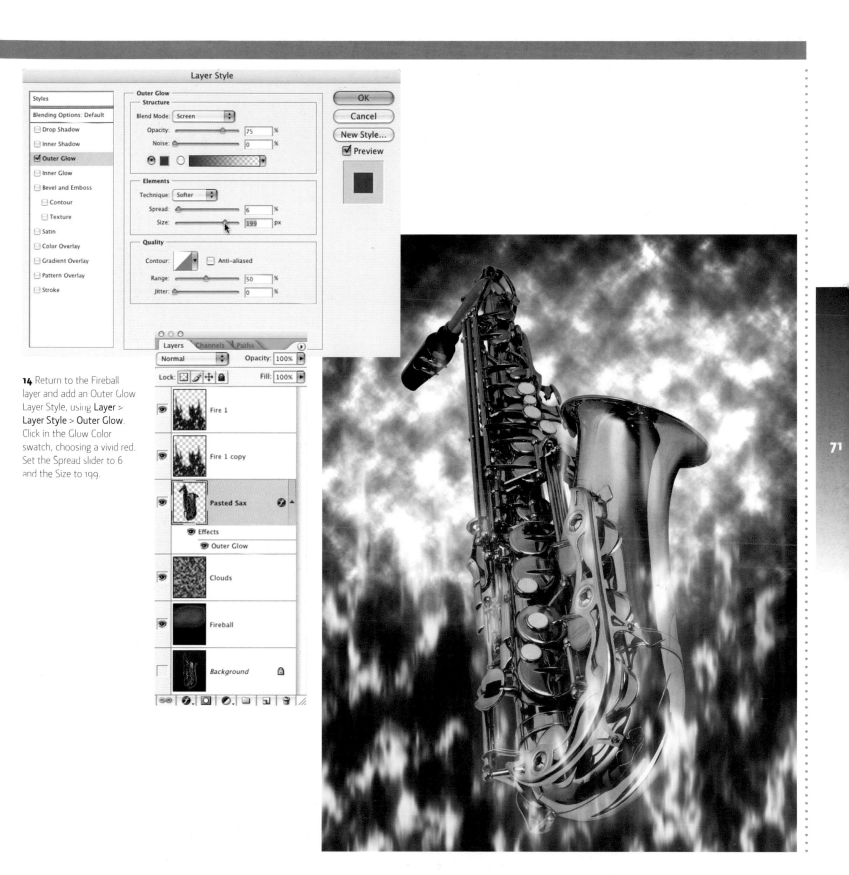

14 Return to the Fireball layer and add an Outer Glow Layer Style, using **Layer > Layer Style > Outer Glow**. Click in the Glow Color swatch, choosing a vivid red. Set the Spread slider to 6 and the Size to 199.

Simulating candlelight

Candlelight has unique properties and is the very essence of romantic, atmospheric still-life studies. Unfortunately it's notoriously difficult to photograph successfully. Fortunately, Photoshop supplies us with all of the tools that we need to simulate stunningly convincing candlelight effects. Here we'll begin by using the powerful Lighting Effects filter to set the scene. The essential extras for the candlelight are supplied by simple gradients and layer blending modes.

1 To begin, we need to adjust the overall lighting in the image. To simulate authentic candlelit conditions, we need a single diffused pool of light that illuminates just one area of the scene. Duplicate the background layer (Ctrl/Cmd+J) and call it "Lighting Effects."

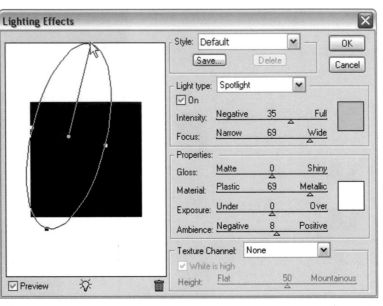

2 Go to **Filter > Render > Lighting Effects**. In the Lighting Effects dialog box, click the light color swatch in the Light Type category, and choose a mid-yellow color from the Color Picker. From the Style box, choose Default. Now, in the Preview pane, grab the spot in the very center of the light pool and drag it so it sits at the top of the candle. Drag the light pool handle at the bottom right of the image thumbnail and rotate the pool counter-clockwise until it's at the one o'clock position. Next, drag this handle upward so that it just disappears from view.

3 Now drag the left side handle outward a little to enlarge the light pool. Set the Intensity slider to 53, and Ambience to 10. Click OK, bearing in mind that this filter can take a while to apply.

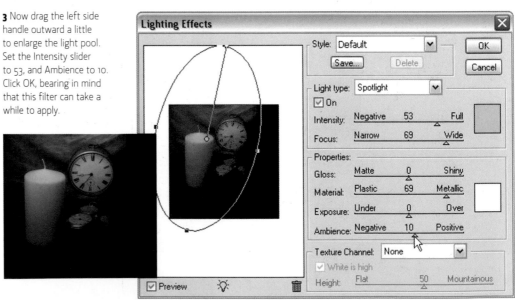

4 Select the Clone Stamp tool and clone out most of the candle wick. Position the tool next to the wick, hold down the Alt/Opt key, and click to sample. Then click over the wick

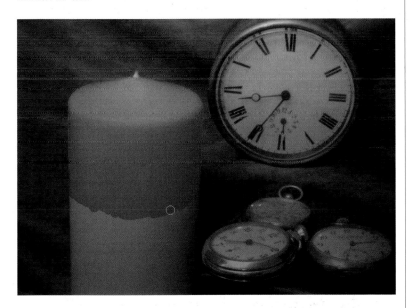

5 To simulate the light from the candle flame that would be diffused through the body of the candle, select the top half of the candle. Switch to Quick Mask mode (Q) and paint the mask over the candle with a hard-edged brush. When the mask is complete, hit Q again to exit Quick Mask. Go to **Select > Feather** and use a Feather Radius of 5 pixels.

6 Add a new layer (Ctrl/Cmd+Shift+N), call it "Candle Glow," and choose a bright yellow for the foreground color. Select the Gradient tool, click in the Gradient Picker, and select Foreground to Transparent from the swatches. Now, click and drag the gradient tool vertically from top to bottom across the selection.

7 Hit Ctrl/Cmd+D to deselect the selection and go to **Filter > Blur > Gaussian Blur**. Set the radius to 8 pixels and apply the filter. Change the layer's blending mode to Screen, and slightly reduce the opacity.

8 Duplicate the Candle Glow layer (Ctrl/Cmd+J) and hit V on the keyboard to activate the Move tool. Move the duplicate layer so that it sits over the left half of the clock face. Blur this layer further with **Filter > Blur >**

Gaussian Blur, using a 37-pixel Radius. Set the blending mode for this layer to Overlay. Now use the Eraser tool to erase the parts of this layer that are outside of the clock face.

10 Create a new layer, call it "Flame," then hit L on the keyboard to activate the Lasso tool. Draw a simple

flame shape over the wick. Feather this selection with **Select > Feather** using a Radius of 5 pixels.

11 Select the Brush tool, and choose a very light yellow for the foreground color and a soft brush from the Brush Picker. Reduce the Brush Opacity to 40% in the Options bar and paint within the selection. After filling the selection, paint again at the top of the flame to intensify the color. Reduce the size of the brush, change the color to white, and paint some small white streaks within the flame. Deselect (Ctrl/Cmd+D) and go to **Filter > Blur > Motion Blur**. Choose 90 degrees for Angle and 65 for Distance. Click OK. Set the layer blending mode to Screen.

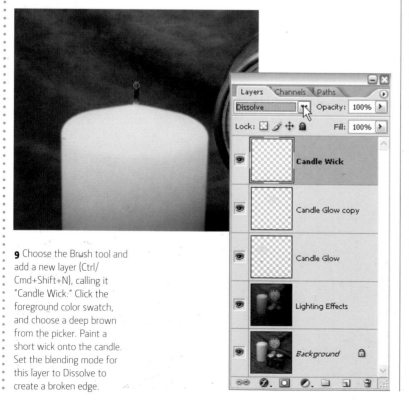

9 Choose the Brush tool and add a new layer (Ctrl/Cmd+Shift+N), calling it "Candle Wick." Click the foreground color swatch, and choose a deep brown from the picker. Paint a short wick onto the candle. Set the blending mode for this layer to Dissolve to create a broken edge.

12 Change the foreground color back from white to yellow and return to the candle glow layer. Increase the brush size to approximately 700 pixels and with a single click place a soft glow over the candle flame.

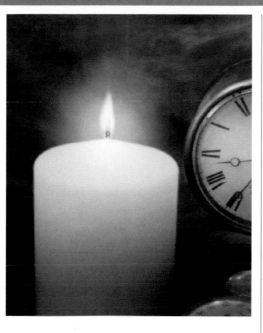

13 Next, add a new layer, setting the blending mode to Overlay, and choose a warm orange color. Reduce the size of the brush and paint with it at low opacity over a few parts of the watches that are nearest the candlelight. Also paint with this brush around the left hand side of the clock case. Sample the lightest part of the flame with the Eyedropper and then, with a small soft brush set to Soft Light in the Mode menu of the Options bar, paint a slightly wavy line from the tip of the flame up to the top of the image.

Tip

DODGE TOOL

When the image is complete, you can use the Dodge tool on the Lighting Effects layer to selectively lighten parts of the image nearest the candlelight. This will give the effect of bright accents and highlights here and there. To use this tool, select it from the Toolbar (it may be nested below the Burn tool) and set the Exposure to just 7% in the Options bar. Set the Range to midtones and choose a small brush size, then carefully add subtle lighting to small areas.

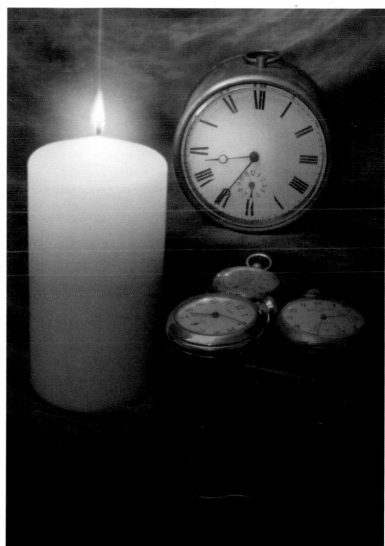

75

Lens flare

As a general rule, lens flare is something to be avoided when using a camera. Photographers use lens hoods to this end and lens manufacturers go to great lengths in their research and development to create lenses that are highly resistant to the phenomenon. However, adding deliberate and controlled lens flare in Photoshop can yield great results when applied to a suitable image.

When lens flare occurs in the camera, we have no control over the effect, whereas in Photoshop we can scale, position, and control the effect with pixel-perfect precision. Added to these advantages is the fact that Photoshop comes complete with a built-in filter designed to create realistic lens-flare effects.

Obviously, some images are better suited than others when it comes to this effect, and the classic subjects are very shiny objects that are brightly lit, or, as in this example, an image where the camera was pointed toward the sun.

76

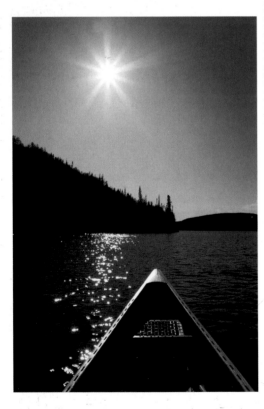

1 This lake image is well-suited to the lens flare effect, which will add a convincing third dimension to the scene.

2 Begin by increasing the size of the image canvas. This allows the flare layer to be moved freely without creating lines on the background layer. Go to **Image** > **Canvas Size** and increase the canvas by 35%.

3 Next, add a new layer (Ctrl/Cmd+Shift+N), and call it "Flare Layer." The Lens Flare filter cannot perform its magic on an empty layer and needs active pixels to work. Begin by filling the new layer with black—go to **Edit** > **Fill**, and choose Black for the Contents.

4 Don't worry that the entire image is obliterated, we'll remedy that after we've created the flare. Go to **Filter** > **Render** > **Lens Flare**. First, we need to determine the position, length, and direction of the flare. Grab the small cross hair in the preview pane and drag it around the pane to see the effect its position has on the actual flare. The closer to the top the cross hair is, the longer the flare. If we position the cross hair anywhere near the center of the pane, the flare becomes very short.

5 In this image, a medium-length flare radiating to somewhere about a 4 o'clock position would work best, so place the cross hair at 10 o'clock about halfway up the pane. Set the Brightness slider to 126%. We have a choice of lens types to generate the flare, but on this occasion use the 105mm Prime lens. Hit OK.

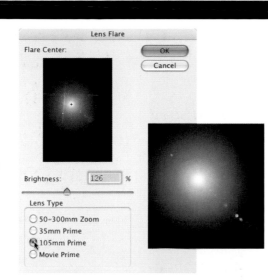

7 Finally, the lens flare needs positioning so the brightest point sits over the sun. Choose the Move tool and drag the flare into position. Once you're happy with the result, use the Crop tool to crop away the excess white area.

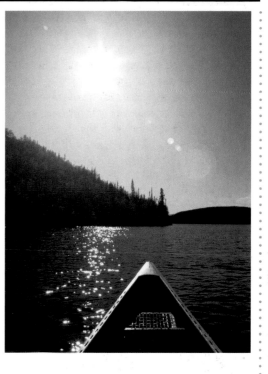

6 The flare is now complete, but we need to hide the black fill within the layer. This is easily done by changing the blending mode for the lens flare layer to Screen. This leaves just the flare visible on the layer.

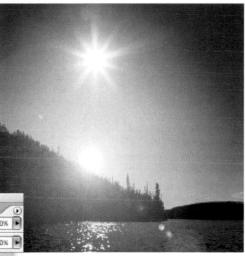

8 Here are the results of the other available Lens Types used at the same settings:

35mm Prime

50–300mm Zoom

Movie Prime

Tip

FLARE COLORS

You can adjust the Hue and intensity of the colors contained within the Lens Flare by using Image > Adjustments > Hue/Saturation on the flare layer. In the Hue/Saturation dialog box, adjust the Hue slider to change the actual colors in the flare. Drag the Saturation slider to the right to intensify them, and to the left to reduce their intensity.

Chiaroscuro

Chiaroscuro, literally translated as "light and dark," is a technique of pictorial representation most associated with great artists such as Rembrandt and Caravaggio. A similar effect could be created in the photographic studio with careful use of studio lighting, but most of us lack the knowledge and the equipment necessary.

By simulating this classic technique in Photoshop, we're allowed much more control over which parts of the image fade into darkness, and which parts are blessed with the scintillating highlights with characterize the technique. Key to this Photoshop effect is the use of a layer filled with 50% gray, a pure neutral in digital imaging terms. By setting this layer to Overlay and painting onto it with black or white, the tones within the image can be very accurately controlled and modified. All we need to create a stunning image is to follow the recipe and take a trip into the dark side of light.

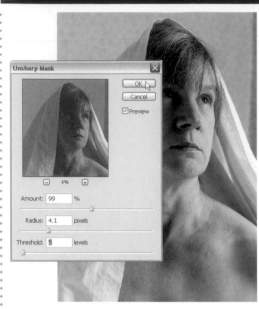

1 It's vital that the original base image for this effect is very sharp, so go to **Filter > Sharpen > Unsharp Mask**. Use the following values: Amount 99, Radius 4.1, Threshold 5. This will give the image a very crisp appearance.

3 Click the adjustment layer icon at the bottom of the Layers palette and choose Solid Color. Choose a very dark tan color for the fill and click OK. Set the layer blending mode to Soft Light and reduce the opacity to 22%.

2 Add a new layer to the image (Ctrl/Cmd+Shift+N). Call it "Dark Paint" and set the blending mode for this layer to Multiply. Select the Brush tool and choose a large, soft brush from the Brush Picker. In the Color palette, choose a very dark brown color and then paint around the head with the brush to conceal the background behind the main subject. Paint over the edges of the veil a little at very low opacity.

4 Now, to begin creating the dramatic tones in the image, click on the background layer and then select **Layer > New > Layer**. Go to **Edit > Fill** and choose 50% Gray from the Contents box. Set the blending mode for this layer to Overlay, and call it "Gray Layer." By painting onto this layer with black and white, we can selectively darken and lighten the image tones.

78

5 Ensure that black is set as the foreground color and choose the Brush tool. Using a soft brush, paint at very low opacity (13%) over the shaded side of the face and veil. As we paint, the tones in this area will darken. Concentrate on the areas of dark and midtones.

6 We need to create some really dramatic dark shadows here, taking the darkest ones down to almost black. The more we paint over the tones on this layer, the darker they will become. Increase the size of the brush with the square bracket keys on the keyboard and paint over the chest area.

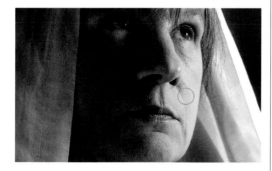

7 Now concentrate on the midtones on the lighter side of the face. Using the brush at a fairly small size, gently paint over these areas with black to increase the contrast between these areas and the lightest tones on the face.

8 Now introduce a little color into the image to give an aged effect. Add a new layer (Ctrl/Cmd+Shift+N), call it "Tan Layer," and set the blending mode to Color. Choose a mid-tan color and paint with this color here and there. Again, use the brush at low opacity, gradually building up the depth of the color.

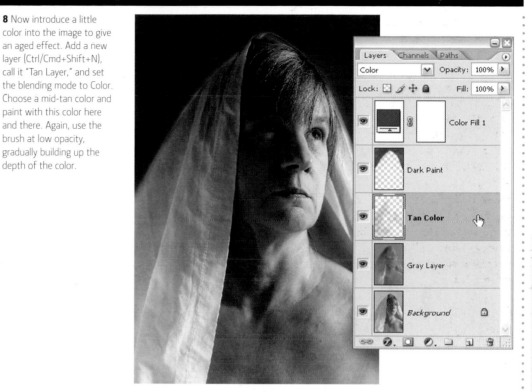

9 Return to the background layer, click the "Create a new fill or adjustment layer" icon at the foot of the Layers palette and select Hue/Saturation. We need to make a subtle change to the Hue and desaturate the image slightly, so use these settings in the dialog box: Hue 4, Saturation -24, Lightness -6.

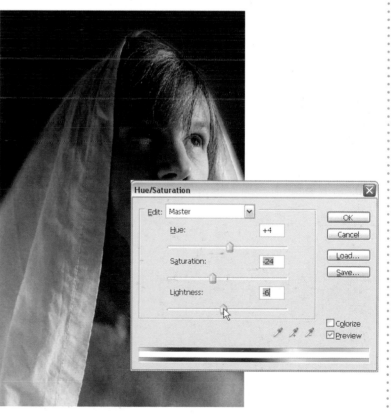

Chiaroscuro continued

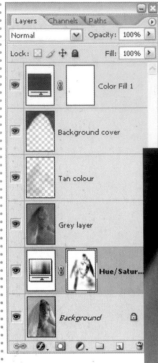

10 This adjustment layer has a layer mask attached to it, allowing us to hide parts of the layer. So, with the layer mask thumbnail selected, paint with black on the lighter side of the face and veil to reveal a little of the color from the underlying background layer.

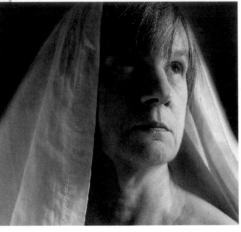

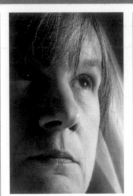

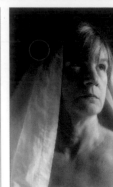

11 Next, we need to selectively boost the highlights to add some sparkle, so return to the 50% gray layer. This time, paint with white onto this layer to lighten tones. With the foreground color set to white, use a small brush set at 10% opacity to paint over the lightest tones in the face.

13 Add a final new layer at the top of the layer stack and set the blending mode to Multiply. Hit D on the keyboard so foreground color is black, increase the brush size, and paint black onto this layer over the back edge of the veil. Use the brush at 35% opacity to soften the transition between the background and figure.

14 Reduce the brush opacity even further in the Options bar and paint black very gently over the other darkest areas in the image.

Tip

UNDER PRESSURE

For a project such as this, it's a great advantage to use a pressure-sensitive graphics tablet instead of a standard mouse. The brushes in Photoshop can be modified to react to the pressure capabilities of a graphics tablet, which makes controlling the opacity of a brush much easier than using the Opacity slider in the Options bar. To set these pressure capabilities, hit F5 on the keyboard to display the Brush Options palette, and choose the Other Dynamics category. From the Opacity Jitter Control box, choose Pen Pressure. Now, when you're using the Brush tool, the more pressure you apply to your stylus, the more opaque the brushstroke will be.

12 Try to pick out sparkling highlights and edges with the brush, paying special attention to the lighter parts in and around the eyes. Increase the size of the brush and gently brush over the lightest areas in the shadow side of the face, including the white of the eye.

15 To increase the aged appearance, double-click the Solid Color adjustment layer and choose a vivid medium green. Paint with black onto this adjustment layer's mask over the lightest parts in the image to hide the green fill over these areas.

16 For more authenticity, add texture to the image. Click on the top layer in the Layers palette and then go to **Layer > New Fill Layer > Pattern**. Hit OK and in the following Pattern Fill dialog box, click in the Pattern swatch. Choose the right-pointing arrow, select Artists Surfaces. Choose Canvas from the thumbnails and increase the Scale slider to 496%. Set the blending mode for this layer to Multiply, opacity 55%.

17 Finally, return to the 50% gray layer, set the foreground color to white, and use a hard-edged brush, set at 50% opacity, to add the slightest suggestion of a teardrop just under the eye.

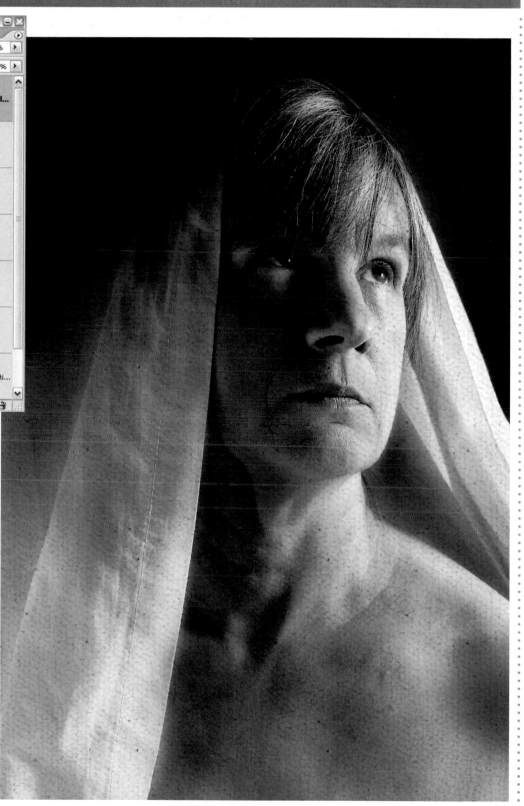

NATURAL WORLD EFFECTS

Painting clouds into skies

On your summer vacation, you might shoot a great photo that has one big drawback: the sky is very plain and adds nothing to the image. With Photoshop, there are several ways to add a few clouds to liven up a clear blue sky. There's always the option of cutting and pasting a better-looking sky from another image, but there's also another way to fix the sky, with a lot more flexibility.

The essential characteristic of summertime clouds is that the shapes are random and soft, and the best way to achieve that is by painting them in. The word "painting" can turn the novice Photoshop user's knuckles white with apprehension. However, in this example, we're really just scribbling with soft airbrushes, so you don't have to have the talent of Michelangelo to create realistic-looking clouds and a more interesting sky.

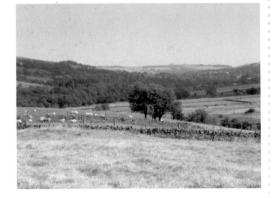

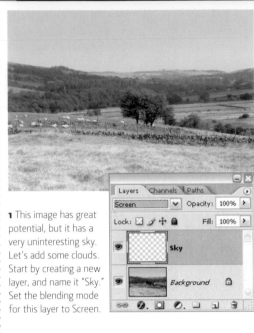

1 This image has great potential, but it has a very uninteresting sky. Let's add some clouds. Start by creating a new layer, and name it "Sky." Set the blending mode for this layer to Screen.

2 Select the Brush tool from the Toolbar and click in the Brush Picker in the Options bar. Click the small right-pointing arrow and choose Reset Brushes from the menu, and click OK in the subsequent dialog box. This will reset the Brush to Photoshop's default selection. Scroll to the bottom of the thumbnails, and choose Airbrush Dual Soft Round 45. Increase the size of the brush to about 250 pixels.

3 If you're using a pressure-sensitive graphics pad, hit F5 to display Brush Options. Set Opacity Jitter in Other Dynamics to Pen Pressure. If you're using a mouse, set the Brush Opacity to 26% in the Options bar. Choose the Eyedropper tool from the Toolbar and click in the blue sky.

4 Now click on the foreground color swatch, which should be the blue color we just sampled from the sky. The Color Picker will appear, with a dot indicating that blue color. Choose a slightly lighter shade of blue by clicking in the Color Picker window just a little way above the dot. Click OK, and return to the Brush tool to start painting some very faint cloud-like shapes in the sky.

Tip

THE COLOR OF CLOUDS
You can easily give each cloud layer a subtle hint of color using Image > Adjustments > Photo Filter. Make sure you uncheck the Preserve Luminosity check box, and then choose your tint color from the Filter box. Control the strength of the tint with the Density slider, ensuring that Preview is checked so you can judge the results. Warm tints such as magentas and oranges suit summer skies.

84

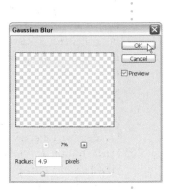

5 Remember, because the Brush tool is in Airbrush mode, if the brush is kept in one place with the mouse button held down, it will keep on applying color, which is handy for creating more obvious patches of cloud. Remember to keep the shapes of the clouds very irregular and random. It may be helpful to try and locate a few reference images of cloudy skies.

7 Set the new layer to Screen and continue to build up the clouds with some lighter tones. Remember that the lightest tones will occur mainly on the top edges of the clouds. As we paint, bear in mind that we want to create a soft summer sky here, so be subtle with the brush.

8 Reduce the size of the brush with the left-facing square bracket key on the keyboard and increase the Brush Opacity to 45% in the Options bar. Add a few lighter, more-defined areas to the clouds, and include a few streaks to simulate the look of a summer sky.

9 Add some warmth to the clouds: go to the Color Picker again, and click on the yellow section of the spectrum (just to the right of the big color window). Choose a very pale yellow, click OK, and return once again to the Brush tool. Paint a few strokes of the pale yellow here and there on the clouds to warm things up a bit.

10 Depending on how soft you'd like your clouds to look, the layer can be blurred a little with **Filter > Blur > Gaussian Blur**, using a very small Blur Radius. Continue to add some more subtle brushwork to the clouds until you're happy with the result.

85

6 Use the Brush tool at varying sizes, adjusting the size with the square bracket keys on the keyboard. When the base layer of clouds is complete, add another layer to the image, naming it "Sky 2." Click again in the foreground swatch, this time choosing an even lighter shade of the same blue.

Simulating rain

Hands up, anyone who wants to stand in the rain on a cold gray day with an expensive digital camera! No takers? It's hardly surprising—there are some aspects of nature that we may wish to capture on camera, but without enduring the misery of the actual experience. Rain isn't difficult to simulate in Photoshop. The Noise filter plays a major role in the process, providing exactly the kind of random factor that this subject demands. The part of the wind, driving the rain across the image, is played by the Motion Blur filter, and a simple layer blending mode adds the required subtlety.

1 Open a suitable image for the rain treatment. Hit Ctrl/Cmd+D on the keyboard to revert to default foreground and background colors. Add a new layer (Ctrl/Cmd+Shift+N), call it "Rain Layer," and fill it with white using **Edit > Fill > Use: White**. Go to **Filter > Noise > Add Noise**. Use an Amount of 95, Uniform and Monochromatic.

2 The noise is a bit too dense, so go to **Image > Adjustments > Levels**. Drag the Black Point slider to the right until the Input Value reads 71. This will increase the contrast of the Noise layer and thin out the speckles.

3 Blur this Noise layer a little with **Filter > Blur > Gaussian Blur**, using a Radius value of 0.5 pixels. To add the effect of driving rain, go to **Filter > Blur > Motion Blur**, choosing an Angle of 63 and a Distance of 49 pixels.

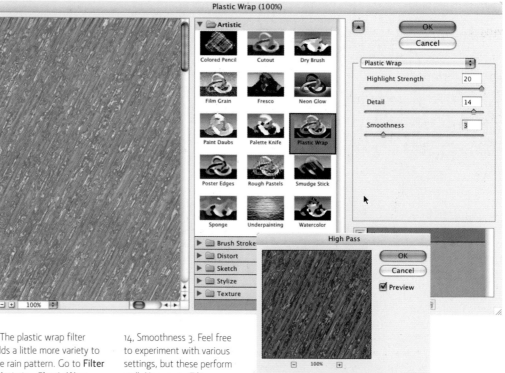

4 The plastic wrap filter adds a little more variety to the rain pattern. Go to **Filter > Artistic > Plastic Wrap**. Use the following settings: Highlight Strength 20, Detail 14, Smoothness 3. Feel free to experiment with various settings, but these perform well. Now go to **Filter > Other > High Pass**, using a Radius of 72 pixels.

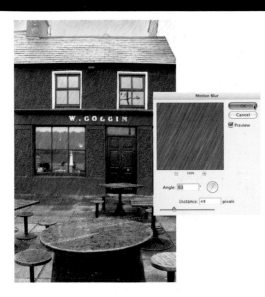

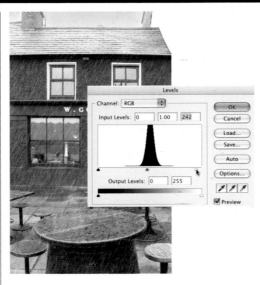

9 Set the Reflections layer blending mode to Soft Light. Choose the Eraser tool and erase any parts of this layer that sit on top of the furniture in the foreground. Flatten the image using **Layer > Flatten Image**.

5 Re-apply the Motion Blur filter, with the settings from the previous step, and set the blending mode for the Rain layer to Hard Light.

7 Return to the Rain layer and go to **Image > Adjustments > Levels**. Drag the White Point slider to the left a little to increase the brightness of the rain itself.

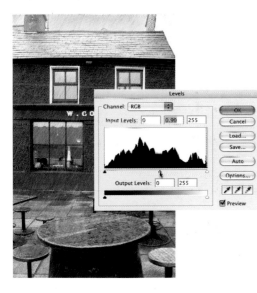

6 Click on the background layer and go to **Layer > New Adjustment Layer > Levels** and click OK. We need to darken the image a little to intensify the Rain layer, so drag the midpoint slider to the right a little.

8 For the reflections, choose the Rectangular Marquee tool and click on the background layer. Drag a selection over the very bottom of the building. Right-click/Ctrl-click within the selection with the Marquee tool, and choose Layer Via Copy. Now go to **Edit > Transform > Flip Vertical**. Use the Move tool to drag the Reflections layer down so that it sits on the paving in front of the building.

Tip

RE-EDITING ADJUSTMENT LAYERS

The reason we use adjustment layers to make Levels or Curves adjustments is that they can easily be readjusted at any time during the image-making process. To modify a Levels adjustment layer, simply double-click its thumbnail in the Layers palette to invoke the Levels dialog box. Make your alteration to the Levels value and click OK.

The classic image of a flower or some foliage glistening with drops of dew can be very difficult to capture. Not only is this photo opportunity one that requires the photographer to be in the right place at the right time, but finding that place demands early-morning forays out with camera in hand. For the digital photographer who is more of a late riser, Photoshop once again comes to the rescue. The process of creating digital dewdrops involves making simple elliptical selections, using the Spherize filter, and then calling on Layer Styles for a little help with the final effect. Twinkling highlights are added courtesy of the Gradient tool.

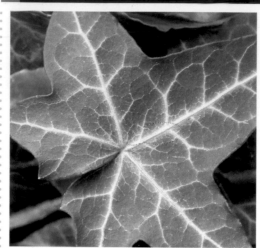

1 Open the original image and select the Elliptical Marquee tool from the Toolbar. Ensure that the Add to Selection icon is active in the Options bar. Drag two overlapping elliptical selections near the middle of the leaf to generate the water droplets.

2 Right-click/Ctrl+click inside the active selection and choose Layer Via Copy. This will paste the selected part of the leaf onto a new layer. Call the new layer "Pasted Droplet."

3 Right-click/Ctrl+click the Pasted Droplet layer thumbnail and choose Select Layer Transparency. Now, with the selection active, go to **Filter > Distort >**

Spherize. Use an amount of 100% and set the Mode to Normal. Click OK and go to **Filter > Spherize** to reapply the filter (or hit Ctrl/Cmd+F).

4 To create a subtle shadow, duplicate the Pasted Droplet layer (Ctrl/Cmd+J) and Ctrl/Cmd-click this new layer thumbnail to generate a selection from its

transparency. Ensure that black is the foreground color and go to **Edit > Fill**. Choose Foreground Color from the Contents box and hit OK. Ctrl/Cmd+D to deselect.

Tip

MANUALLY DRAWING SELECTIONS FOR FREEHAND SHAPED DROPLETS
You may prefer your water droplets to have a less regular and more organic shape. In this case, instead of drawing the initial droplet selection with the Elliptical Marquee tool in Step 1, try drawing a freehand shape for the drops with the Lasso tool. Remember to close your selection by returning to your starting point and clicking with the tool.

8 Click and drag a gradient vertically over the active selection. Hit Ctrl/Cmd+D to deselect. To blur this highlight a little, go to **Filter > Blur > Gaussian Blur**. Use a Blur Radius of 0.7 pixels.

9 Add a final layer and draw a very small elliptical selection at the end of the droplet. Fill this selection with white using **Edit > Fill**. Blur the layer with Gaussian Blur, using a Radius sufficient to disguise the hard edge. Here I've used 3.7 pixels.

10 Using the above method, you can add as many droplets as you wish, although the best effect is achieved with just a few.

5 Hit Ctrl/Cmd+[to move this layer one position down the stack. Now blur it with **Filter > Blur > Gaussian Blur**, using a Blur Radius of 10 pixels. Use the Move tool to move it down and to the right so it creates a shadow for the droplet. Set the blending mode to Darken and reduce opacity to 57%.

6 To create the shadow inside the droplet, click on the top layer and go to **Layer > Layer Style > Inner Shadow**. In the Layer Styles panel, set the opacity to 77%, Distance to 10 pixels, Size to 29 pixels. For Angle, choose 108.

7 Add a new layer (Ctrl/Cmd+Shift+N) and call it "Reflections." With the Elliptical Marquee tool, drag an elongated ellipse across the largest of the two droplets. Ensure that the

foreground color is white, and choose the Gradient tool. Choose Foreground to Transparent from the Gradient Picker, and Linear Gradient from the Toolbar.

89

Adding rainbows

Of all weather phenomena, rainbows are the most beautiful and colorful, and carry the mythical promise of pots of gold. Unfortunately, capturing a rainbow with a camera requires a huge amount of luck—it's another classic example of the right-time, right-place school of photography. Luckily, with Photoshop, it's not difficult to add a rainbow to an image after the fact.

In this example, we'll use the Gradient tool, which includes a ready-made rainbow gradient. To get more realistic results, we'll use the rainbow gradient in conjunction with a black-to-transparent gradient.

So, no more chasing rainbows—it's Photoshop to the rescue!

90

1 The ideal candidate for a rainbow effect is an image that has a dark, dramatic sky, contrasted with shafts of sunlight.

2 Begin by adding a new layer to the image (Ctrl/Cmd+Shift+N), and call it "Rainbow." This will help us position the finished rainbow. Now choose the Gradient tool from the Toolbar. Click in the Gradient Picker in the Options bar.

3 Click the small, right-pointing arrow in the top right of the Gradient Picker and choose Special Effects. Click OK. From the Gradient Swatches, choose Russell's Rainbow. Click on the light gray-colored Opacity Stop on the upper edge of the gradient band and enter 75 in the Location box.

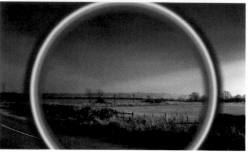

4 Choose Radial Gradient from the Options bar, and, with the blank layer active in the Layers palette, position the mouse pointer on the horizon line and click and drag a gradient from the center of the image toward the right-hand edge. Release the mouse button at the tree near the edge of the image.

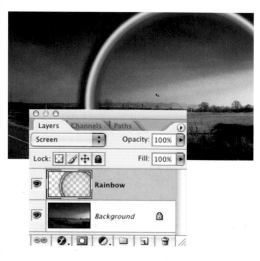

5 Choose the Move tool and drag the rainbow into position, just past the center of the image. If the rainbow needs to be resized, ensure Show Transform Controls is checked in the Options bar and resize the rainbow using the bounding box corner handles. Remember to hold down the Shift key to retain the proportions. Set the blending mode for this layer to Screen.

6 Go to **Filter** > **Blur** > **Gaussian Blur** and set the Radius slider value to 60 pixels.

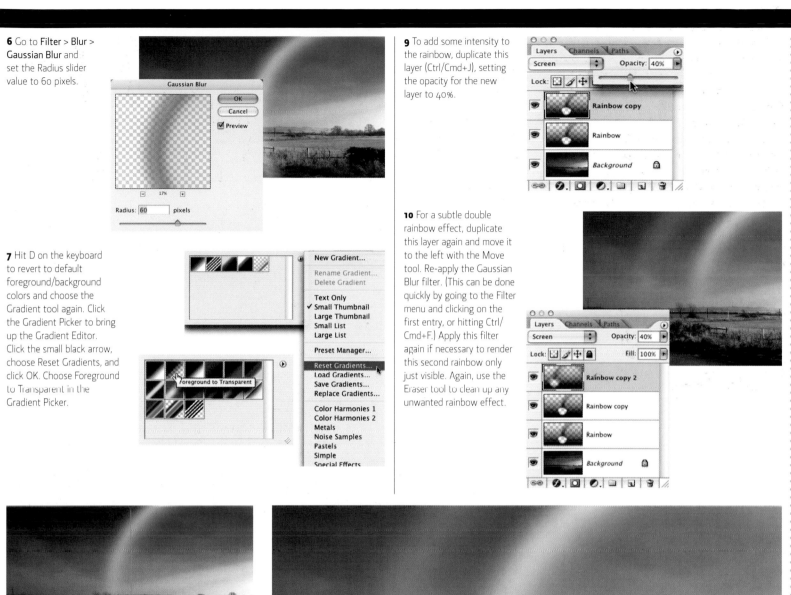

7 Hit D on the keyboard to revert to default foreground/background colors and choose the Gradient tool again. Click the Gradient Picker to bring up the Gradient Editor. Click the small black arrow, choose Reset Gradients, and click OK. Choose Foreground to Transparent in the Gradient Picker.

8 Choose Linear Gradient in the Options bar and click and drag a gradient from the bottom to the top of the entire image. Clean up any parts of the rainbow that project over the land with the Eraser tool.

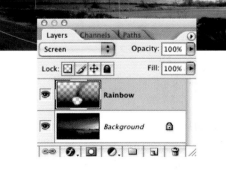

9 To add some intensity to the rainbow, duplicate this layer (Ctrl/Cmd+J), setting the opacity for the new layer to 40%.

10 For a subtle double rainbow effect, duplicate this layer again and move it to the left with the Move tool. Re-apply the Gaussian Blur filter. (This can be done quickly by going to the Filter menu and clicking on the first entry, or hitting Ctrl/Cmd+F.) Apply this filter again if necessary to render this second rainbow only just visible. Again, use the Eraser tool to clean up any unwanted rainbow effect.

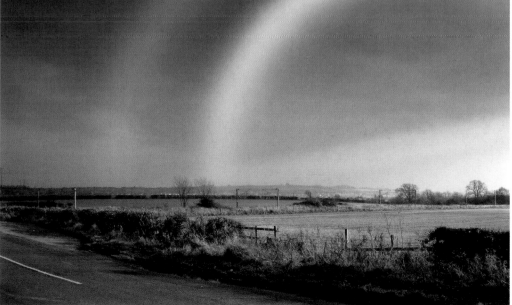

Simulating lightning

atching real lightning with a compact digital camera can be a difficult and somewhat dangerous activity. The choice is either to spend a great deal of time outside in a storm waiting for the perfect moment, or a great deal of money on special photographic equipment.

Although we can't replicate the roar of thunder in Photoshop, we can easily add realistic lightning effects to photographic images. Of course, we could just draw a lightning bolt with a brush and apply a little glow to the layer, but that's unlikely to resemble the random qualities of real lightning. Instead, in this example, we'll use the Clouds filter and a simple gradient to convincingly imitate Mother Nature. The effect is positively electrifying.

1 This image certainly has the potential to be stormy, but let's start by adding a little more drama before we create the lightning. Add a new layer (Ctrl/Cmd+Shift+N), call it "Sky Gradient," and choose a dark blue/black for the foreground color. Choose the Gradient tool from the Toolbar. Select Foreground to Background from the Gradient Picker, and Linear Gradient from the Options bar. Drag a Gradient from the top to the bottom of the image. Set the layer blend mode to Multiply and reduce opacity to 60%.

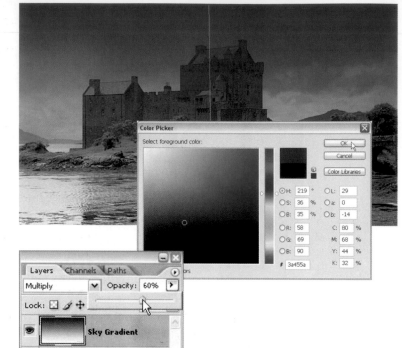

2 Stay with the Gradient tool and add another new layer (Ctrl/Cmd+Shift+N), calling it "Lightning." Choose Foreground to Background from the Gradient Picker and hit D on the keyboard to revert to default black/white swatches. Drag a short gradient diagonally across the central tower of the castle.

3 Now go to **Filter > Render > Difference Clouds**. A dark jagged band will appear across the diagonal center of the layer. Go to **Image > Adjustments > Levels** and drag the middle slider below the histogram to the left until the lightning bolt is distinct amid the cloud fill.

4 We want the lightning bolt to be white, with the surrounding area black, so go to **Image** > **Adjustments** > **Invert** (Ctrl/Cmd+I).

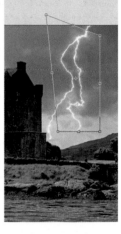

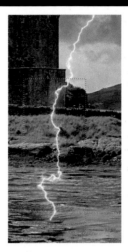

5 Again, choose **Image** > **Adjustments** > **Levels**. Grab the central gray point marker and drag it to the right until most of the clouds surrounding the lightning bolt have disappeared. Stop dragging the slider when just a few cloudy wisps remain attached to the bolt itself.

6 Now set the blending mode for the lightning layer to Screen to hide all of the black on the layer, leaving just the lightning visible. To color the lightning, go to **Image** > **Adjustments** > **Hue**

and **Saturation**. Check the Colorize box and drag the Hue slider to the right until the lightning bolt is an electric blue color. Increase the Saturation value according to taste

7 Choose the Rectangular Marquee tool and drag a selection around the unwanted lower half of the lightning bolt. Right-click/ Ctrl click within the selection, and choose Layer Via Cut. This will paste this section onto a new layer

8 Go to **Edit** > **Transform** > **Distort** to move the second branch of lightning into position at the top of the first bolt. Click and drag within the bounding box to move it. Click and drag the corner handles to distort the layer a little, altering the shape of the bolt.

93

Tip

TREMENDOUS TRANSFORMATIONS

In this project, we've made use of a transformation in Photoshop to position and distort the second bolt of lightning. These commands are useful for making adjustments to the size and shape of any element on a layer. Once in Transform mode (in this case Edit > Transform > Distort), you can adjust the size and shape of a layer element by dragging any of the handles attached to the surrounding bounding box. You can move a layer element while in Transform by simply placing your pointer within the box and dragging. There are a number of Transformations available: Distort, Rotate, Scale, Skew, and Perspective. When you have made your adjustments to the layer, click the Commit checkmark in the Options bar to apply the changes, or simply double-click within the bounding box.

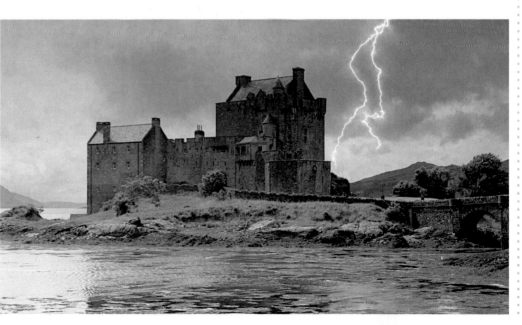

Creating snow

Sometimes a winter image is required and the only image available is a summer scene. Green grass, green leaves, and warm summer daylight all have to be transformed to change the season.

Here, we'll take a distinctly summery photo and dress it in a blanket of snow, adding a blizzard for good measure. For a relatively simple technique that uses a few common Photoshop techniques in combination, the end result is surprisingly convincing. Let it snow!

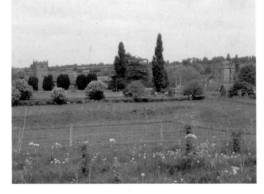

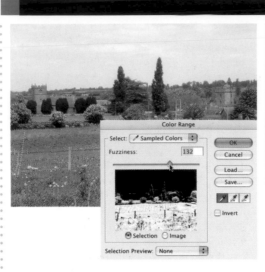

1 First, we need to generate a layer of snow to cover the ground and trees in this summertime image. Choose the Eyedropper tool from the Toolbar and click in the field to sample a mid-green color. We now need to make a selection based on

the distribution of this color throughout the image. Go to **Select > Color Range**. Use a Fuzziness slider setting of 132 and choose Sampled Color from the Select box. Click OK.

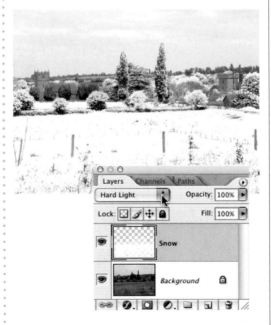

2 Add a new layer (Ctrl/Cmd+Shift+N), naming it "Snow." We need to fill this active selection with white to begin the snow effect, so go to **Edit > Fill**, and choose

White for Contents. Hit Ctrl/Cmd+D to deselect. In the Layers palette, change the blending mode of the Snow layer to Hard Light.

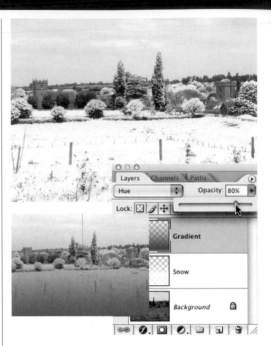

3 The image needs to be made a little colder now. Add another layer, call it "Gradient," and click in the foreground color swatch, choosing a vibrant blue/violet. Select the Gradient tool from the Toolbar and click in the Gradient Picker,

choosing Foreground To Transparent. Click and hold with the tool at the bottom of the image and drag the gradient guide vertically to the top. Set the blending mode for this layer to Hue and the layer opacity to 80%.

4 Now to add some snow. Add another new layer (Ctrl/Cmd+Shift+N) naming it "Snowfall." Fill this layer with 50% Gray using **Edit > Fill > Contents: 50% Gray**. To begin creating the

snowfall, we need to add some random noise to this layer. Hit D on the keyboard to revert to default black/white colors, and go to **Filter > Noise > Add Noise**.

5 In the Add Noise dialog box, drag the Amount slider up to 50%. Choose Gaussian for Distribution and check the Monochromatic check box. Click OK. This noise is too fine for a snow effect, so blur this layer using **Filter > Blur > Gaussian Blur**. Use a Blur Radius of 5 pixels to clump the noise a little.

7 Set the blending mode of the Snowfall layer to Screen and reduce the opacity to about 50% to allow the landscape to show through the snow. To blur the snow a little, and to give the impression of it being blown by the wind, go to **Filter > Blur > Motion Blur**. Use an Angle of 65 degrees and a Distance of 13 pixels.

8 Adding a few larger snowflakes will give the impression of distance. Duplicate the Snowfall layer (Ctrl/Cmd+J) and go to **Edit > Transform > Flip Horizontal**. Zoom out from the image using the Zoom tool and go to **Image >**

Transform > Scale. Lock the chain-link in the Options bar to constrain the proportions and drag the corner handle on the bounding box outward. Hit the Enter key to commit the Transformation.

9 Finally, on this duplicate Snowfall layer, go to **Filter > Blur > Motion Blur**. We want to blow this snow in the other direction, so use an Angle of -59 and a Distance of 31. If the landscape is not showing sufficiently, reduce the opacity of the two Snowfall layers a little more.

95

6 We need to adjust the contrast of this layer. Do this using **Image > Adjustments > Levels**. In the Levels dialog box, grab the White Point marker and drag it to the left until it's below the center of the histogram peak. Now drag the Black Point marker to the right until it almost disappears behind the white marker. Click OK.

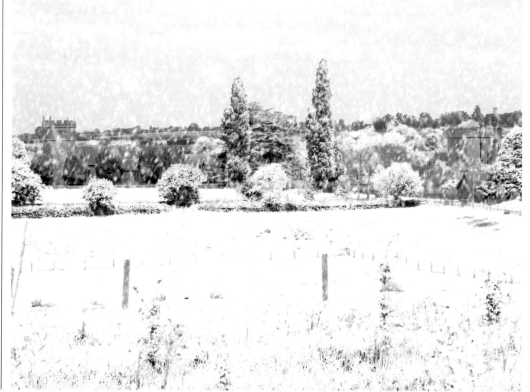

Tip

SNOW UPON SNOW
Once you've completed the image, you can add some more touches of snow manually for extra effect. Return to the main Landscape layer and click the Brush tool. Choose Dry Brush from the Brush Picker and hit F5 to display Brush Options. Add a new layer, and set the blending mode to Screen. Now paint with pure white here and there throughout the image to add some more defined areas of snow and frost.

Adding reflections

Reflections are essentially mirror images of objects, but creating them accurately in Photoshop takes careful manipulation. In this example, we're going to look at how we can transform simple still-life subjects by adding realistic reflections.

We'll be controlling the opacity of the reflection by using a gradient applied to a layer mask. For an even more convincing effect, we'll also use a very subtle shadow to indicate a surface plane.

1 Here we'll create a realistic reflection from the two objects in this image. We want to create the illusion of the objects standing on a highly polished glass-like surface. First, we need to isolate the objects from the background. Select the Magic Wand tool from the Toolbar.

2 Set the Tolerance for the wand to 30 in the Options bar. Check the Anti-aliased and Contiguous boxes to ensure a smooth-edged, continuous selection. Now, click with the Wand anywhere in the white area that surrounds the objects. Go to **Select > Inverse** (Ctrl/Cmd+Shift+I) so that the apples are selected rather than the background.

3 Go to **Edit > Copy** (Ctrl/Cmd+C), and then to **Edit > Paste** (Ctrl/Cmd+V) to paste a copy of the selected objects onto another layer. Duplicate this new layer by going to **Layer > Duplicate Layer**.

4 We need to extend the canvas downward so we have some space for the shadows. Hit D on the keyboard to set white as the background color. Now go to **Image > Canvas Size**. Click in the top center square in the Anchor box, select Percent, enter 20 in the Height box, and choose Background for Canvas extension color. Click OK to extend the canvas downward.

5 Now click on the lower Reflection layer in the Layers palette. We need to flip this layer vertically to begin creating the reflection, so do this using **Edit > Transform > Flip Vertical**. Hit M on the keyboard to activate the Move tool and then use the downward arrow key on the keyboard to move the reflection down the canvas. Moving the layer with the arrow keys will ensure that the reflection stays perfectly aligned with the actual apples. Don't forget that the two apple layers need to overlap a little. Using the Crop tool, crop away any large areas of white beneath the reflected apples.

Tip

ANOTHER SURFACE

As an attractive alternative, you can create the reflections so that they appear to be reflected in frosted glass rather than a perfectly smooth surface. When you've completed all of the steps, return to the Reflection layer and go to Filter > Distort > Glass. Choose Frosted for texture and adjust the size and the slider according to taste.

6 Still working on the Reflection layer, add a Layer Mask using **Layer > Layer Mask > Reveal All**. Now add a gradient to the mask to gradually dissolve the reflection. Choose the Gradient tool and click in the Gradient Picker. Check that the foreground color is black and choose the Foreground to Transparent gradient. Click OK.

7 Click and drag with the Gradient tool from the very bottom of the image up to the top of the reflected apples. By holding down the Shift key while clicking and dragging, we can ensure that the gradient is perfectly horizontal. Once the gradient mask has completed, right-click/Ctrl+click the thumbnail for the mask in the Layers palette and choose Apply Mask.

8 To add a little more realism, blur the Isolated layer using **Filter > Blur > Motion Blur**. Choose an Angle value of 90 degrees and 21 pixels for Distance. This will give a subtle effect of the surface distorting the reflection. Click OK and reduce the opacity of this layer to 75%.

9 Duplicate the Isolated copy layer (Ctrl/Cmd+J). Ctrl/Cmd-click the thumbnail for this layer to generate a selection from it. Choose a dark brown color for foreground and fill the selection using **Edit > Fill > Contents: Foreground Color**. Hit Ctrl/Cmd+D to deselect.

10 We need to make the shadows lie flat, so go to **Edit > Free Transform**. Grab the top center handle on the Transform bounding box, hold down the Ctrl/Cmd key, and drag it to the right to compress the shadows. Double-click within the bounding box to apply the Transform. In the Layers palette, drag this shadow layer down the stack so that it sits below the Isolated copy layer. Blur the shadow with **Filter > Blur > Gaussian Blur**, using a value of 34 pixels. Now reduce the opacity of this layer to 65%. Finally, use the Eraser tool at low opacity to partially erase the furthest points of the shadows.

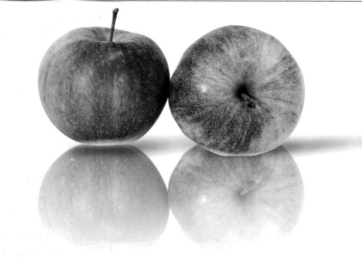

Simulating sunsets

Sunsets are beautiful, but transient—and often somewhat elusive. Good sunsets can be caught on camera, but the odds are that they won't quite capture the majesty of the real thing.

Sometimes the result appears flat, and lacking in the russets, oranges, and warm gold tones provided by the setting sun. The good news is that, armed with Photoshop, we can simulate the evening sky's crowning glory very well indeed.

With the powerful Gradient tool, some well-chosen filters, and a little imagination, we have all the tools we need to turn day into brilliant dusk.

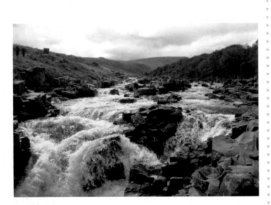

1 Begin the sunset conversion by adding a gradient on a separate layer. Open the original image, add a new layer (Ctrl/Cmd+Shift+N), and call it "Sunset." This image has a dull, but fairly cloudy, sky, so it's an ideal candidate. Click on the background color swatch and choose a bright yellow from the Color Picker. Now click the foreground swatch, and choose a bright orange/red.

3 Duplicate the original background layer (Ctrl/Cmd+J). Go to **Image > Adjustments > Photo Filter**. From the Photo Filter dialog box, choose Magenta from the Filter drop-down menu, and increase the Density slider to 84%. This will add a warm cast to the overall image.

2 Choose the Gradient tool and click in the Gradient Picker, selecting Foreground to Background. Select Linear Gradient from the Options bar. Click and drag with the tool from the very top of the image, releasing the mouse button on the horizon line. Set this layer to Linear Burn, reducing the opacity to 80%.

4 Now we need to add the sun. Click on the Sunset layer and select the Elliptical Marquee tool from the Toolbar. The tool is nested below the Rectangular Marquee tool, so click and hold on this tool to reveal it. Select Fixed Aspect Ratio from the Style box in the Options bar. Create a new layer (Ctrl/Cmd+Shift+N) at the top of the Layer stack called "Sun," and drag a small circle, overlapping the horizon.

Tip

IMAGE > ADJUSTMENTS > PHOTO FILTERS
The Photo Filters command in Photoshop CS2, as used here in step 3, is a great way to simulate traditional photographic filters, or to add a subtle color cast to an image. There is a huge range of different color filters to choose from, each selected using the Filter drop-down menu. The intensity of the color overlay is controlled with the Density slider, and checking Preserve Luminosity ensures that the image's original brightness and contrast level are not altered by the filter itself.

5 Choose a very light yellow for the foreground color and fill the selection by clicking in it with the Paint Bucket tool. Hit Ctrl/Cmd+D to deselect. Blur the sun a little with **Filter > Blur > Gaussian Blur**, using a Radius of 5.8. Set the blending mode for this layer to Vivid Light and reduce the opacity to 85%.

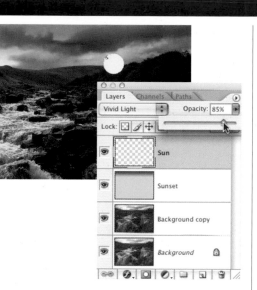

6 Remain on the Sun layer and choose the Brush tool from the Toolbar. Select a soft-edged brush from the Brush Picker, and reduce the Brush Opacity to 33% in the Options bar. Also in the Options bar, click on the Airbrush symbol. Now paint with bright yellow above the sun and between the clouds.

7 Now choose a very bright and vivid red. Paint with this color at low opacity along the very edge of the horizon line. Also paint with this color here and there in the water to give the effect of the reflected sky.

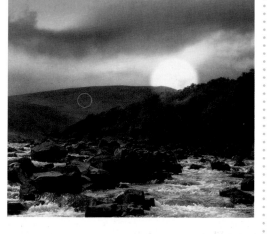

8 With the Eyedropper tool, sample the mauve color from the clouds. Paint some of this color at very low opacity over the top surfaces of some of the rocks, to reflect some color from the sky.

9 For the finishing touch, add a lens flare. Create a new layer at the top of the stack (Ctrl/Cmd+ Shift+N). Fill this layer with black using **Edit > Fill > Contents Use: Black**. Now go to **Filter > Render > Lens Flare**. Once the dialog box opens, choose 50-300 Zoom at a Brightness of 77%. Drag the crosshair for the lens flare up toward the top right. Hit OK. To hide the black, set the blending mode to Screen. Reduce the opacity to 79% and move the flare into position with the Move tool. Position the brightest flare directly over the sun. Finally, select the Sunset layer and, with the Eraser tool, erase some of the yellow from the sunset layer to reveal the cooler magenta underneath. Use a large-sized brush and concentrate on the foreground area.

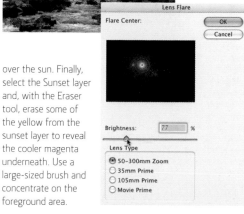

Day into night

Nighttime shots can be difficult at the best of times. With such low light levels, long exposures are required, and gauging them correctly can be a pretty hit-and-miss affair. However, starting with a straightforward daytime shot, it's possible to simulate an after-dark image in Photoshop, complete with atmospheric street lighting.

Here we'll begin by using the Lighting filter to set the scene, adding soft radiating light beams and subtle glows with Gradients. It's vital to remember that when it comes to artificial light sources, the actual color of each light can vary to an enormous extent. By carefully controlling the hue and intensity of the added lights, a wonderful degree of realism can be achieved.

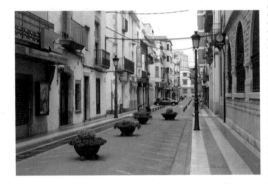

1 Open the original daytime image and duplicate the background Layer (Ctrl/ Cmd+J), renaming it "Night layer." To set the scene, go to Image > Adjustments > Hue/Saturation. In the Hue/Saturation dialog box, check the Colorize box and also be sure that Preview is checked so it's easy to see the changes. Move the Hue slider to 232, and the Saturation to 42. Darken the entire image by setting the Lightness to -57.

2 Now introduce another color to liven things up a bit. Add a new layer (Ctrl/ Cmd+Shift+N) and select the Gradient tool. Choose a deep blue for the foreground color and click in the Gradient Picker, choosing Foreground to Transparent. Now drag a Gradient from the bottom left corner diagonally across the image. Set the blending mode for this layer to Hue.

3 Duplicate the Night layer again (Ctrl/Cmd+J). Now go to Filter > Render > Lighting Effects. Choose Blue Omni from the style box and Spotlight for Light Type. Drag the handles around the light pool in the preview box to the position shown. Set the Intensity slider to 60 and choose a light blue from the Light Color swatch. Click OK. Set to Lighten, opacity 30%.

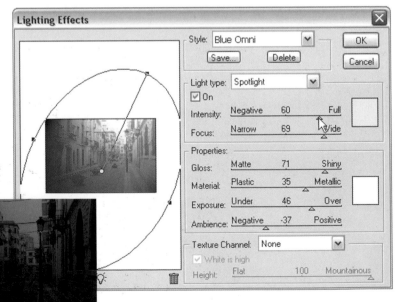

4 Open the moon image and go to **Select > All** (Ctrl/Cmd+A), **Edit > Copy** (Ctrl/Cmd+C). Close the moon image, then return to the main image and paste the moon into the composition (**Edit > Paste**). Size and position the moon using **Edit > Transform > Scale**. Hold down the Shift key while reducing the size of the moon with one of the corner handles to retain the correct proportions. Set the blending mode to Screen.

5 Time to turn on the street lamps! Add a new layer (Ctrl/Cmd+Shift+N), call it "Lamps," and drag it to the top of the layer stack. Select the Polygon Lasso tool, making sure that Add To Selection is active in the Options bar. Draw two selections from the nearest lamp, radiating outward down to the ground. Go to **Select > Feather** and use a Feather radius of 10 pixels.

6 Choose a bright yellow from the Color palette and select the Gradient tool. In the Gradient Editor, select Foreground to Transparent. Choose Radial Gradient from the Options bar. Click and drag the gradient from the top to the bottom of the street light. Hit Ctrl/Cmd+D to deselect and set the layer blending mode to Screen. Blur with **Filter > Blur > Gaussian Blur**, using a Radius of 19 pixels.

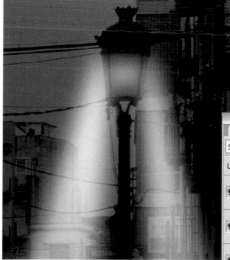

7 Add another new layer (Ctrl/Cmd+Shift+N) and zoom into the top of the lamp. With the Gradient tool, drag a very small gradient in the center of the lamp. Again, blur a little with Gaussian Blur and set the blending mode to Screen.

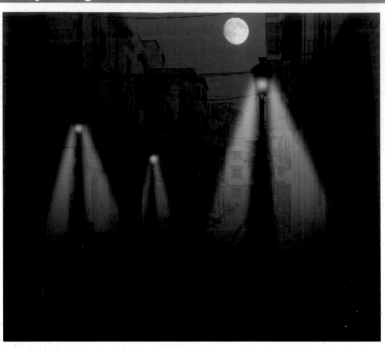

8 Now, duplicate the two lamplight layers (Ctrl/Cmd+J), and move the duplicated light beams into position on the other streetlights with the Move tool. The light beams can be sized to fit the other lamps by using **Edit > Transform > Scale**.

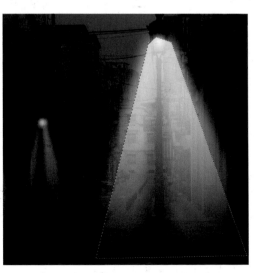

9 Draw another large triangular selection over the first lamp, using the Polygon Lasso tool. Add another new layer and drag another radial gradient out from the light to the bottom of this selection. Deselect and blur with **Filter > Blur > Gaussian Blur**, using a radius of 90. Set the blending mode to Screen. Duplicate this layer twice, placing the duplicates over the other lamps.

10 Return to the original Night layer and add a Layer Mask using **Layer > Layer Mask > Reveal All**. Select the Brush tool and choose a soft brush from the Picker. Paint with Black at very low opacity around and beneath the street lamps to reveal a little color from the underlying background layer. This will give the impression of the light illuminating the nearby building and ground.

11 On a new layer, change the foreground color to a vivid blue. With the Gradient tool, drag a tiny gradient just in the doorway on the left to create a small light. Create another new layer, and use the Brush tool at a large size to paint some reflected blue at very low opacity onto the pavement and the walls. Set the layer blending mode to Hard Light.

12 As a final touch, we need to add some lights to the car. Zoom right in to the car in the distance and choose the Polygon Lasso tool. Draw a selection for the headlight beam and choose a very light blue for foreground. With the Gradient tool, drag a gradient over the selection. Again, blur this a little using Gaussian Blur. Set the layer blending mode to Screen.

13 To finish off, use the Brush tool and a soft brush to add the red rear light on the car and various yellow orange lights in the distant windows of the buildings.

How many distant lights to add is really a matter of personal choice. A few stars can be also added to the night sky with a small brush.

TRADITIONAL PHOTOGRAPHIC EFFECTS

Simulating color filters

Contrast masking

Adding film grain

Infrared photography effect

Cross-processing effect

Hand tinting

Duotones

Simulating color filters

In traditional photography, there are hundreds of subtle color filters available, which, when placed over the camera lens, can give subtle tints and hues to an image. These filters can be very useful for exaggerating a particular color in a scene, or for adding overall tonal effects, such as creating a warm romantic feeling in an otherwise neutral image.

Digitally, we can replicate the effects of these filters with the Photo Filter command built in to Photoshop CS2. Using this command, we can choose a preset tinted filter, or make one of our own with a Custom color. We can also control the density of the color tint, moving from a very subtle effect to a stark color overlay effect. The command has the facility to preserve the luminosity of an image, so that even with the filter applied, the image retains its original tonal integrity.

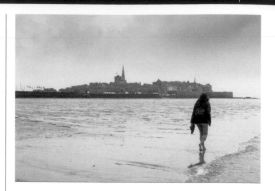

1 With the start image open, go to Image > Adjustments > Photo Filter to begin the toning process.

2 The filter has many preset colored filter effects to choose from. Begin by selecting Sepia from the Filter pull-down menu. At the default Density setting, this filter has a very subtle warming effect. To increase the effect of the filter, drag the Density slider up toward 100%, and click the Preserve Luminosity box. This is a great way to add an antique sepia effect to an image.

3 We can create a more marked effect with this filter by desaturating the target image first, using Image > Adjustments > Desaturate (Ctrl/Cmd+Shift+U). This results in a simple but effective sepia-toned monochrome image.

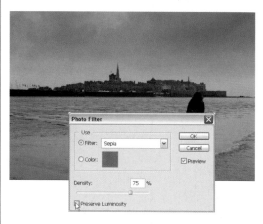

4 The Preserve Luminosity option maintains the original image's brightness and contrast characteristics.

A more dramatic effect can be achieved if this option is left unchecked.

5 There are a couple of filters that are especially useful for correcting white balance errors and color casts on digital photographs.

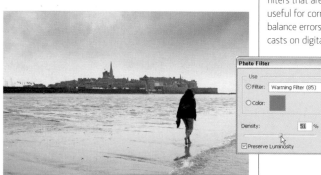

The two Warming filters are very useful for images that have an exaggerated blue/green bias, such as those taken under fluorescent lighting. Again, access these using the Filter box. First, try the filter at the default density of 25%, with Preserve Luminosity checked. To increase the effect of the filter and cancel out any color cast, slowly increase the filter Density value.

6 The Cooling filters, which use blue as their base, are useful for neutralizing any overly warm color casts in images.

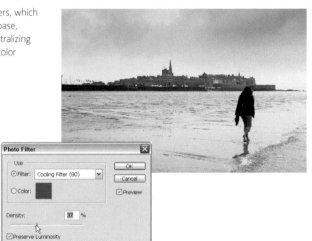

1 Graduated color filters can work very well with landscape shots, adding intensity and atmosphere. By using the Photo Filter command on a duplicate layer, we can achieve this very useful effect. Simply duplicate the original background layer (Ctrl/Cmd+J), and apply the Photo Filter to the duplicate layer as before.

7 Here, with the image divided into eight sections, we can see the toning effect of various filters from the Color Filters command, all applied at 35% Density. We can also choose a Custom filter color, by clicking on the color swatch in the dialog box.

2 Now add a layer mask to the duplicate layer using Layer > Layer Mask > Reveal All.

3 To add a gradient to this layer mask, choose the Gradient tool from the Toolbar. Hit D on the keyboard to revert to default black/white colors and click in the Gradient Picker. Choose Foreground to Background from the gradient swatches and select Linear Gradient from the Options bar. Choose the layer mask thumbnail and click and drag the gradient from the top to the bottom of the image, holding down the Shift key to keep the gradient perfectly vertical.

107

Contrast masking

From time to time, each and every one one of us will become the not-so-proud owner of a badly exposed digital photograph. It's true that digital photography has the distinct advantage of enabling us to review our images just seconds after shooting, but some images that look OK on the camera's LCD display can still present us with some nasty surprises when we look at them later in Photoshop.

High-contrast scenes are notorious for producing poorly exposed shots, and are equally notorious for being extremely difficult to correct, often requiring a lot of time spent manipulating curves and levels in Photoshop. There is, however, an often-overlooked "quick fix" for such images that involves the digital equivalent of an age-old darkroom technique known as contrast masking. The few steps involved in the following digital-imaging contrast masking technique can breathe new life into moderately over- or underexposed images that would otherwise be destined for the Trash or Recycle Bin.

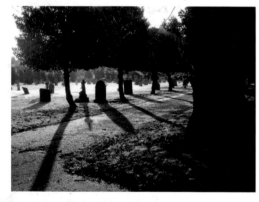

1 Here's a classic example of an image where the camera's metering system has been fooled into exposing for the lighter areas of the image, and as a consequence has overexposed the dark and midtones, leaving almost no detail visible in these areas.

2 Contrast masking involves overlaying the original image with a negative, monochrome, duplicate copy layer. First, duplicate the background layer using **Layer > Duplicate Layer**, naming the duplicate layer "Contrast Mask."

3 To desaturate this contrast masking layer, go to **Image > Adjustments > Desaturate** (Ctrl/Cmd+Shift+U).

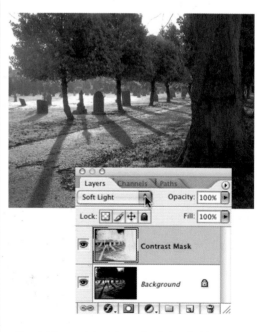

4 For this technique to work, the tones in this contrast masking layer need to be the exact opposite of the original image it overlays—the dark areas in the original should be light, and the light areas dark. To achieve this, invert the masking layer with **Image > Adjustments > Invert** (Ctrl/Cmd+I).

5 Now, let the magic begin! Change the layer blending mode for the Contrast Mask layer to Soft Light. Already we can see a huge difference in the tonality of the image— the dark and midtones have opened up nicely, with much more detail evident in these areas. However, the effect is a little harsh at this stage.

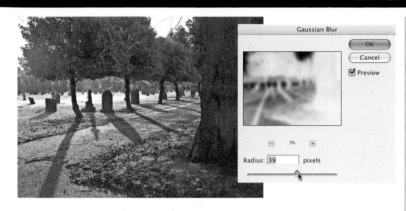

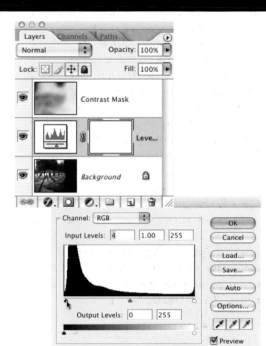

6 To soften the effect, we need to blur the contrast masking layer, so go to **Filter** > **Blur** > **Gaussian Blur**. It's essential that the Preview box in the Gaussian Blur dialog box is checked so we can monitor the effect in the actual image as the Blur Radius is increased.

7 The amount of Blur required depends very much on the individual image. Start with the Blur Radius set to its lowest value and slowly increase the amount, giving the main image time to update. As we increase the value, we'll see the image become clearer and the colors more realistic. Here, at a 39-pixel Blur Radius, there is a marked improvement.

10 As a final touch, and again with the contrast mask layer set to Soft Light, click on the background layer and add a Levels adjustment layer using **Layer** > **New Adjustment Layer** > **Levels**. Grab the black point below the Histogram and drag it to the right a little to boost the darks in the image. If we compare the original image with the corrected version, it's clear just how successful this simple technique can be.

8 Here, with the Blur Radius increased to 125 pixels, the image is much improved. All fogginess in the image has disappeared and the result is nice and sharp, with a good spread of tones and lots of detail in the shadows. Click OK when a satisfactory result is achieved.

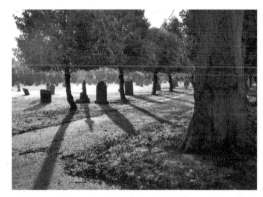

9 A more dramatic effect can be achieved by changing the blending mode for the contrast masking layer to Overlay. This can be suitable for some images, as it boosts the saturation overall.

Adding film grain

In traditional film photography, films of a faster speed, i.e., higher light sensitivity, produce visible grain in the final printed image. Although this is often viewed as a shortcoming of fast films, it can be deliberately exploited with some truly artistic results. When digital cameras are set at high ISO settings, they produce their own kind of grain, which is known as "noise." In-camera, we have very little control over this phenomenon. However, with Photoshop we can manipulate noise and add film grain effects to get results that rival those achieved by more traditional methods.

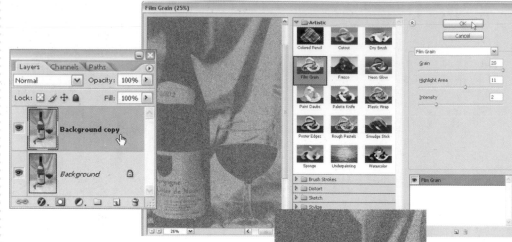

Grain in color images

1 It's important to apply the Film Grain filter on a duplicate layer, so layer blending modes can be used to modify the effect. Duplicate the original background layer by dragging it to the "Create a new layer" icon at the base of the Layers palette (or hit Ctrl/Cmd+J).

2 The Film Grain filter works best on a grayscale layer, so go to **Image > Adjustments > Desaturate** (Ctrl/Cmd+Shift+U). To begin adding the grain, go to **Filter > Artistic > Film Grain**. Set the Grain slider to the maximum value of 20, Highlight Area 11, Intensity 2. Click OK.

3 On the Grain layer, change the blending mode to Overlay. The effect can be lessened, if necessary, by reducing the opacity of this layer. To make the grain a little more realistic, go to

Filter > Noise > Median and use a Radius value of 2 pixels. This will blur the grain a little and make the effect more natural and less mechanical.

4 A more subtle effect can be created by using a Hard Light blending mode for the Grain layer. Both methods give excellent results.

110

1 Film Grain works particularly well on monochrome images. Begin by desaturating the background layer of the chosen image using **Image > Adjustments > Desaturate** (Ctrl/Cmd+Shift+U). For a dramatic effect, increase the contrast using Curves (**Image > Adjustments > Curves**). Replicate the curve shown in the screenshot, which is the classic curve for a subtle increase in contrast.

2 Duplicate this layer and again go to **Filter > Artistic > Film Grain**, using the same settings as in Step 2. Set the blending mode for this layer to Hard Light. We can control the strength of the grain effect by reducing the opacity of this Grain layer.

3 An alternative to the Film Grain filter is the Grain filter that can be found using **Filter > Texture > Grain**. The essential difference here is that we can select various distribution patterns for the grain. Access these using the Grain Type drop-down in the Filter dialog box. For a really dramatic effect, try the Enlarged grain type.

4 Each of the available Grain Types gives very different results, as we can see above.

Contrasty

Sprinkles

Horizontal

Speckle

Infrared photography effect

Traditionally, black-and-white infrared photography involves the use of special filters and film stock that is only sensitive to light from the far end of the visible spectrum. Although many digital cameras are capable of "seeing" this essentially invisible light, infrared photography is not just the preserve of those who possess the correct filters, techniques, and equipment. It's also something that can be created with standard full-color digital images in Photoshop.

An infrared photograph gains its mysterious and otherworldly qualities from the infrared light that is reflected back into the camera at different strengths, depending on the local color of elements within the subject. Some local colors reflect a lot of infrared light. Trees and foliage take on an ethereal white glow, similar to the effect of a really hard winter frost. Skin tones adopt a rather waxy, ghostlike quality, while blue summer skies are rendered almost black. To add to the mix, the entire image adopts a soft, glowing quality that makes for truly unique monochrome images.

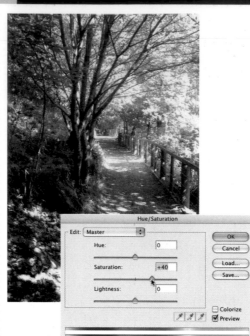

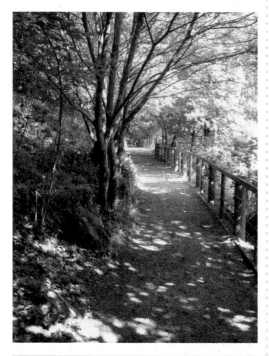

1 Images that contain lots of green foliage are ideally suited to this technique. Open the image and increase the saturation a little using **Image > Adjustments > Hue/ Saturation**. Drag the Saturation slider to the right until the foliage is quite vivid. Here I've used a value of 40.

2 Let's apply the infrared effect to a duplicate layer. Hit Ctrl/Cmd+J to duplicate the background layer, and call it "Infrared layer." Now click on the Channels palette tab and select the Green channel.

3 To create the infrared glow, blur this channel. Go to **Filter > Blur > Gaussian Blur** and use a Radius of 16 pixels. Click back on the RGB channel and return to the Layers palette, choosing the Infrared layer. Set the blending mode for this layer to Screen.

4 This layer needs to be monochrome, and we need to adjust the channel ratios. Add a Channel Mixer adjustment layer with **Layer > New Adjustment Layer > Channel Mixer**. First check the Monochrome box; then intensify the Green channel by dragging the slider for the channel to 200. Set the Red slider to -50 and the Blue slider to -50.

Tip

THREE WAYS TO DUPLICATE A LAYER

In many of the recipes in this book, we sart by making a duplicate copy of a layer. There are three ways to do this—choose whichever method suits you best.

1 You can make a duplicate copy of a layer by dragging the layer to the "Create a new layer" icon at the base of the Layers palette.

2 You can use the duplicate layer keyboard shortcut. Simply hold down the Ctrl/Cmd key and hit J.

3 Make a duplicate copy layer using the Layers menu. Choose Layer > Duplicate Layer.

112

5 Now the infrared effect is becoming apparent, but the opacity of the Infrared layer needs reducing for a better effect. Click on that layer now and reduce the opacity to 32%.

6 Typically, infrared images are detailed but very grainy, due to the qualities of the film stock used. To replicate this, we need to add some noise to the original background layer. Click on this layer and go to **Filter > Noise > Add Noise**. Drag the amount slider to 20%, select Uniform for Distribution, and ensure that Monochromatic is checked. For a higher degree of noise, simply increase the Amount value, although a higher value tends to flatten the tones in the image.

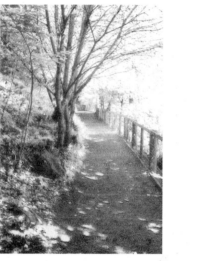

7 To control the overall intensity of the infrared effect, simply increase or decrease the opacity of the Infrared layer. Here I've increased the opacity to 53% for more impact.

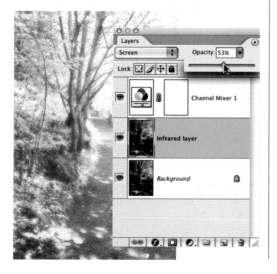

8 As a final touch, flatten the image using **Layer > Flatten Image** and go to **Image > Adjustments > Curves**. Here I've dragged the curve to create a subtle "S" shape to increase the contrast a little.

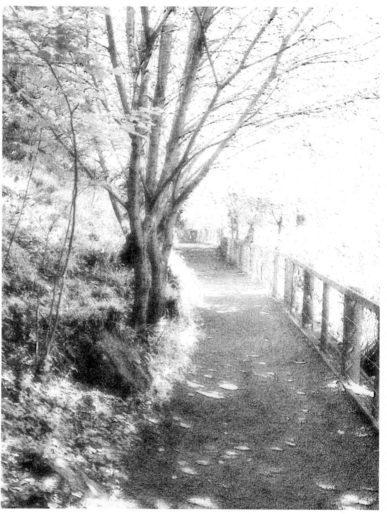

Cross-processing effect

Back in the days of wet-process photography, there were specific chemical processes for particular film types, and mix-and-match was not recommended by the manufacturers. However, since true creativity is often about breaking the rules, some photographers experimented with cross-processing, deliberately developing slide film with the chemicals meant for print film. The resulting images had a striking and distinctive look, and, while the process could be a bit unpredictable, when it worked, it worked well. The characteristics of the effect are over-saturated colors and an overall color shift, blown highlights, deep rich blacks, and marked contrast. In Photoshop we have more control over the effect, as we can tweak layers and experiment with individual color channels—with stunning results.

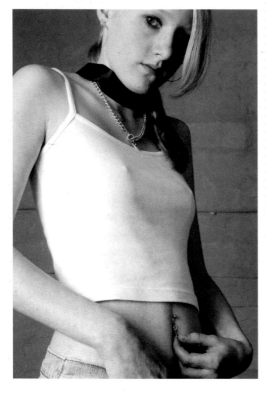

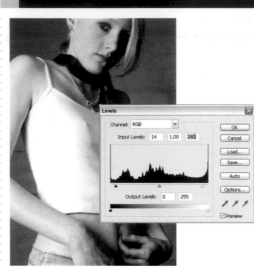

1 The cross-processing effect works best with high-contrast images with very saturated colors, so open the image and first go to **Image** > **Adjustments** > **Levels**. Drag the White Point slider to the left and the Black Point to the right to pump up the contrast.

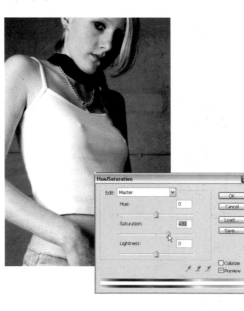

2 For the saturation boost, go to **Image** > **Adjustments** > **Hue/Saturation** and drag the Saturation slider to the right until the colors in the original image are quite vivid.

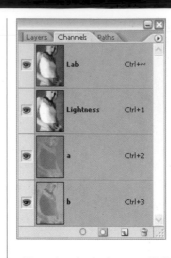

3 We need to change the color mode, and we'll do that on a duplicate file (**Image** > **Duplicate**). On the duplicate image, go to **Image** > **Mode** > **Lab Color**.

We'll be working on the individual Lab channels, so click on the Channels tab at the top of the Layers palette.

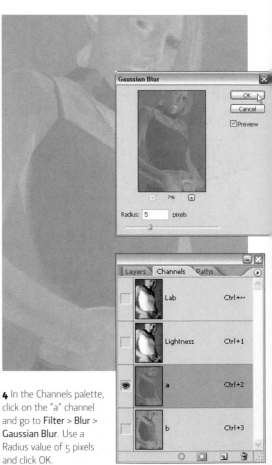

4 In the Channels palette, click on the "a" channel and go to **Filter** > **Blur** > **Gaussian Blur**. Use a Radius value of 5 pixels and click OK.

8 Working on the original image file, go to **Edit > Paste** (Ctrl/Cmd+V). Change the layer blending mode for this pasted layer to Overlay in the Layers palette to achieve the cross-processing effect.

5 Go to **Image > Adjustments > Levels** and drag the Black Point slider to the right until the Input Value box reads 77. Click OK.

6 Now click on the "b" channel in the Channels palette. Go again to **Image > Adjustments > Levels**, drag the Black Point slider to the right until the Input Value box reads 76, and then enter 1.4 in the central (Gamma) box.

7 Click on the Lab channel. and go to **Select > All** (Ctrl/Cmd+A). Then go to **Edit > Copy** (Ctrl/Cmd+C) to copy the entire background layer with all channels intact. This duplicate image can now be closed without saving, and we can return to the original image.

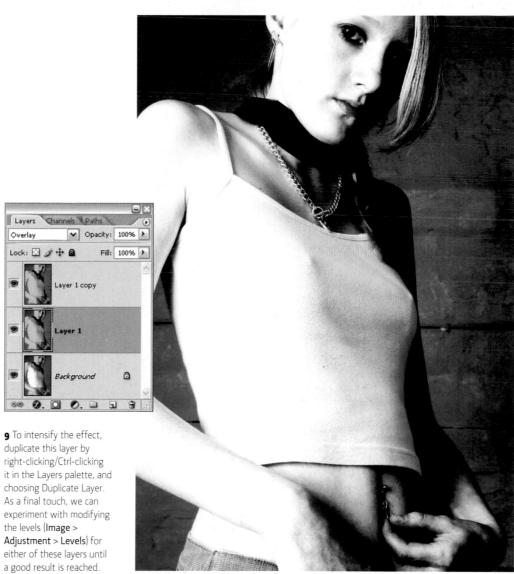

9 To intensify the effect, duplicate this layer by right-clicking/Ctrl-clicking it in the Layers palette, and choosing Duplicate Layer. As a final touch, we can experiment with modifying the levels (**Image > Adjustment > Levels**) for either of these layers until a good result is reached.

Hand tinting

Before the age of color film, when black-and-white photography was the only option, it was common practice for photographers to tint a black-and-white image with colored dyes to mimic real-life colors. Although we now have all the advantages of stunning color photography, we can still use Photoshop to replicate this technique, and add great charm to black-and-white images.

What we're looking for here is not truly lifelike color, but a decorative and subtle effect. Essentially, we can tint as little or as much of the image as we like, but the effect works best where areas of color are contrasted with the uncolored grayscale image.

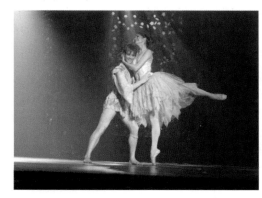

1 Open a suitable image. Go to **Image > Mode**. If the original image is in color, first convert it to grayscale. Then convert it back to RGB so we can add color back into it. If the original is grayscale, it'll need to be converted to RGB mode.

3 Hit F6 on the keyboard to display the Colors palette. This is where we'll choose all of the painting colors. To choose a color, pass the mouse pointer over the spectrum bar and click to choose the approximate color. The colors can be fine-tuned with the RGB sliders above the bar, and the chosen color can be seen in the foreground swatch.

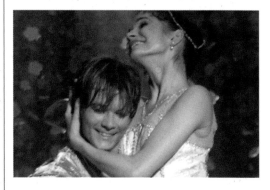

2 The color needs to be painted onto a separate layer, so create a new layer (Ctrl/Cmd+Shift+N). Set the blending mode for this layer to Color in the Layers palette. This mode will allow any added color to overlay the image. Now choose the Brush tool and select a soft-edged brush from the Brush Picker. In the Options bar, set the brush opacity to 50% and activate the Airbrush icon.

4 Begin by choosing a warm yellow/orange. Paint over all of the areas of flesh with this color. Remember, because the brush is in Airbrush mode, if we leave the brush in one position for too long the color will build up on the image, so we need to keep it moving at all times. Vary the skin color slightly by occasionally dragging the RGB sliders. Remember, we only want to tint the image with color.

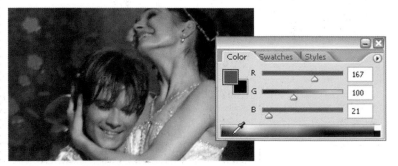

5 Now choose a deep brown and paint over the hair of both dancers. Again, modify the color and tone using the sliders to introduce a little variety.

116

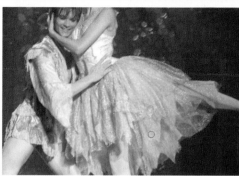

6 I've chosen a light blue to paint over the male dancer's costume. Essentially, we want less color over the lighter parts of the costume and heavier pigment over the darker parts. To make accurate application of color easier, zoom into the image and adjust the size of the brush with the square bracket keys on the keyboard. Again, modify the color after applying the initial covering of blue and add a few touches of a darker purple shade.

8 Here I've continued to paint yellows and oranges into the dancer's tutu using the Brush tool on the tinting layer.

Tip

MAKING A SELECTION WITH QUICK MASK

Quick Mask mode is a great way to make accurate selections. Enter Quick Mask by hitting Q on the keyboard. With black as the foreground color, paint an overlay onto the image over any areas of the image you wish to select. The masked areas will appear to be red, even though you are painting with black as the foreground color. When you have painted all of the areas you want to select, hit Q again to quit Quick Mask mode. You will now have an active selection in the shape of the mask you just painted.

9 To complete the image, I've zoomed into the ballerina's feet and applied a little color to her shoes.

7 To help keep the colors separate in complicated areas, try selecting a particular area first and then painting within the active selection. Here I've isolated the dancer's bodice by painting a Quick Mask onto the area first. (See the Tip Box for more on using Quick Mask mode.) Exit Quick Mask mode (hit Q) to activate the selection, and paint the color into the selection.

Duotones

Basically, duotones are two-toned images (usually black and a second color). The use of the second color extends the tonal range of an image beyond that which is possible with just one color. In a duotone, you can map the distribution and density of the two colors across the tonal range of the image with pinpoint precision. The colors in duotones—with the exception of black—are known as "spot colors." These are industry-standard, predictable shades of ink used by printers to maintain consistent color in their print jobs.

In Photoshop, duotones can be created via the Duotone option in the Mode menu. (Monotones, Tritones, and Quadtones are also available, and are accessed from the Duotone dialog box.) If you're tired of straight black and white, just follow the steps in this recipe to add some color and depth to your images.

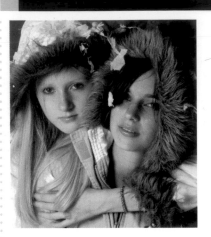

1 Open the original color image. Before the image can be converted to a duotone image, we need to change the color image to grayscale, so go to **Image > Mode > Grayscale**. Answer OK to the "Discard Color Information" dialog box and save the grayscale image under a different filename.

3 Photoshop includes a variety of Duotone settings. To access them, click on the Load button. Choose the Process Duotones folder and select Magenta BL2 from the list. Click the Load button to confirm.

2 To begin the duotone process, go to **Image > Mode > Duotone**. In the Duotone options dialog box, choose Duotone from the Type box. This dialog box is "control central" when it comes to controlling the properties and appearance of the Duo/Tri/Quadtone. In the next few steps we'll concentrate on making adjustments to the properties here. Make sure that the Preview box is checked.

4 This Duotone is made up of Black and Magenta for a nice warm monochrome effect. We can specify how these two colors will be distributed throughout the tonal range of the grayscale image. This is achieved by modifying the Curve or Density Ramp for each of the colors. It's generally best to leave the distribution of the Black ink at the default, but we can modify the distribution of the Magenta. Hit the Duotone Curve thumbnail for Ink 2.

118

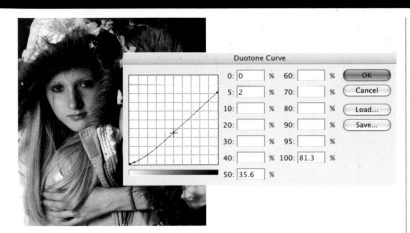

5 The distribution of the separate inks in Duotone mode is controlled using a Curve or Density Ramp for each individual ink. These Curves work in a way similar to conventional Curves in Photoshop. The tonal range within the original grayscale image is represented by a graph with a curve straddling the entire tonal scale. Highlights are represented on the left side of the graph, through midtones and the darkest tones on the right. The height of the curve itself at a particular tonal point in the graph designates the density of the particular ink color at that tone in the grayscale image. The various tones in the image are represented by percentage boxes to the right of the curve graph in 10% increments of tonality.

6 To increase the intensity of magenta in the midtone range, grab the handle near the center of the curve and drag it upward. Dragging a color's curve up will darken the color in the image, dragging it down will lighten it. When a suitable color density is achieved, click OK.

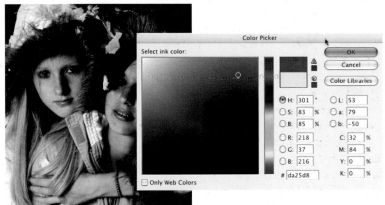

8 We're not limited to the supplied Presets: we can choose alternate colors by simply clicking the ink swatches in the dialog box and choosing a color from the Picker. Here I've replaced the Black Ink 1 with a bright red, and chosen a vivid pink for Ink 2.

9 Although duotones are generally used to create subtly tinted images, when extreme adjustments are made to the ink curves some surprising and surreal effects can be achieved.

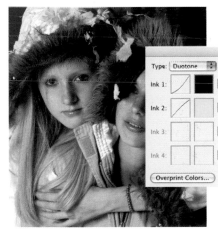

7 We can choose an alternative duotone combination at any time, simply by returning to **Image > Mode > Duotone**. Click the Load button again and choose a different duotone preset. This Duotone preset uses Black and Yellow.

Tip

TRITONES AND QUADTONES

In a duotone, you use just two colors, or inks, to create the image. However, you can take the concept of duotones a couple of steps further with tritones and quadtones. As their names suggest, these siblings of the duotone process use three and four colors, respectively. Photoshop includes a large selection of preset tritone and quadtone combinations, which can be accessed from the main Duotone dialog box. Just choose Tritone or Quadtone from the Type box, and try some of the same techniques used in this example.

119

DISTORTION EFFECTS

Let's roll back time and try a little reverse engineering. This technique harks back to the days before digital, when we use to fiddle around with those tiny two-and-a-quarter-square bordered prints. It's a fun effect, but there are skills to be learned along the way that will be useful for any digital manipulator. For each single image section, we'll make transparency selections from a template layer, cutting and pasting the sections from the original image. The Drop Shadow layer style comes into its own here, enabling subtle variations in shadow depth and helping with the 3D feel of this piece.

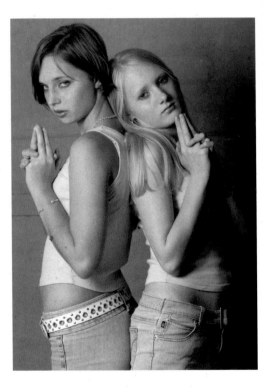

1 Add a new blank layer to the image (Shift+Ctrl/Cmd+N) and call this layer "Template." Select the Rectangular Marquee tool with Style: Fixed Aspect Ratio in the Options bar and drag a square selection over one of the girls' faces in the image. Go to Edit > Fill > Use: White. Reduce the opacity of this layer to 50%. This layer will serve as a template for the individual images.

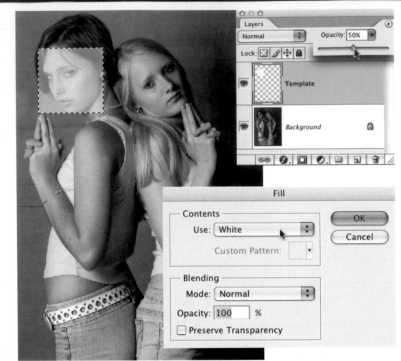

2 Go to Edit > Transform > Rotate and rotate the layer a little, so that the square is tilted. Place the cursor next to a corner point and drag. Double-click to commit the transformation.

3 With the Template layer selected, Ctrl/Cmd-click the Template layer thumbnail to make a selection from its Transparency. Select the background layer and place the cursor inside this selection on the main image. Right-click/Ctrl-click and choose **Layer Via Cut**. This will cut and paste the first square image section on another layer.

122

4 Return to the Template layer, and Ctrl/Cmd-click the Template layer thumbnail to make a selection from its Transparency again. Go to **Edit > Transform > Rotate** again to rotate and move it. To move the square, put the cursor inside it, click, and drag. To rotate it, put the cursor on one corner, click, and drag. Commit the transformation and return to the background layer. Again, right-click/Ctrl-click the selection on the main image and go to **Layer Via Cut**. Repeat this same procedure, moving and rotating the template square and performing Layer Via Cut until the entire image is divided into small squares. It's very important to work on the correct layer for each part of the process. Ctrl/Cmd-clicking the Template layer sets the selection, and be sure you're on the background layer when you

right-click/Ctrl-click the main image to choose Layer Via Cut. Make sure that the individual sections

overlap here and there—this will help to tie the image together.

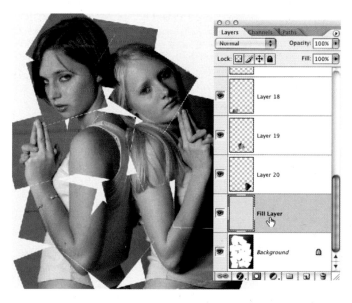

5 When all the cuts are complete—which should be obvious from viewing the original background layer—return to the background

layer, hit Ctrl/Cmd+Shift+N to add a new blank layer, and call it "Fill layer." Choose a light straw color for the foreground swatch and go

to **Edit > Fill > Use: Foreground Color**. This will create the background.

6 Click on the topmost cut layer in the stack and then Ctrl/Cmd-click that layer's thumbnail to generate a selection from it. Ensure that the foreground color is white and go to **Edit > Stroke**. Enter 20 pixels for the Stroke Width and choose Inside for Location. Repeat this process for each of the cutout layers, stroking the edges of all the separate images.

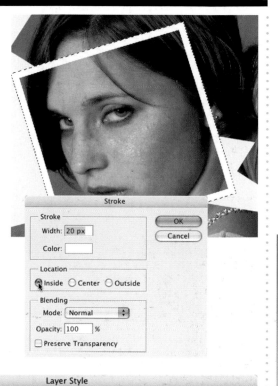

7 Click again on the top layer in the stack and click on the Layer Styles button at the base of the Layer palette, choosing Drop Shadow from the list. Experiment with the Distance and Size sliders for the best effect. Click OK to apply the Layer

Style. Right-click/Ctrl-click the Effects panel attached to this layer and choose Copy Layer Style.

Tip

GET MOVING
In addition to moving layers with the Move tool, you can nudge them, pixel by pixel, with the keyboard arrow keys.

124

8 Now right-click/Ctrl-click the rest of the cutout layers, one by one, choosing Paste Layer Style from the pop-up sub-menu. This will apply the drop shadow to each of the layers, and consequently each separate image area. Once applied, we can double-click the individual effects panes and modify the distance value to vary the effect throughout the image.

9 To make the strip of negatives, add a new layer (**Layer > New Layer**) and drag it to the top of the layer stack. Choose the Rectangular Marquee tool and drag a long rectangle from the left-hand side of the image. Click the foreground color swatch and choose a dark red/brown. Go to **Edit > Fill** and set the blending mode for this layer to Multiply.

10 Choose the Text tool and add some text to the top and bottom strip of the negatives. Choose white for the text color, and move this layer into position with the Move tool. Set the layer blending mode to Overlay and reduce the opacity.

11 To place the negative images within the strip, click on one of the image layers and Ctrl/Cmd-click the layer thumbnail to generate a selection. Go to **Select > Modify > Contract**, using a value of 20 pixels. Copy this layer using **Edit > Copy** (Ctrl/Cmd+C) and go to **Edit > Paste** (Ctrl/Cmd+V). Drag this new layer into position on the film strip, rotating the image using **Edit > Transform > Rotate**. Invert the layer using **Image > Adjustments > Invert** (Ctrl/Cmd+I).

Blending Options...

Drop Shadow...
Inner Shadow...
Outer Glow...
Inner Glow...
Bevel and Emboss...
Satin...
Color Overlay...
Gradient Overlay...
Pattern Overlay...
Stroke...

Copy Layer Style
Paste Layer Style
Clear Layer Style

Global Light...
Create Layer
Hide All Effects
Scale Effects...

Tip

A CHANGE OF HUE
Once you've completed the image, you can add a little variety by returning to one or two of the individual image layers and modifying the color using the Hue slider (go to Image > Adjustments > Hue/Saturation). Try checking the Colorize box for added effect.

12 Link all the layers that constitute the negative strip and go to **Edit** > **Transform** > **Rotate**. Rotate the entire strip and drag into position. Right-click/Ctrl-click one of the Drop Shadow layer styles panels, choosing Copy Layer Style. Now right-click/ Ctrl-click the main negative strip layer and choose Paste Layer Style.

13 Finally, display the Styles palette using **Window** > **Styles**. Click the right-point arrow in the palette, and choose Textures. Return to the filled layer above the background layer and choose the Painted Wallboard swatch from the Styles palette.

Soft focus and selective depth of field

Soft focus is the classic way to create romantic portraits. In camera, this is achieved by the use of special softening filters, but the same effect can be achieved very simply in Photoshop. Soft focus is not simply blurring an image (although we'll use Gaussian Blur as part of the process); we also need to preserve the detail in the image and yet add an overlay of the romantic softening that creates wonderful halos around highlights.

Selective focus, on the other hand, is a technique we can use in Photoshop to recreate convincing depth-of-field effects, where there is an increasing falling-off of focus in front of and behind the main subject or focal point. This wonderful pictorial device has great power when it comes to directing the viewer's attention. We have two methods of achieving this in Photoshop. We can simulate selective focus manually with the Gaussian Blur filter and a layer mask, which can do a pretty good job. Alternatively, in Photoshop CS2, we have the new Lens Blur filter, which can simulate selective focus with stunning accuracy and realism. We'll be looking at both methods here.

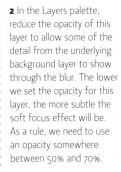

Soft focus

1 Open the image and duplicate the background layer by dragging it to the "Create a new layer" icon in the Layers palette. Now blur this duplicate layer, using **Filter > Blur > Gaussian Blur**. Use a Blur Radius of anywhere between 30 and 50 pixels. The higher the setting, the more pronounced the effect will be in the final image. Here I've used a value of 31.8 for a moderate blur.

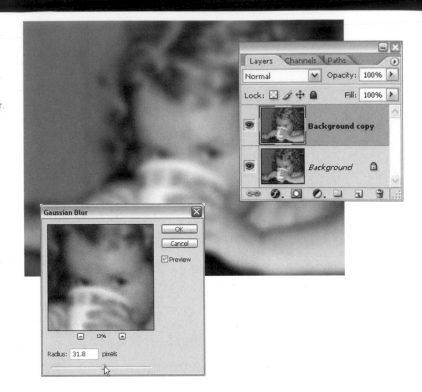

2 In the Layers palette, reduce the opacity of this layer to allow some of the detail from the underlying background layer to show through the blur. The lower we set the opacity for this layer, the more subtle the soft focus effect will be. As a rule, we need to use an opacity somewhere between 50% and 70%.

3 Choose the Eraser tool and select a soft brush from the Brush Picker. Reduce the Eraser opacity to 20% in the Options bar. Gently erase the blur over the eyes and the fingernails. At this opacity, the blur will not be entirely erased, but this will bring a little focus back into the features.

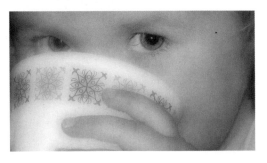

4 We need to add an extra glow to the highlights, so choose the Eyedropper tool and click in the lightest part of the hair to sample the color. Go to **Select** > **Color Range** and use a Fuzziness slider setting of 70. This will determine the range of colors selected. Choose Black Matte from the Selection Preview box so we can see which parts will be selected.

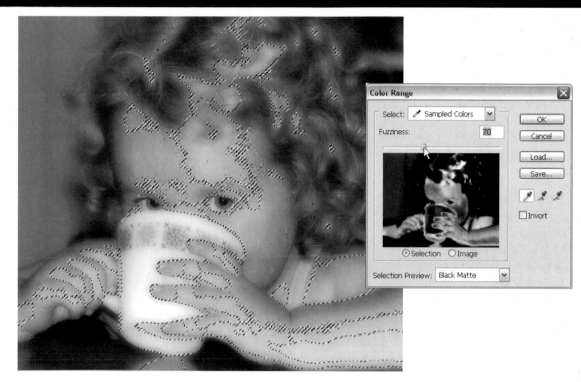

5 With the selection active, add a new empty layer (Ctrl/Cmd+Shift+N). Fill the selected areas with white, using **Edit** > **Fill** > **Use: White**. Blur this highlight layer using Gaussian Blur, with a high radius value of 100. Set the blending mode for this layer to Screen and reduce the opacity.

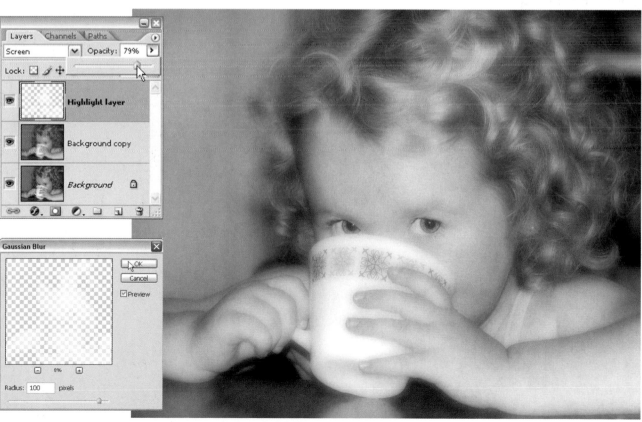

Selective focus

1 For the first selective focus technique we'll use the Gaussian Blur filter. For more effect, we need to increase the depth of field in this macro shot. First, duplicate the background layer (Ctrl/Cmd+J). Go to **Filter > Blur > Gaussian Blur** and use a Radius setting of 10. Ensure that the Preview box is checked. We can make the depth-of-field effect more pronounced by using a higher value.

2 Add a layer mask to the layer using **Layer > Layer Mask > Reveal All**. Ensure that we are working on the layer mask itself by checking for a bold outline around its thumbnail. Ensure that the foreground color is black and background is white. Now choose the Gradient tool. Select Foreground to Background from the Gradient Picker, and choose Reflected Gradient from the Options bar.

3 We need a very narrow area of focus here, so click and drag with the Gradient tool vertically over the ring. The width of the gradient determines where the focus will fall off in the image. Note that the layer mask now has a fading black gradient across its center, allowing some of the underlying layer to show through the blur.

Selective focus with the Lens Blur filter

The previous method gives fairly good results, but now let's try the new Lens Blur filter available in Photoshop CS2.

1 Starting with the sharp-focussed original image, we'll use an alpha channel to control the focus area for the Lens Blur filter. Begin by clicking on the tab for the Channels palette. Click on the "Create new channel" button at the base of the palette.

2 Next, choose the Gradient tool and set white as the foreground color and black as background. Hit the swap arrow next to the swatches if these are the wrong way around (or hit X on the keyboard). Click in the Gradient Picker and choose Foreground to Background. Choose Reflected Gradient from the Options bar.

Tip

CHANGING CHANNELS

When using the Lens Blur filter, we use an alpha channel to describe the depth of field within the image. Normally, all full color RGB images are made up of three channels: Red, Green, and Blue, simply described as RGB. When you add an additional channel, as you do here, this extra channel is known as an alpha channel. If you add just one extra channel, Photoshop will name it Alpha 1. When using the Lens Blur filter, we fill this alpha channel with a Black to White gradient. The filter interprets the white end of the gradient as in focus and the black end of the gradient as out of focus, and the overall image areas are affected accordingly. You can access the Channels palette by clicking its tab, which sits next to the Layers palette tab, or you can display it using Window > Channels.

3 With the new alpha channel selected in the Channels palette, click the visibility eye next to the RGB channel at the top of the stack. The black fill will change to a red overlay as Photoshop enters Quick Mask mode. Starting near the bottom of the ring, click and drag upward with the Gradient tool, releasing the mouse button just above the top edge of the ring. Now click the visibility eye next to the alpha channel to hide it and click back on the RGB channel.

5 To control the degree of blur in the out of focus areas, slowly drag the Iris Radius slider to the right until you're happy with the degree of blur in those out of focus areas. Here, I used a value of 68 for quite a dramatic effect. The point of focus can be moved with the Blur Focal Distance slider.

6 It helps if a little noise is added to the blur, so set the Amount slider in the Noise panel to 16, selecting Uniform for Distribution. Click the OK button. Be patient—the filter can take quite a while to render.

7 Compared with the previous Gaussian Blur effect, this impression of selective focus is much more effective and looks more realistic. Although this process is a little more complicated, the results justify the effort.

4 Go to **Filter > Blur > Lens Blur**. After the dialog box opens, hold down the Alt key on the keyboard and click Reset to revert to default values. Check the Preview box and choose Alpha 1 from the Depth Map Source box. This will use the previously created alpha channel to determine where the area of focus lies. Click the Invert box to invert the channel.

Movement and motion blur effects

Some of the most enigmatic and compelling images are those in which movement is frozen in one area of the image, while making the most of the abstract qualities of figures in motion. Dance is an ideal subject for this kind of effect, where a relatively slow shutter speed will render stationary figures sharply, but where dancers in motion are rendered as soft, abstract shapes. However, this effect need not be confined to the moment when the camera shutter clicks, as we can replicate the effect in Photoshop with a greater degree of control. The technique consists mainly of making accurate selections using Quick Mask mode, and making maximum use of Photoshop's Blur filters. We can carefully combine each of these filter effects using layer masks for ultimate control.

1 With the source image open, click the Quick Mask mode icon at the foot of the Toolbar to bring up the Quick Mask Options. Click Selected Areas and hit OK. Hit Q on the keyboard to enter Quick Mask mode.

Choose the Brush tool, click in the Brush Picker, and select a standard hard-edged, round brush. Hit F5 to open the Brush Options palette and make sure the Shape Dynamics category is not checked.

3 Hit Q again to exit Quick Mask mode and save this selection using **Select > Save Selection**, naming it "Figure." Hit Ctrl/Cmd+D on the keyboard to deselect.

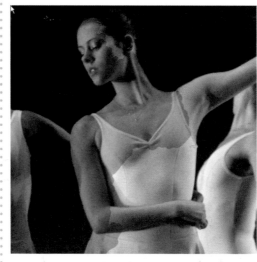

2 Ensure that black is the foreground color and paint the red Quick Mask over the dancer on the left of the image. To paint the mask over more intricate parts, reduce the size of the brush with the square bracket keys on the keyboard. Take great care to accurately mask out the figure, carefully following the outlines.

4 Now, to begin constructing the motion blur effect, right-click/Ctrl-click the background layer and choose Duplicate Layer. Name this layer "Motion Blur." Go to **Filter > Noise > Add Noise**. In the Noise dialog box, choose Monochromatic and

Gaussian, setting the Noise amount to 13. Click OK. Now reload the saved selection by going to **Select > Load Selection**, choosing Figure from the Channels box. Hit the Backspace key on the keyboard to delete the main figure from this layer.

5 Ctrl/Cmd+D to deselect and go to **Filter > Blur > Motion Blur**. Make sure that the Preview box is checked, set the Angle to 0 and the Distance to 193 and click OK. Go to **Select > Reselect** and hit the Backspace key.

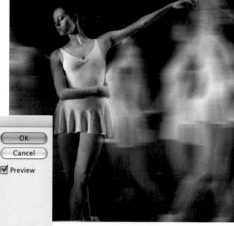

7 Using white for the Foreground color, choose the Brush tool and a soft brush from the Picker. Paint with this brush at low opacity onto the mask to reveal some of the blur layer just over the dancers' heads and limbs. This will add a little more focus here and there.

8 Go to **Layer > Merge Down** to merge the two Blur layers. Add a layer mask to the layer, using **Layer > Layer Mask > Reveal All**. Using the same brush, paint with black onto the mask just around the area where the dancers' hands are linked to reveal just a little of the unblurred background layer. Flatten the image (**Layer > Flatten Image**) and save.

Tip

QUICK MASK MODE
In Quick Mask mode (activated by hitting Q on the keyboard), selections can be made by painting a temporary red-colored mask over the areas you wish to select. By double-clicking the Quick Mask icon which sits below the foreground and background color swatches, you can decide whether your painted mask relates to Masked or Selected areas. Once you exit from Quick Mask mode, it's always a good idea to save the selection using Select > Save Selection. With this same dialog box, you can also change the color of the temporary Quick Mask overlay, which makes the mask easier to see on some images.

131

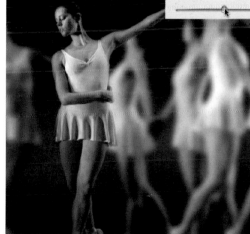

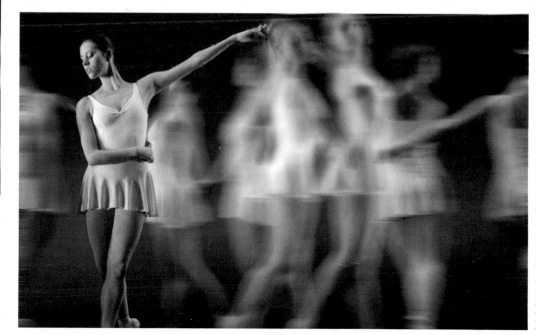

6 Right-click/Ctrl-click again on the background layer and choose Duplicate Layer. Drag this layer to the top of the stack and call it "Gaussian Blur." Now, reload the saved selection again (**Select > Load Selection**, and choose Figure from the Channels box). Hit the Backspace key on the keyboard to delete the main figure from this new blur layer. Go to **Filter > Blur > Gaussian Blur**, using a Blur Radius of 25. Add a Layer Mask to the layer by going to **Layer > Layer Mask > Hide All**.

Fish-eye lens effect

Few of us can afford or have the need for a fish-eye lens. They are notoriously expensive pieces of equipment, and require a professional SLR camera in order to use them. It's possible, however, to get close to the effect of a fish-eye lens in Photoshop with the following technique.

Essentially, a fish-eye lens is ultra-wide-angle and, as such, produces surprising and highly distorted results when used for portraiture. In the following project we'll simulate this effect, Photoshop-style, using the Spherize filter. To complete the effect we'll add a touch of lens flare, creating the illusion of light spilling into the ultra-wide lens.

1 For the fish-eye effect, it's very important that we begin with a perfectly square image to enable the generation of a perfect circle using the filter. Although this will initially distort the proportions of the face, it will not be obvious after the fish-eye effect has been applied. To make the image square, go to **Image > Image Size**.

2 In the Image Size dialog box, check the Resample Image check box, ensuring that Bicubic is selected for Interpolation type. Uncheck Constrain Proportions so we can alter just one dimension. Click in the Height box and type in exactly the same value that is displayed for the Width. Click OK.

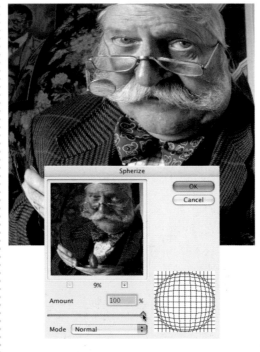

3 Now that the image is square we can begin the fish-eye distortion. Go to **Filter > Distort > Spherize**. In the Spherize dialog box, choose Normal for Mode and increase the Amount slider to a maximum 100%. Click OK to apply the filter.

4 The distortion is bordered by a circular edge around the lens effect. We need to accurately select this central distorted area. Choose the Elliptical Marquee tool from the Toolbar, choosing Fixed Aspect Ratio from the Style box in the Options bar. Position the mouse pointer in the center of the image, hold down the Alt key, and click and drag a circular selection. Don't worry about this selection fitting exactly, we'll adjust it in the next step.

132

5 To adjust the selection to fit the distortion, go to **Select > Transform Selection**. Click the Maintain Aspect Ratio chain link in the Options bar and grab one of the corner handles on the selection bounding box. Carefully adjust the size of the selection with these handles until the circular selection matches the size of the lens distortion. We can move the selection by dragging inside the bounding box. Commit the transformation with the checkmark in the Options bar.

6 To fill the area around the outside of the lens distortion with black, invert the selection using **Select > Inverse** (Ctrl/Cmd+Shift+I) Now go to **Edit > Fill**, choosing Black for Contents. Hit Ctrl/Cmd+D to deselect.

7 For the next step, we need to extend the canvas a little. First hit D on the keyboard for default black/white colors, followed by X to swap them so black is background. Go to **Image > Canvas Size**. Check the Relative box and enter 2 cm in both dimension boxes. Make sure that the central Anchor square is selected, and that the Canvas Extension Color is set to Background.

8 Now we'll add a touch of Lens Flare for added effect. Go to **Filter > Render > Lens Flare**. In the Lens Flare dialog box, set the Brightness slider to 100% and choose 105 mm Prime for the Lens Type. Drag the cross hair in the Preview pane across to the very edge of the circular image.

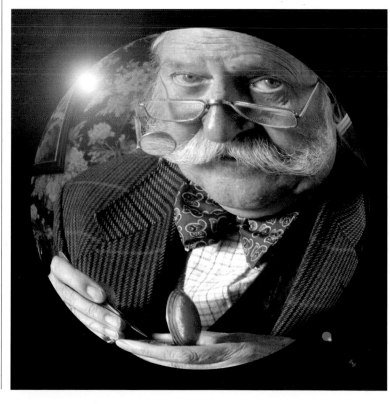

Tip

INCREASING DISTORTION
To increase the distortion, you can reapply the Spherize filter. Following Step 6, while the selection is still active, go again to Filter > Spherize. This time use a smaller Amount value for the filter, increasing the distortion. You can take the extent of the distortion as far as you wish, depending on how surreal and distorted a result you require.

Creating panoramas

Unless you have a very expensive, super-wide-angle lens and a large-format camera, you'll need to resort to stitching together a number of sequential but separate images to create an entire panorama. There was a time when this was accomplished by a manual and very complicated process in Photoshop, or by using a stitching plug-in. However, Photoshop CS2 features the Photomerge command, which takes much of the trouble out of the process. Panoramas can now be created in a couple of mouse-clicks.

Although a panorama can be made up of as many separate images as you desire, in this example we're using just three.

134

1 Panoramas are surprisingly easy to create in Photoshop CS2. In fact, it's pretty much an automated process. To begin, open all of the images that will be used in the final panoramic image. Remember that it's important that the actual content of each separate image overlaps with the next.

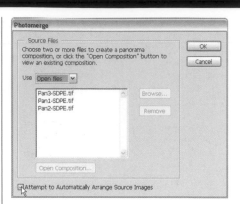

3 Check Attempt to automatically arrange source images and Photoshop will do its best to put the individual images in the correct place in the panorama. (You can always leave this box unchecked if you prefer to arrange the images manually.) Click the OK button to begin the Photomerge process.

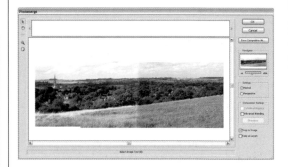

4 We now see Photoshop reading and placing each file, which may take a while depending on the speed of the computer and the size of the files. Just let Photoshop complete the process. In the next screen, which is the Photomerge dialog box proper, Photoshop will display the completed panorama.

2 CS2 has a Photoshop command specifically for creating panoramas. It's buried in the File menu, so go to **File > Automate > Photomerge**. The first dialog box gives us the opportunity to choose the individual files that will make up the final panorama. As the images are already open, Photoshop will automatically list these in the File Box. Alternatively, if we click the arrow next to the Use: box, we can select individual unopened files or folders.

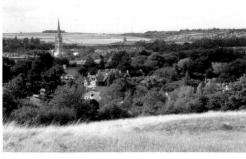

Tip

IMAGES FOR PANORAMAS

When you're shooting the source images, remember to use a tripod. The better the features in the images line up with each other, the more success Photoshop will have at stitching them together. By using a tripod you can pan the scene between shots, ensuring that the camera remains level.

5 Depending on how consistent the camera exposure was in each image, a few faint "joins" may be visible where each image blends into the next. If this is the case, try checking the Advanced Blending check box on the right. Hit the Preview button, and Photoshop will do a much better job of blending the images together. Choose Exit Preview before continuing.

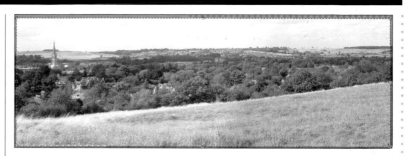

7 Back in the main Photoshop workspace, choose the Crop tool from the Toolbar and click and drag the tool over the entire image. Adjust the handles around the crop box to crop out any transparent or ragged areas around the edges of the image. Double-click within the image to apply the crop.

6 The Perspective radio button in the Settings panel is useful for maintaining the effect of perspective distance in the image, but it's a matter of personal choice whether to enable this or stick with the Normal setting. When you're happy with the panorama, click OK. Photoshop will now create the final panoramic image, and display it in the normal Photoshop workspace. Again, this may take a while to process. When it's done, the original files can be closed.

8 Finally, adjust the Levels for the image using **Image > Adjustments > Levels**. Ensure that the Black Pointer is directly below the left-hand end of the histogram.

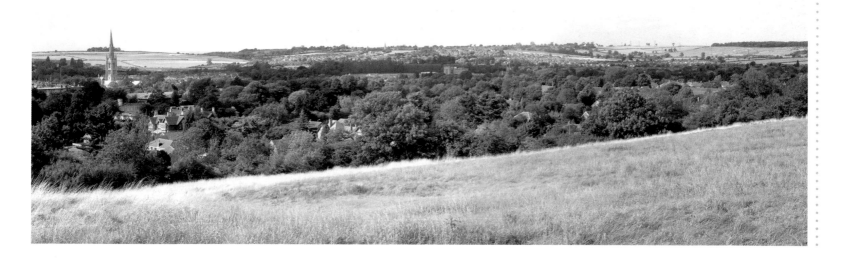

Displacement effect

It's fair to say that the Displace filter in Photoshop is a bit of a mystery to most digital-imaging novices. Put simply, this filter will take one image and distort it in accordance with the contours from another. If it weren't for the Displace filter, we would have to spend hours using the Liquify command to manipulate an image to reflect the contours of a body or an object. Displace achieves the same effect, with far greater accuracy, in just a few mouse-clicks.

Here, we'll wrap a British Union Jack flag around a model's hands and midriff. The Displace filter actually wraps one image precisely over another by following a Displacement Map—a grayscale representation of the contours of an image. In a Displacement Map, black areas are interpreted as low points in regard to contours and white areas are interpreted as high points or contour peaks.

1 For this exercise, we need two images that are exactly the same size and resolution. First, we'll create the Displacement Map with the image of the model. With the image open in Photoshop, convert it to grayscale using **Image > Mode > Grayscale**. To exaggerate the contrast, go to **Image > Adjustments > Brightness and Contrast**, dragging the contrast slider up to 50.

3 To be used with the Displace filter, the map needs to be saved as a PSD file, so now go to Save As, naming the file Displace and choosing PSD for the file type. Close the image.

2 To ensure that the displacement map doesn't contain too much texture, just tones of black and white, blur the image. Go to **Filter > Blur > Gaussian Blur** and use a Blur Radius of 8 pixels.

4 Now open the flag image that will be displaced with the filter. To begin the displacement process, go to **Filter > Distort > Displace**. In the Displace dialog box, set the Horizontal and Vertical displacement scale to 30%, so the flag is just moderately distorted. Choose Stretch to Fit for the Displacement Map and Wrap Around for the Undefined Area option. Click OK.

136

5 A dialog box will now open, asking for the location of the grayscale displacement map file. Browse to the folder that contains the previously prepared displacement map, click on the filename, and choose Open. Photoshop will now apply the displacement to the flag image, based on the grayscale contour values of the image of the model.

6 To complete the image, a copy of this displaced image needs to be overlaid onto the original shot of the model. Go to **Select > All** (Ctrl/Cmd+A) and then to **Edit > Copy** (Ctrl/Cmd+C). Open the original start image (the full-color version, not the displacement map).

7 On the newly opened image, go to **Edit > Paste** (Ctrl/Cmd+V) to paste a copy of the displaced flag over the background layer containing the model shot. Now set the blending mode for this layer to Multiply and reduce the layer opacity to 40%.

8 Add a layer mask to this layer using **Layer > Layer Mask > Reveal All**. We need to mask out any parts of the flag that do not cover the areas of the skin. Choose the Brush tool and select a hard-edged brush from the Brush Picker. Paint with black on the jeans, belt, and the edge of the girl's vest top to hide the flag in these areas. Also paint over the fingernails.

9 When we've masked out all of the unwanted parts of the flag overlay, click on the thumbnail for the flag layer itself (not the attached mask), and go to **Filter > Blur > Gaussian Blur**. Use a Blur Radius of 2.5 pixels to blur the distorted flag overlay a little to blend it in with the underlying image.

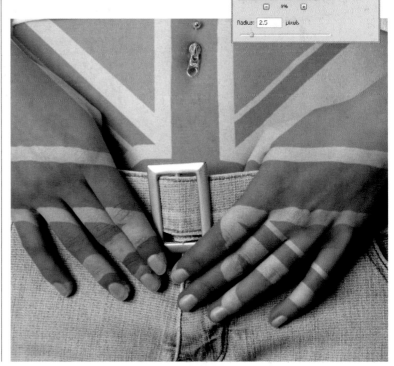

Tip

DISPLACEMENT MAP FILE TYPES

Remember that your displacement map must always be saved as a native Photoshop PSD file type, as this is the only file type that Photoshop will load as a displacement map. In addition, if the displacement map image contains layers, it must be flattened (Layer > Flatten Image) before saving.

TEXTURE EFFECTS

Using texture overlays

With Photoshop as our image-editing tool of choice, we're not limited to producing smooth-toned and flawless images. By using textures, we can apply convincing effects of weathered surfaces and peeling paint. It's really useful to build up a good collection of texture images to use in such projects, and there are always many opportunities to grab some texture shots with a digital camera. There are also many places on the Web where royalty-free texture shots are available.

In this project we'll create a convincing weather-beaten inn sign with realistic surface textures.

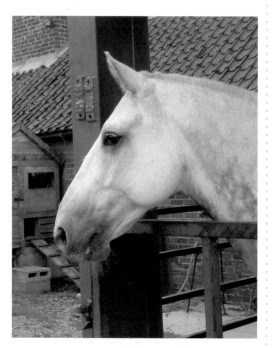

1 Open the horse image. We need to make the current background layer editable, so double-click it in the Layers palette, and name the new layer "Horse" in the dialog box.

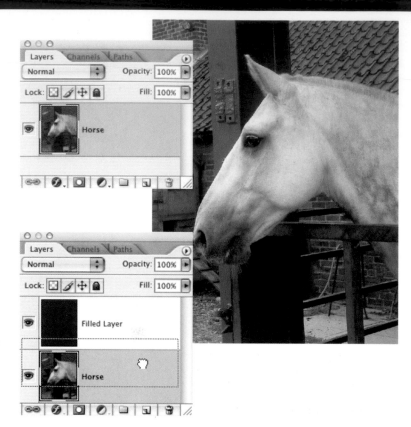

2 To create a base for the sign, add a new layer (Ctrl/Cmd+Shift+N). Choose a deep brown shade from the Color palette. Now go to **Edit > Fill** and choose Foreground Color from the Contents box. In the Layers palette, drag the Horse layer above the Filled layer.

3 Open the Boards image and go to **Select > All** (Ctrl/Cmd+A). Choose **Edit > Copy** (Ctrl/Cmd+C). Close this image. Working again on the main composition, go to **Edit > Paste** (Ctrl/Cmd+V) to paste a copy of the Boards image into the main composition. We need to stretch this layer so that it covers the entire image, so go to **Edit > Transform > Scale**. Holding down the Shift key to retain the proportions, drag on the handles around the bounding box to stretch the Boards image. Hit the Commit checkmark in the Options bar to apply the transformation. Set the blending mode to Hard Light and reduce the opacity to 40%.

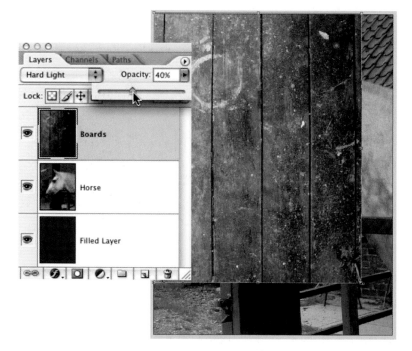

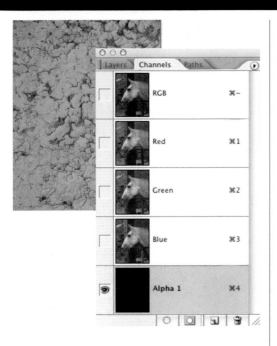

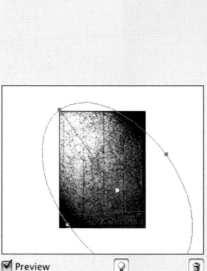

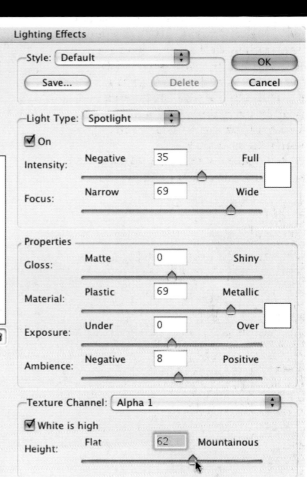

4 Open the Rough Paint image and go to **Select** > **All** (Ctrl/Cmd+A), **Edit** > **Copy** (Ctrl/Cmd+C). Now close this image and return to the main composition. Click on the Channels palette tab and choose the "Create new channel" icon at the base of the palette.

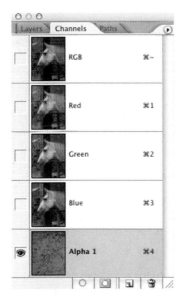

5 Working on the new channel, go to **Edit** > **Paste** (Ctrl/Cmd+V). Fit this rough paint texture to the image using **Edit** > **Transform** > **Scale** as described in step 3. After applying the transformation, click on the RGB channel in the Channels palette and then return to the Layers palette.

6 Right-click/Ctrl-click the Boards layer and choose Duplicate Layer. We're going to light this layer using the alpha channel we just created as the texture reference. Go to **Filter** > **Render** > **Lighting Effects**. Rotate the Light Pool in the Preview Box with the outer handles so the lightest part sits at the top left of the image. Drag on the side handles so the light pool covers the entire width of the image. From the Texture Channel box, choose Alpha 1. Experiment with the other sliders to the best effect, or replicate the settings shown in the screenshot. Click OK and set this layer's blending mode to Overlay, with an opacity of 50%.

Using texture overlays continued

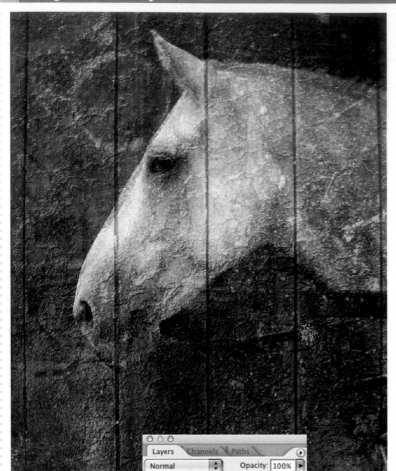

7 Now, we'll hide some of the main Horse layer. Click on the Horse layer, and add a layer mask using **Layer > Layer Mask > Reveal All**. Choose the Brush tool, click in the Brush Picker and hit the right-pointing arrow, selecting Reset Brushes. Choose Dry Brush from the brush thumbnails and paint around the horse's head with black. We're painting onto the mask to hide the unwanted background areas and reveal the Filled layer underneath. Use this brush at 80% opacity (set in the Options bar) so that it leaves just a trace of the surrounding background detail showing here and there.

8 Return to the Boards copy layer, right-click/Ctrl-click it, and choose Duplicate Layer. Drag this layer down the layer stack until it sits directly below the Horse layer. Set the opacity of this layer to 83% and change the blending mode to Normal.

9 To add the lettering, choose the Horizontal Text tool. Click on the top layer in the Layers palette and then click to add text at the bottom of the image. Type the text and choose a typeface from the picker in the Options bar. Adjust the Type size from the Font Size box and choose a suitable color for the type from the Text Color box. Hit the Commit checkmark to apply the text.

10 Now we need to convert the text layer to a pixel layer to apply an effect to it, so right-click/Ctrl-click the text layer and choose Rasterize Type. To age the type, go to **Filter > Distort > Ripple**. Use an Amount of 100 and Medium size. Drag this layer down the stack until it sits directly above the Horse layer. Reduce the layer opacity a little.

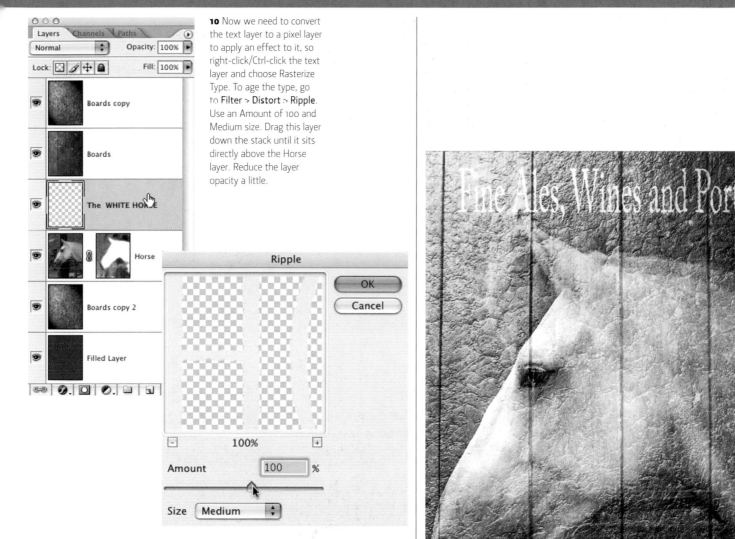

11 If desired, it's easy to create another line using the same method.

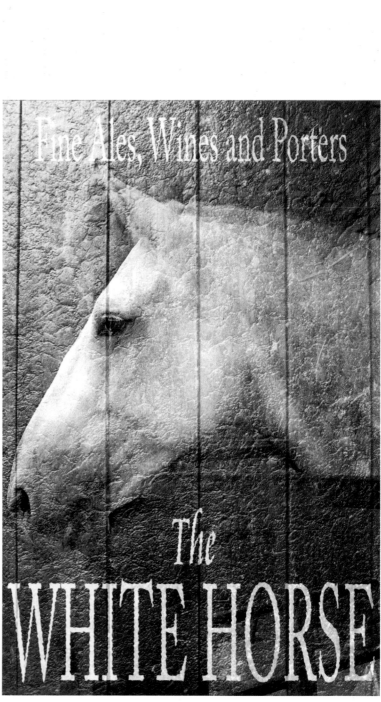

Tip

THE LIGHTING EFFECTS FILTER

The majority of adjustments within the filter dialog box take place within the preview window. First, make sure that the Preview box is checked, so you can gauge your results as you make adjustments. The circle with the handles around it denotes the pool of light itself, with the highest concentration of light along the axis line bisecting the pool. The light itself can be moved by clicking and dragging the central spot in the light, and the light pool can be widened by pulling on the outer handles. The rake of the light is controlled by using the handles that sit in line with the axis. The Light Type and Properties sliders control the intensity of the light and the effect it has on the subject.

143

Turning a figure to stone

It's the stuff of legend: a witch turns an unsuspecting maiden to stone with a flick of her magic wand. In Photoshop, we can cast a similar spell, taking an ordinary digital image and using powerful layer blending mode features and a few layer masks to transform a figure into a stone statue.

This effect is all about how multiple layers combine and meld together. We can make these layer-blending properties even more sophisticated by controlling the opacity of the various parts of multiple layers with layer masks. This technique makes extensive use of the extra brush sets, from which we can choose very effective brushes that are able to express textures within the stroke.

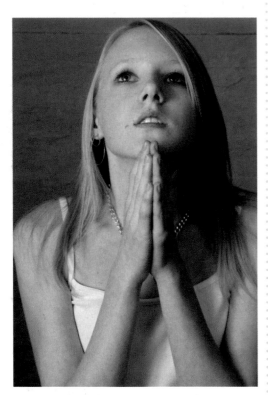

1 This image, with the praying position of the model, lends itself well to this effect, and is already quite statuesque. Start by duplicating the background layer (**Layer > Duplicate Layer**), as this preserves a pristine copy of the image at the bottom of the layer stack. Desaturate the duplicate layer by going to **Image > Adjustments > Desaturate** (Ctrl/Cmd+ Shift+U).

2 To increase the contrast, go to **Image > Adjustments > Curves** and replicate the curve shape in the screenshot. This curve shape lightens the midtones and highlights and darkens the shadows.

3 Open an image of a stone surface, and go to **Select > All** (Ctrl/Cmd+A), **Edit > Copy** (Ctrl/Cmd+C) to copy the entire image. Return to the main composition and go to **Edit > Paste** (Ctrl/ Cmd+V). Now stretch this stone layer to cover the entire figure, using **Edit > Transform > Scale**, dragging the corner handles to fit. Set the blending mode for this layer to Hard Light, and the opacity to 42%.

4 Add a layer mask to the Stone layer using **Layer > Layer Mask > Reveal All**. Use the Brush tool to paint around the girl's head and shoulders with black onto the layer mask to hide the stone texture in these areas.

5 Open a second, rougher stone image and copy and paste it into the main composition as above. Resize this layer using **Edit > Transform > Scale** so it covers just the head and upper arms. Set the blending mode to Hard Light and opacity to 58%. Add a layer mask and paint with black around the head as in step 4.

6 Return to the background copy layer in the Layers palette and choose the Dodge tool from the Toolbar. In the Options bar, set the Range to Shadows and the Exposure to 23%. Click with the tool over the girl's eyes to lighten the tone of the pupils.

Range: Shadows Exposure: 23%

7 Change to the Healing Brush tool and clone out the highlights in the eyes. Set the clone source point by first Alt/Opt-clicking next to the highlight.

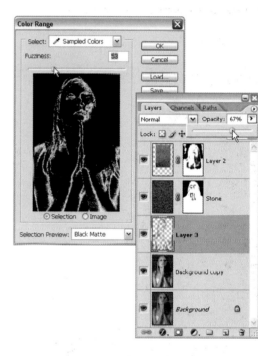

8 Choose the Eyedropper tool and click to sample one of the highlights in the hair. Now go to **Select > Color Range** and move the Fuzziness slider to 53. Hit OK and go to **Edit > Copy**, then **Edit > Paste** to paste the highlights onto a separate layer.

Tip

LAYER MASKS

It's as simple as black and white. Layer masks can be confusing at first, but don't be put off. Think of a layer mask as an invisible grayscale overlay, where black hides the associated image layer and white reveals it. A Reveal All mask is filled with white, and as a consequence, the entire layer is visible. Conversely, a Hide All mask is filled with black. When you paint with black at low opacity (or light pressure with a stylus) onto a Reveal All mask, the brushstrokes make that part of the mask layer partially opaque, so that the associated image layer only partially shows through. It's vital to make sure you're painting onto the layer mask and not the layer itself. You can check this by looking for a bold outline around the thumbnail for the mask in the Layers palette and for the mask symbol in the Layers palette margin.

Turning a figure to stone continued

9 Blur this layer by going to **Filter > Blur > Gaussian Blur**, using a Radius value of 28. This will enable this layer to give the image a softer appearance. Alternatively, a higher Radius value can be used to make the effect more subtle. Reduce the layer opacity to 67%.

10 Click on the background copy layer and duplicate it (Ctrl/Cmd+J). Go to **Select > All** (Ctrl/Cmd+A), **Edit > Copy** (Ctrl/Cmd+C), and Ctrl/Cmd+D to deselect. Now click on the Channels palette tab and click the "Create new channel" icon at the bottom of the palette. Go to **Edit > Paste** (Ctrl/Cmd+V) to paste the contents of the new duplicate layer into the alpha channel. Blur this channel with **Filter > Blur > Gaussian Blur** using 5.2 Radius. Click on the RGB channel before returning to the Layers palette.

11 To light the figure, go to **Filter > Render > Lighting Effects**. Choose Spotlight, and for the Texture Channel, choose Alpha 1. Rotate the light direction pool in the Preview window so the light falls from the top left. Use the settings in the screenshot as a guide for the other values. Hit OK. Set the layer blending mode to Luminosity, opacity to 45%.

12 Click on the foreground color swatch and select a light blue from the Color Picker. Add a new layer (Ctrl/Cmd+Shift+ N) and drag it to the top of the layer stack. Choose the Gradient tool and Foreground to Transparent in the Gradient Picker. Click and drag from the top to the bottom. Set the layer blending mode to Color and opacity to 46%.

13 Click on the layer mask thumbnail attached to the upper stone layer and choose the Brush tool. Click in the Brush Picker and on the small, right-pointing arrow. Load the Dry Media Brush set from the list and choose the Pastel Rough Texture Brush from the thumbnails.

14 If you're using a graphics tablet, hit F5 to display the Brush Options dialog box and click in the Other Dynamics category. For Opacity Jitter choose Pen Pressure. Ensure that Shape Dynamics is not checked.

15 Paint with black at varying opacities on the layer mask in the darkest areas of the girl's head and shoulders to obliterate some of the stone texture. Paint with black into the mask around any edges of the stone layer to hide them.

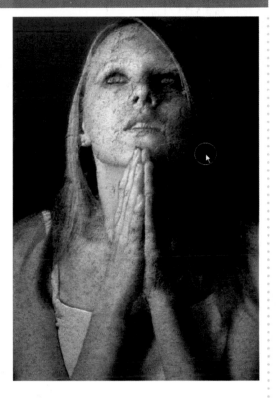

16 Repeat step 15 on the layer mask for the lower stone layer, paying special attention to the edges of the visible layer. Paint around these edges, using black at a very low opacity to carefully blend this layer into the figure. Refer to the Layer Masks box on page 143 for more tips.

Turning a figure to stone continued

17 Now to add some drama to the image. Add a new layer (Ctrl/Cmd+Shift+N) and drag it below the blue gradient layer. Choose a very dark blue for the foreground swatch and select the Gradient tool. Drag a gradient over the entire image from top to bottom. Change the blending mode for this layer to Linear Light.

18 Add a layer mask to this layer using **Layer > Layer Mask > Reveal All**. Make sure you're working on the mask for this layer by checking for an outline around the thumbnail.

19 Choose the Brush tool and use the previously selected brush to paint black into the mask at varying opacities over the entire upper half of the figure. Paint at higher opacity over the left side of the face to give the impression of light falling on that side. Reduce the brush opacity (or use less pressure on your stylus) on the other side of the face to subtly reveal just parts of the face.

20 Add another layer (Ctrl/Cmd+Shift+N) and set the layer blending mode to Color. Change the foreground swatch color to dark green and paint here and there over the head at very low opacity to add just a little color. Repeat this process using a rich brown color.

21 Flatten the image (**Layer > Flatten Image**) and use the Healing Brush tool to clone out the edges of the vest top. Choose the Healing Brush tool, press Alt/Opt on the keyboard, and click at a point next to the edge of the girl's top to set the Healing Brush source point. Release the Alt/Opt key and click along the edges of the top to hide them.

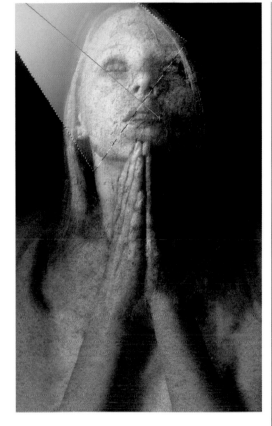

22 Finally, add one more new layer. Choose the Polygon Lasso tool and draw a wedge shape in the top left-hand corner for the light beam. Using light blue for the foreground color, drag a gradient diagonally across the selection. Change the layer blending mode to Screen and reduce the layer opacity.

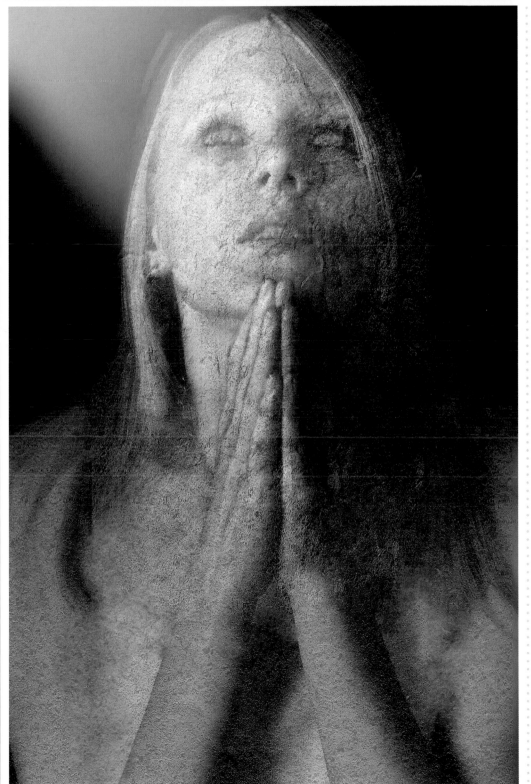

Wood textures

In this recipe, we'll look at a method that uses Photoshop's Layer Styles to create a wood texture. Layer Styles provide a quick route to a texture, but their ability to be customized is limited. We'll get around that by emphasizing the texture and adding some realism with the Lighting Effects filter. Ultimately, these textures can be used for everything from creating stunning texturized lettering to making virtual surfaces suitable for use as bases for still-life photomontages.

1 As an example of how to use a wood Layer Style, I've added some type to a layer, which we'll now turn into wood. Start by creating a new document with a colored background layer. Then use the Horizontal Type tool to add some text, which will appear on a new layer.

2 Here, the plain text can be seen on a separate layer. To create the first wood effect, we'll apply a Style to this layer. Working on the type layer, go to **Window > Styles** to display the Styles palette. Click the small, right-pointing arrow in the palette and choose Textures. Click OK to load the Textures styles. Choose Oak from the Style swatches and apply the wood texture to the type.

3 There are now three Layer Style items attached to the type layer in the Layers palette. Double-click on "Pattern Overlay" and adjust the scale in the dialog box. Then double-click on "Color Overlay" to change the color of the wood effect by selecting the color swatch that appears and choosing a new color in the Color Picker.

4 Add another layer (Ctrl/Cmd+Shift+N) below the text layer and fill it with white (**Edit > Fill > Contents Use: White**). Right-click/Ctrl-click the type layer in the Layers palette and choose Copy Layer Style. Right-click/Ctrl-click the new white-filled layer and choose Paste Layer Style. Double-click this layer to bring up the Layer Style dialog and select Color Overlay. Choose another color to create a parquetry effect where two different kinds of wood are combined.

5 Next, flatten the image using **Layer > Flatten Image**. Now apply some lighting, using this image as an alpha channel for added effect. Go to **Select > All** (Ctrl/Cmd+A) and then to **Edit > Copy** (Ctrl/Cmd+C). Hit Ctrl/Cmd+D to deselect. Click on the tab for the Channels palette and add a new channel using the "Create new channel" icon at the base of the channel. This will add an alpha channel, initially filled with black.

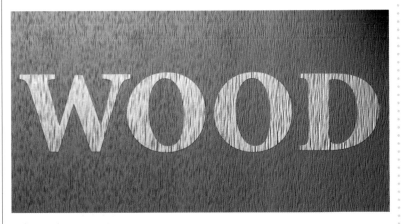

6 Now go to **Edit > Paste** (Ctrl/Cmd+V) to paste the image copy into this alpha channel and click the RGB layer. Return to the Layers palette, and click the background layer. To apply the lighting, go to **Filter > Render > Lighting Effects**.

In the Lighting Effects dialog box, click in the Texture Channel box, choosing Alpha 1 (the pasted-in wood texture). The Height slider determines how exaggerated the texture will be, so set this to 73 for a fairly heavy texture.

7 We want the surface of the wood to be fairly matte in appearance, so set the Gloss Properties slider to -41. Finally, drag on the sliders around the light pool in the Preview pane to position the light. Position the light by dragging the central spot in the pool. Click OK to apply the lighting and texture.

The added effect of applying the texture using an alpha channel in the Lighting Effects dialog box makes the finished wood texture far more convincing.

Tip

THE TYPE TOOL

Using the Type tool is as simple as clicking and typing. You don't need to add a new layer for type as Photoshop does this automatically. As soon as you've typed your words, you can choose a font and a type size from the Options bar by clicking in the relevant boxes and making changes.

Stone texture

Here we'll look at the texture of stone, which by its very nature has a very random quality. If you've followed many of the recipes in this book, you'll know that the best tool for creating a random pattern is the Clouds filter, which we'll use again here. To simulate a surface with very realistic qualities, we'll also employ the Lighting Effects filter, used in conjunction with another alpha channel.

We'll even add some lettering carved into the stone, which will give an added touch of realism, with the application of a couple of Layer Styles.

Like the rest of the textures in this section, this stone texture is a great way to add an extra touch of sophistication to composite images.

1 To begin creating the carved stone effect, start with a new document. Here I've selected **File > New** and created a new document with a white background, measuring 3 inches square at 200 ppi.

2 Click on the tab for the Channels palette behind the Layers palette. Add a new channel to the image using the "Create new channel" button at the base of the Channels palette. The new channel will be named Alpha 1—we'll create the texture map for the stone effect here.

3 Still working on the alpha channel, hit D to revert to default black/white colors and go to **Filter > Render > Clouds**. This will give us a random fill with which to begin the effect. Use **Filter > Noise > Add Noise** to add some texture to the clouds fill. Set Amount to 6%, and opt for Gaussian.

4 Now go to **Filter > Render > Difference Clouds** to create a more random texture. Reapply the filter (Ctrl/Cmd+F) until a suitably intricate texture is achieved—here I applied it four times. Then click on the RGB layer at the top of the Channels palette.

5 Return to the Layers palette, and click on the original background layer. Working on the blank document, choose a dark gray for the foreground swatch and a warm light gray/brown for background. Go to **Filter > Render > Clouds**. Again, add some noise to the clouds with **Filter > Noise > Add Noise**, using an Amount of 4%.

6 Now light this layer, using the alpha channel as a texture map. Go to **Filter > Render > Lighting Effects**. Position the light pool by rotating it so the light falls from the top left. Set the Intensity to 35, Focus to 69. From the Texture Channel box choose Alpha 1 (the channel we created earlier). Set the Height slider to 76. Feel free to experiment with the settings in the Properties section. Hit OK to apply the lighting. The result is a very realistic-looking stone surface.

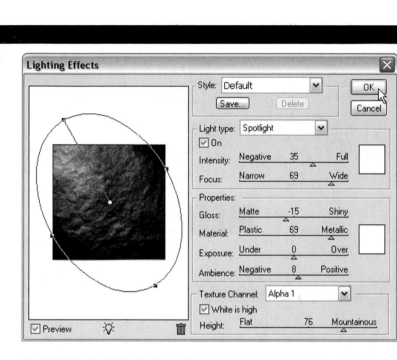

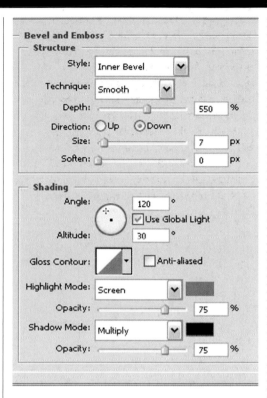

7 To add the chiseled lettering to the stone, choose the Horizontal Type Mask tool from the Toolbar. Click in the image area and type some words using a suitable font. Adjust the size of the font in the Options bar. Click the Commit checkmark in the Options bar to generate a selection from the type.

9 To add the finishing touch, duplicate this pasted type layer. Right-click/Ctrl-click the new layer and choose Clear Layer Style. Now go to **Layer > Layer Style > Bevel and Emboss**. For the Style, choose Inner Bevel. Set Technique to Smooth (or try one of the Chisel settings), set Depth to about 550, and Size to about 7. Click OK to apply the style. Now set the blending mode for this layer to Hue in the Layers palette.

8 With the selection active, go to **Select > Feather**, using a feather radius of 2 pixels. Now go to **Edit > Copy** (Ctrl/Cmd+C), followed by **Edit > Paste** (Ctrl/Cmd+V) to copy and paste the type. On this pasted layer, go to **Layer > Layer Style > Inner Shadow**. Set Angle to 120, Distance to 13, Choke to 32, and Size to 24. This will create the effect of chiseled lettering.

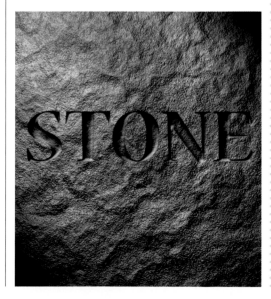

Metal effect

Another texture effect that has many uses is metal. Using metal textures as backgrounds or as part of a composition can add unusual and interesting effects.

Here, again, we'll use a combination of layers and the powerful Lighting Effects filter. We also need to create an alpha channel, which will act as a texture map for the contours of the surface when we throw light across it within the filter. This gives the end product that extra 3D appearance that transforms a fairly simple texture into a convincingly realistic surface. We could even use the virtual surface for a background in a modern portrait image, throwing a shadow from the figure onto the metal surface.

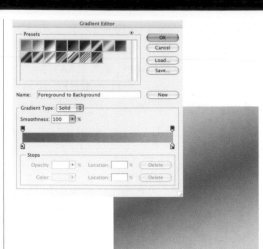

1 First, create a new document using **File > New**, and call it "Metal Effect." Here I've made a document 5 inches square at a resolution of 250 ppi. Click OK to create the new document. In the new document, choose the Horizontal Type tool from the Toolbar. Click in the blank document and type the word "Metal." From the Options bar, choose a suitable typeface (here I've chosen Impact) and adjust the size.

2 We need to blur the type a little so that it has an embossed effect on the metal. Go to **Filter > Blur > Gaussian Blur**, and click OK to first rasterize the type. Use a Blur Radius of 4 pixels. Click OK and then flatten the image, using **Layer > Flatten Image**.

4 To create the metal base, choose a mid-blue/gray for the foreground color swatch and a light shade for the background. Select the Gradient tool from the Toolbar. Click in the Gradient Picker, choosing Foreground to Background from the swatches. Now choose Reflected Gradient from the Options bar. Click and drag the gradient from the center of the canvas to the upper left-hand corner.

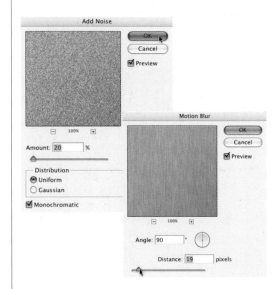

3 Now we need to copy this image to an alpha channel, so go to **Select > All** (Ctrl/Cmd+A) followed by **Edit > Copy** (Ctrl/Cmd+C). Click the tab for the Channels palette and hit the "Create new channel" button at its base.

Then go to **Edit > Paste** (Ctrl/Cmd+V) to paste the image into the alpha channel. Click the RGB layer in the Channels palette and then return to the Layers palette and click on the background layer.

5 To add some grain to the metal, go to **Filter > Noise > Add Noise**. Use an Amount of 20%, Uniform for Distribution, and check Monochromatic. Go to **Filter > Blur > Motion Blur**, using an Angle of 90 degrees and a Distance of 19.

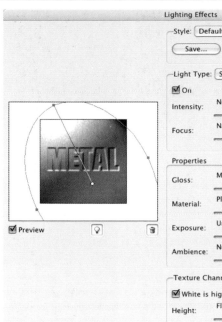

6 Next, we'll add some scratches and imperfections to the metal plate. Add a new layer (Ctrl/Cmd+Shift+N) and set the layer blending mode to Soft Light. Reduce the layer opacity to 70%. Select the Brush tool from the Toolbar, and choose a very small, hard brush from the Brush Picker. Scribble over the plate with this brush using white to simulate scratches on the plate.

8 Finally, flatten the image using **Layer > Flatten Image**. Now light the metal plate using the previously made alpha channel. Go to **Filter > Render > Lighting Effects**. From the Texture Channel box, select Alpha 1 (the Type channel), and set the Height slider to 62. In the Preview pane, drag the handles around the light pool to position it, and in the Properties options, set Gloss to 43, Material to 82. Click OK.

7 Add another new layer (Ctrl/Cmd+Shift+N) with the same blending mode and opacity. Draw more scratches on this layer. Increase the size of the brush and paint small blobs here and there over the metal plate to simulate dents in the metal. Try to place these randomly. Now add a Layer Style to this layer using **Layer > Layer Style > Bevel and Emboss**. Choose Inner Bevel from the Style box and use the sliders to get the best effect. Here I've used Depth 111, Size 6. Add some Noise to this layer using **Filter > Noise > Add Noise** to give the effect of corrosion in the dents.

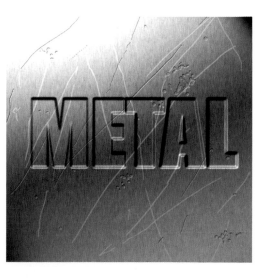

Glass effect

In this example, we'll create a decorative stained-glass effect. This effect can be used for realistic backgrounds in any Photoshop work—for example, in a portrait or still-life composition. This technique could also be used to create unusual and attractive greetings cards.

Essentially, the technique works by first building a framework representing the lead in a stained-glass window, and then filling the individual cells with color and applying Photoshop's own Glass distortion filter.

1 For this effect, begin with a new document. Go to **File > New**. Set the dimensions of the document—here I've chosen 8 inches by 5 inches. Set the resolution to 300 dpi and choose White for Background Contents.

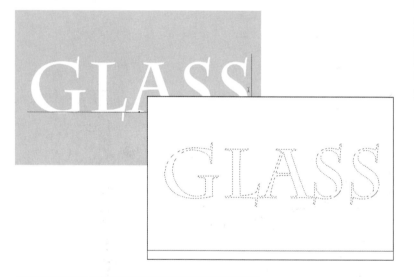

2 First, we need to establish the outline for the lettering in the stained-glass panel. Click and hold the Horizontal Type tool, and choose the Horizontal Type Mask tool from the fly-out. The Type Mask tool creates a selection in the shape of the type, which is what we need here rather than solid letters. Add a new layer (Ctrl Cmd+Shift+N) and click in the document with the tool. Type the line of text and adjust the font face and size in the Options bar. Click the Commit checkmark to apply the type selection.

3 To begin creating the lead strips around the glass, go to **Edit > Stroke**, using a Stroke Width of 25 pixels, and Outside for Location. Hit OK. Once the lettering is outlined, hit Ctrl/Cmd+D on the keyboard to deselect. To create a border, go to **Select > All** (Ctrl/Cmd+A) and return to **Edit > Stroke**, choosing Inside for Location. Hit OK, and Ctrl/Cmd+D to deselect.

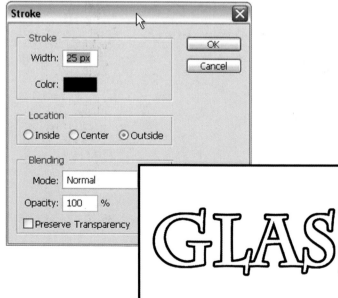

4 Now, we need to divide the empty white section around the lettering into cells for the various sections of colored glass. Choose the Line tool (which may be nested beneath the currently displayed Shape tool) from the Toolbar, and set the Weight to 25 pixels in the Options bar. Choose the Fill Pixels icon from the far left of the Options.

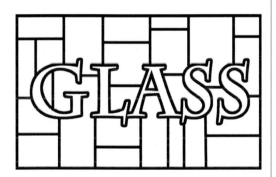

5 Now, holding down the Shift key on the keyboard, click and drag with this tool from the lettering outward to divide up the empty white space. Feel free to create as few, or as many cells as desired. Try to place the lines so that they don't render the lettering illegible.

6 Now that we have the framework for the stained-glass panel established, we need to select each cell individually, color them, and apply the glass surface. Duplicate the Framework layer (Ctrl/Cmd+J), renaming the lower layer "Colored Glass." Select the Magic Wand tool and ensure Add To Selection is checked in the Options bar. Click in a few of the cells that will be the same color in the final piece.

7 Add another new layer (Ctrl/Cmd+Shift+N). This layer will hold the color fills for the cells. Click the foreground swatch and choose a color for the glass in these cells. Now go to **Edit > Fill**, choosing Foreground Color for Contents.

Glass effect continued

Glass (33.3%)

Tip

TWILIGHT GLASS

As an alternative, and to create a stained glass effect with a much more atmospheric feel to it, try changing the blending mode of the topmost Color Fill layer to Difference and reducing the layer opacity a little.

8 Now we'll apply the glass texture to these cells. With the selection still active, click on the Color Fills layer in the Layers palette and go to **Filter > Distort > Glass**.

Use 12 for distortion, 4 for Smoothness, 200% for Scale and Frosted for Texture. Once the filter has been applied, hit Ctrl/Cmd+D to deselect.

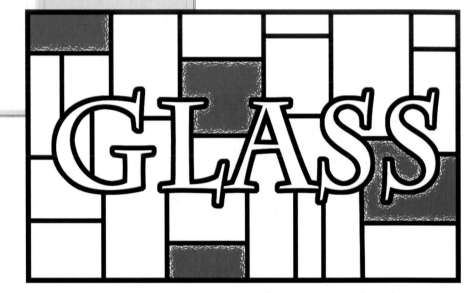

9 Repeat steps 6 to 8 to fill the other cells with different colors and apply the Glass filter. Make sure the Framework Copy layer is active while the selections are made, but fill and apply the Glass filter on the Color Fills layer. Feel free to experiment with the settings and apply different Glass textures in the Glass filter to vary the effect throughout the panel.

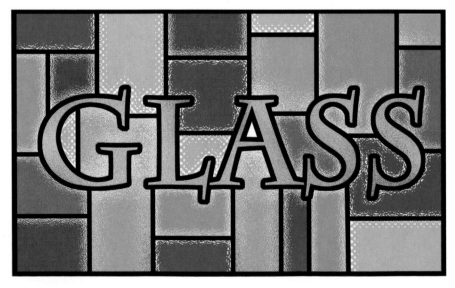

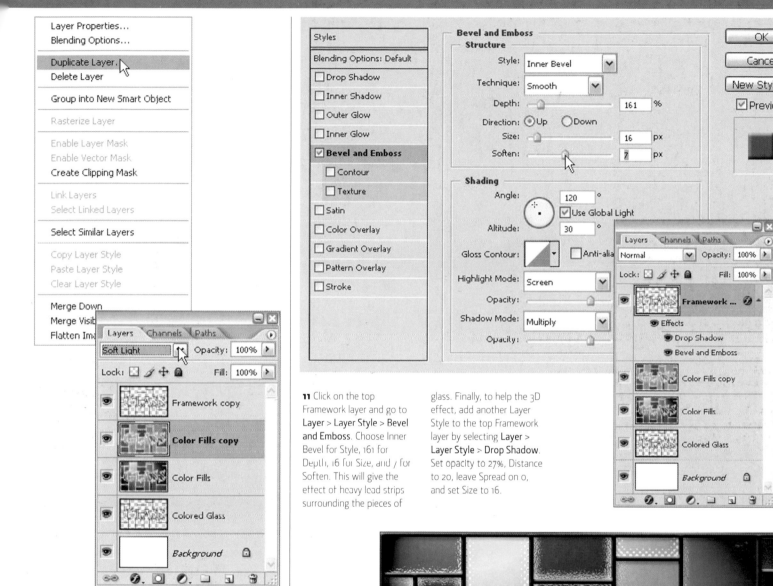

11 Click on the top Framework layer and go to **Layer > Layer Style > Bevel and Emboss**. Choose Inner Bevel for Style, 161 for Depth, 16 for Size, and 7 for Soften. This will give the effect of heavy lead strips surrounding the pieces of glass. Finally, to help the 3D effect, add another Layer Style to the top Framework layer by selecting **Layer > Layer Style > Drop Shadow**. Set opacity to 27%, Distance to 20, leave Spread on 0, and set Size to 16.

10 Once all the cells are filled and filtered, duplicate the Color Fills layer by right-clicking/Ctrl-clicking it and selecting Duplicate Layer. Click on the lower of these two duplicate layers and go to **Filter > Render > Lighting Effects**. Use the defaults setting for the filter and drag the light pool to sit at the top left on the stained-glass panel. Click OK and set the Color Fills copy layer blending mode to Soft Light.

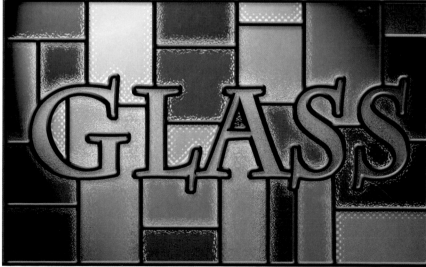

Plastic effect

You are probably familiar with the plastic effect that is often applied to display type or clickable buttons on web pages. While the effect applied to these objects is very effective, here we'll try something different and apply it to a human hand. There's great potential for using this technique to create some weird and wonderful android and sci-fi images.

We'll use Photoshop's Plastic Wrap filter, combined with a few layer blending modes and styles, to create this unique effect.

Tip

SUMPTUOUS STYLES!

With this effect, you're not limited to using the Style you've used here. It's worth experimenting with many of the Styles in the Web Styles library for the effect of different colored plastics and materials. Go on, try it. You might be pleasantly surprised!

1 Here, we'll "plasticize" a hand. With the start image open, choose the Magic Wand tool and set the Tolerance to 10 in the Options bar. Click with the Wand in the white area around the hand. Invert the selection using **Select** > **Inverse** (Ctrl/Cmd+Shift+I). Go to **Edit** > **Copy** (Ctrl/Cmd+C) and then go to **Edit Paste** (Ctrl/Cmd+V) to paste the hand onto a new layer. Right-click/Ctrl-click this pasted layer and choose Duplicate Layer so we have two hand layers.

2 To begin the plastic effect, click on the upper hand layer and go to **Filter** > **Artistic** > **Plastic Wrap**. In the Plastic Wrap dialog box, select 12 for Highlight Strength, 1 for Detail, and 15 for Smoothness. Click OK to apply the filter. Now drag this layer below the lower hand layer in the Layers palette and rename it "Plastic Wrap."

3 Click on the top Hand layer. On this layer we'll use a Photoshop Style and make modifications to it. Display the Styles palette using **Window** > **Styles**. Click the small, right-pointing arrow in the Styles palette, choose Web Styles and click OK. From the Style thumbnails in the palette, choose Blue Gel With Drop Shadow. Don't worry if the effect doesn't look too realistic, we'll modify it in the next step.

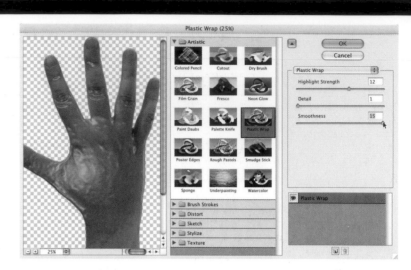

4 Set the blending mode for this layer to Darken, reducing the layer opacity to 75%. In the Layers palette, double-click the Hand layer to bring up the Layer Style dialog box and double-click the words Bevel and Emboss. Change the Depth value to 71%, and the Size to 152. While the dialog box is still open, uncheck the box for Outer Glow, on the left.

5 Click on the Plastic Wrap layer and change its blending mode to Luminosity.

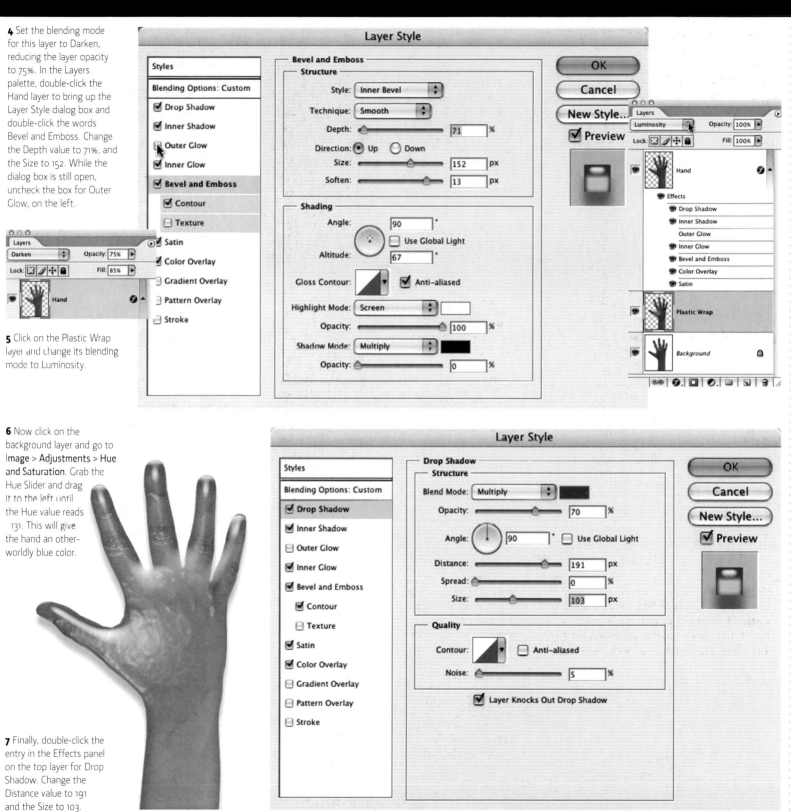

6 Now click on the background layer and go to Image > Adjustments > Hue and Saturation. Grab the Hue Slider and drag it to the left until the Hue value reads 131. This will give the hand an other-worldly blue color.

7 Finally, double-click the entry in the Effects panel on the top layer for Drop Shadow. Change the Distance value to 191 and the Size to 103.

PRESENTATION EFFECTS

Frame effect
Vignette effects
Painterly borders
Out of the frame
Signature or monogram custom brush

Frame effect

Every great image deserves a great frame. With Photoshop at our disposal, we have the ability to frame images digitally with surprising ease. What's more, unlike a local framing shop, Photoshop offers an almost endless array of colors and textures to choose from.

Essentially, the frame is constructed of simple flat fills on a couple of layers, combined with the sheer power of Photoshop Styles. By using Bevel and Emboss layer styles, we can create stunningly realistic molded frames with strong textures and beautiful effects.

Try this easy recipe and don't just print those images—frame them!

164

1 Open the image to be framed in Photoshop. We need to extend the canvas to allow space around the image for the frame. Hit D on the keyboard to revert to default foreground/ background colors and go to **Image > Canvas Size**. Ensure that the measurement units are set to inches for Width and Height. Now check the Relative check box. We want a fairly heavy frame on this image, so enter 2.5 inches in both the Width and Height boxes. Make sure that the central box is selected in the Anchor box and click OK.

2 Now choose the Magic Wand tool from the Toolbar, set the Tolerance to 10 in the Options bar, and click in the white border to generate a selection. Add a new layer to the image (Ctrl/Cmd+Shift+N), naming it "Frame." Fill this selection using **Edit > Fill**, choosing White for fill Contents.

3 Hit Ctrl/Cmd+D on the keyboard to deselect. Now add another layer, naming it "Frame Trim." On this layer we'll create a thinner section running around the frame. Choose the Rectangular Marquee tool and, from the Options bar, choose the Subtract from Selection icon. For guidance while making the next selection, display the grid using **View > Show > Grid**.

4 Using the grid as a guide, drag a selection about halfway through the width of the frame surround.

5 Click and drag another selection a small distance inside the previous one, making a thin strip selection running around the frame. Fill this selection using **Edit > Fill**, choosing 50% Gray as the fill color. Hide the grid, using **View > Show > Grid**.

6 Now we need to give the frame a surface. Display the Styles palette using **Window > Styles**. Click again on the Frame layer. In the Styles palette, click the small, right-pointing arrow and choose the Textures style set. From the Styles swatches, select Painted Wallboard.

8 Return to the Frame Trim layer, and from the Styles palette choose the Oak swatch. Emboss this layer. Go to **Layer > Layer Style > Bevel and Emboss**. Choose Pillow Emboss for Style and Smooth for Technique. Adjust the Depth, Size, and Soften sliders to taste. Click OK to apply the Layer Style.

7 Now that the main frame is decorated, we need to give it a 3D look. Go to **Layer > Layer Style > Bevel and Emboss**. Choose Inner Bevel for Style, Chisel Hard for Technique. Set the Depth slider to 81, Size to 46, and Soften to 16. These sliders can be adjusted to increase or decrease the depth of the frame as desired. Click OK to apply the Layer Style.

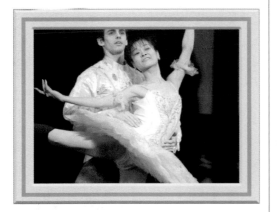

Tip

MORE STYLES

There are many variations on this simple frame, which you can alter to your own tastes or to suit a particular image, by simply choosing another style from the Styles palette. Photoshop has many textures and surfaces contained within the various Style sets, which are available by clicking the small, right-pointing arrow in the palette.

165

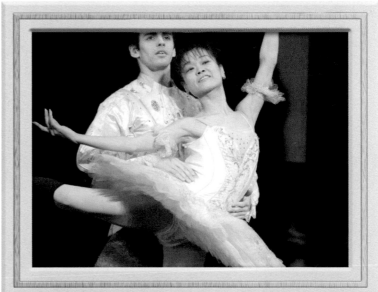

Vignette effects

The vignette, another classic photographic printing technique, is presented here with a digital twist. In essence, a vignette (an edge effect in which the image fades off gradually), can be a soft mask of any shape around an image, and can be easily applied digitally with the aid of a simple layer mask. Layer masks are effective because we can construct any black-filled shape on a mask and use it as a vignette. The optimum degree of blur for the shape is achieved using Filter > Blur > Gaussian Blur. This gives us almost unlimited possibilities, and raises this classic technique to new heights.

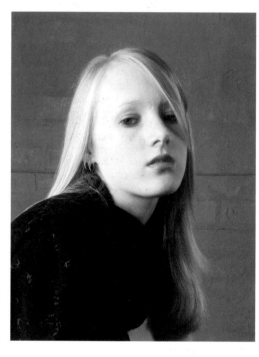

1 For the vignette effect to be successful, the original image needs to have plenty of room around the main subject.

Begin by adding a new blank layer to the chosen image (Ctrl/Cmd+Shift+N) and calling it "Vignette."

3 Once the vignette selection is in position, choose an appropriate color for the fill by clicking the foreground color swatch.

Then invert the selection by going to **Select** > **Inverse** (Ctrl/Cmd+Shift+I).

2 The simplest vignette is the classic oval. Choose the Elliptical Marquee tool from the Toolbar and ensure that Normal is selected from the Mode box in the Options bar. Drag an oval selection within the image, covering the center of interest. The selection can be moved into place by simply clicking-and-dragging inside the active selection.

4 Now to fill the vignette selection with the foreground color, choose the Paint Bucket tool and click within the active selection. After filling, hit Ctrl/Cmd+D on the keyboard to deselect.

5 Blur the vignette layer to create the effect. Go to **Filter** > **Blur** > **Gaussian Blur** and make sure that the Preview box is checked in the Gaussian Blur dialog box. The higher the blur

Radius setting, the softer the vignette effect will be, so experiment with the slider until a satisfactory result is reached. I've chosen a Radius of about 41. Click OK.

6 Tweak the color of the vignette layer using **Image** > **Adjustments** > **Hue/ Saturation**. Check the

Preview box, and move the Hue slider to find an appealing color.

7 Any of the other selection Marquee tools can be used to create the vignette, so

it's worth experimenting with different shapes in the initial stages.

8 You can also use the Custom Shape tool to create the vignette. This gives a great deal of flexibility for creating the initial shape. After adding the new layer, choose the Custom Shape

tool from the Toolbar. Ensure that the Paths icon is selected in the Options bar and choose a shape from the Shape Picker. Drag the shape over the image.

9 Click on the Paths palette tab and right-click/ Ctrl-click the Work Path, choosing Make Selection. Invert the selection using **Select** > **Inverse** (Ctrl/ Cmd+Shift+I). Then fill and blur the vignette by the procedure detailed in the previous steps.

It's surprising how a simple border effect can elevate a run-of-the-mill snapshot into a more attractive piece of art. Painterly borders in particular lend a certain sophistication to an image, and are surprisingly easy to create.

With Photoshop, half of the work is already done for us, as we have a vast selection of natural media and texture effect brushes at our fingertips. These special brushes are stored in brush libraries, which can be loaded from the Brush Picker using the small, right-pointing arrow. Again, layer masks are key to this technique, allowing us to achieve very subtle levels of varying opacities in the border.

1 Open an appropriate image and right-click/Ctrl-click the background layer. Choose Duplicate Layer from the sub-menu, and name the new layer "Border Layer." This will form the main image layer that will have the border applied to it.

2 The original background layer will become the virtual canvas beneath the image layer. Click on the background layer now. Choose two similar colors for the foreground and background at the bottom of the Toolbar, one slightly darker in tone than the other.

3 Hide the Border layer by clicking its visibility eye in the Layers palette. Click on the background layer and go to **Filter > Render > Clouds**. Blur it considerably with Gaussian Blur. I've used a radius setting of about 60. Rename this layer "Canvas" by double-clicking the background layer in the Layers palette.

4 Activate the Border layer again and go to **Edit > Transform > Scale**. Lock the Maintain Proportions link in the Options bar and reduce the size of the layer with the corner handles (the size of the window may need to be increased so that the handles can be seen clearly). When you're happy with the resizing, click the Commit checkmark in the Options bar.

Tip

IT'S BLACK AND WHITE

Remember that layer masks work on a purely grayscale basis, where white reveals the associated layer and black hides it. Shades of gray (or black at lower opacity) partially reveal the associated layer, so by using a pressure-sensitive stylus and tablet you can achieve very subtle transparency tricks around your border.

5 Add a layer mask to the Border layer, using **Layer > Layer Mask > Reveal All**.

6 With the layer mask active, select the Brush tool and click in the Brush Picker. Click the right-pointing arrow and choose Wet Media Brushes. Load the brushes and select Rough Dry Brush from the thumbnails. If you're using a graphics tablet, hit F5 to display the Brush Options panel. Click the Other Dynamics category and set the Opacity Jitter control box to Pen Pressure. Ensure that the Shape Dynamics category is unchecked.

7 Increase the brush size using the square bracket keys on the keyboard, and paint around the very outside edge of the image, using black for the foreground color. Completely obliterate the edge, giving it a rough, broken effect.

8 Reselect the Brush Picker and choose Large Texture Stroke. Set Opacity Jitter to Pen Pressure again if you're using a graphics tablet. Paint with black around the edge of the image, this time painting further inside the outer edge at a lower opacity to create semi-transparent brushstrokes. Reduce the opacity of the black the farther into the image you paint.

9 Finally, to add a touch of texture, select the Canvas layer in the Layers palette and click the "Create new fill or adjustment layer" icon at the base of the palette. Choose Pattern from the menu and click in the Pattern thumbnail. Load the Artist Surfaces and choose Canvas. Increase the pattern scale to 650 and click OK. Set the blending mode for this layer to Soft Light.

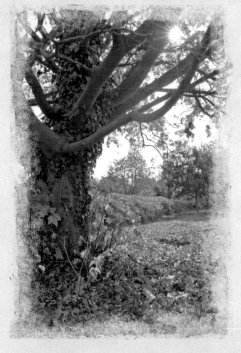

Out of the frame

By definition, frames and mounts are enclosing devices, but in the world of Photoshop anything is possible. Here, subject and frame interact, 2D melds with 3D, complete with the interplay of shadows. The key to this project is the stacking order of multiple layers; the use of a Bevel and Emboss layer style completes the illusion. This is a great technique for adding an extra dimension to images.

170

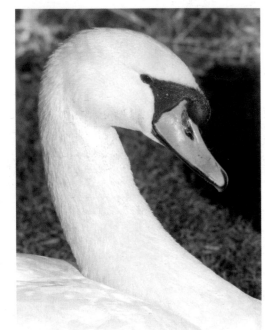

1 Open the image of the swan. Use the Rectangular Marquee tool to make an off-center selection, ensuring that the swan's beak and part of its head project outside the selection itself. Go to **Select** > **Inverse** (Ctrl/Cmd+Shift+I) and right-click/Ctrl-click within the selection, choosing Layer Via Copy.

3 Hit Ctrl/Cmd+D to deselect and click on the Swan's Head layer. Add a layer mask, using **Layer** > **Layer Mask** > **Reveal All**. Choose the Brush tool and paint black onto the mask to hide everything on the layer except the swan's head. Zoom in very close to mask around the outline of the head, using a very small brush. If you accidentally break into the head outline, swap the background and foreground colors and paint back into the mask with white. When it's complete, right-click/Ctrl-click the layer mask thumbnail and choose Apply Layer Mask.

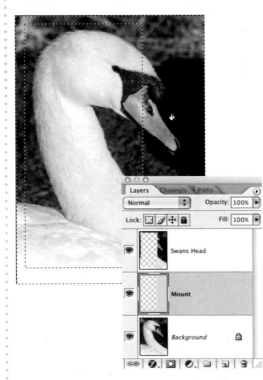

2 In the Layers palette, rename the new top layer "Swan's Head." Ctrl/Cmd-click this layer thumbnail to make a selection from its transparency. Then return to the background layer, add a new layer (Ctrl/Cmd+Shift+N), and call it "Mount." Choose a light straw color for the foreground and click inside the selection with the Bucket Fill tool.

4 Duplicate the Swan's head layer (Ctrl/Cmd+J) and go to **Image** > **Adjustments** > **Threshold**. Drag the pointer to the right to turn the layer element completely black and click OK. Now blur the layer by going to **Filter** > **Blur** > **Gaussian Blur**, using a Radius of 50 pixels.

5 Drag this layer below the layer containing the swan's head, reduce the opacity to 55% and set the blending mode to Darken. Go to **Edit** > **Transform** > **Scale** and drag the corner handles to enlarge the shadow a little. Before committing the transformation, move the shadow down and to the right a little. Erase any shadow that shows over the swan's head.

6 In the Layers palette, return to the Mount layer and click the "Add a layer style" button at the bottom of the palette, choosing Bevel and Emboss. In the dialog box, choose Inner Bevel for the Style and experiment with the Depth slider before clicking OK. I settled on a depth of 131.

7 Click the background layer and choose a light cream color for the background color. Go to **Image > Canvas** Size, check the Relative box, and add one inch to each dimension.

8 Return to the Mount layer and go to **Filter > Texture > Texturizer**. Choose Canvas for the texture, use a high Scale value and choose Top Left for Light Direction.

9 Choose the Vertical Type tool, click on the Swan's head layer, and click in the image to add the text. Adjust the font and size, and select a suitable color, using the Options bar. Hit the Commit checkmark in the Options bar to fix the type.

Tip

CREATING AND MODIFYING TYPE

Using both the Horizontal and Vertical Type tool, there are many ways in which you can modify the appearance of the type itself. The size of the type and the font face can be chosen from the Options bar while the tool is active. A useful shortcut here is to click once in either of these options, and then use the up and down arrow keys on the keyboard to scroll through the various fonts and sizes. Many more variables can be found in the Character palette, displayed using Window > Character. Type can be re-edited at any point during the image-making process by double-clicking the thumbnail for the type layer in the Layers palette.

Signature or monogram custom brush

Anyone who takes pride in their images may want to add their signature to the finished piece. This can sometimes be a rather laborious and fiddly process with digital images, especially if using a mouse. The smart solution is to create a custom brush, so your signature can be stamped onto your images at any size and in any color with a single click.

A custom brush can be created with any grayscale image, although it works best if the background of the original image is pure white. Obviously, if you have a pressure-sensitive graphics tablet instead of a mouse, it's a lot easier to write your name, but you can always use the Type tool instead of actually writing your signature.

172

1 Go to **File** > **New** and make a file measuring 3 inches wide by 2 inches high, at a resolution of 300 dpi. Choose Grayscale for the Color Mode and White for Background Contents.

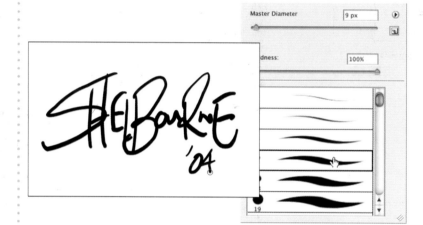

2 Zoom out so the blank image is fairly small in the workspace, and choose the Brush tool. Select a small, hard-edged brush from the Picker and write your usual signature across the blank canvas using black. (You may also want to include a copyright symbol.)

3 Now go to **Select** > **All** (Ctrl/Cmd+A). To define this image as a custom brush, with the entire canvas selected, choose **Edit** > **Define Brush Preset**. Type in a name for the new brush in the space provided and click OK.

Master Diameter — 772 px

Use Sample Size

Hardness:

4 The new brush will be stored in the currently loaded Brush set. Make sure to note which set is displayed, so it'll be easy to find the brush in the future.

5 To use the signature brush, open an image, choose the Brush tool, and select the signature brush from the Brush Picker. To add the signature to the image, simply click once with the brush. The size of the brush can be varied with the bracket keys. Voilà! No more repetitive signing!

6 To make a custom brush using a monogram instead of a handwritten signature, use the Type tool instead of the Brush. In the blank canvas, click with the Type tool and add your first initial. Click the Commit checkmark to confirm.

Layers Channels Paths
Normal Opacity: 100%
Lock: Fill: 100%

T S

T T

Backg

7 Click again with the Type tool and add the second initial, again committing the type in the Options bar. Each initial will be placed on a separate Layer.

Layers Channels Paths
Normal Opacity:
Lock: Fill:

T S

T T

Background

8 Use the Move tool to move the second letter over the first, and adjust the size of the second initial using the size box in the Options bar. Any aspect of the type can be re-edited at any point during the process by double-clicking the appropriate type layer in the Layers palette. When it's finished, flatten the image using **Layer > Flatten Image** and define the custom monogram brush as in step 3.

9 To add more interest to the monogram once it's on an image, choose **Window > Styles** to display the Styles palette. Hit the small, right-pointing arrow in the Styles palette and choose Text Effects 2. Then choose a style from swatches in the palette. Try loading one of the other Styles sets for different effects. For this technique to work, the signature or monogram must be stamped on a layer of its own.

Glossary

Adjustment layer A specialized layer that can be handled as a conventional layer, but designed to enact effects on layers below it in the image "stack." These include changes to levels, contrast, and color, plus gradients and other effects. These changes do not permanently affect the pixels underneath, so by masking or removing the adjustment layer, you can easily remove the effect from part or all of an image with great ease. You can also return and change the parameters of an adjustment layer at a later stage.

Alpha channel A specific channel used to store transparency information. Alpha channels can be used to store and control selections and masks.

Blending mode In Photoshop, individual layers can be blended with those underneath, rather than simply overlaying them at full opacity. Blending modes control the ways in which the layers interact, enacting changes on one layer using the color information in the other. The result is a new color based on the original color and the nature of the blend.

Channels In Photoshop, a color image is usually composed of three or four separate single-color images, called channels. In standard RGB mode, the Red, Green, and Blue channels will each contain a monochromatic image representing the parts of the image that contain that color. In a CMYK image, the channels will be Cyan, Magenta, Yellow, and Black. Individual channels can be manipulated in much the same way as the composite image.

Color cast A bias in a color image, either intentionally introduced or the undesirable consequence of a mismatch between a camera's white balance and lighting. For example, tungsten lighting may create a warm yellow cast, or daylight scenes shot outdoors with the camera's color balance set for an indoor scene may have a cool blue cast.

Contrast The degree of difference between adjacent tones in an image, from the lightest to the darkest.

Crop To trim or mask an image so that it fits a given area or so that unwanted portions can be discarded.

Curves A Photoshop tool for precise control of tonal relationships, contrast, and color.

Depth of field The range in front of the lens in which objects will appear in clear focus. With a shallow depth of field, only objects at or very near the focal point will be in focus and foreground or background objects will be blurred. Depth of field can be manipulated in-camera for creative effect, and Photoshop CS2's new Lens Blur filter enables you to replicate it in postproduction.

Displacement map An image used with filters such as Displace to determine the level and position of distortion to be applied. Any Photoshop PSD file can be used as a displacement map, except those saved in Bitmap mode. The Displace filter uses the first channel in the image for horizontal displacement, and the second channel for vertical displacement.

Dodge A method of lightening areas in a photographic print by selective masking. Photoshop simulates this digitally.

Drag To move an item or selection across the screen, by clicking and holding the cursor over it, then moving the mouse with the button still pressed.

Eyedropper A tool used to define the foreground and background colors in the Tools palette, either by clicking on colors that appear in an image, or in a specific color palette dialog box. Eyedroppers are also used to sample colors for Levels, Curves, and Color Range processes.

Feather An option used to soften the edge of a selection that has been moved or otherwise manipulated, in order to hide the seams between the selected area and the pixels that surround it.

Fill A Photoshop operation which covers a defined area with a particular color, gradient, or texture pattern.

Gradient A gradual blend between two colors within a selection. The Gradient tool can be set to create several types, including linear, radial, and reflected gradients.

Graphics tablet A drawing device consisting of a stylus and a pressure-sensitive tablet. Many people find them easier to use than mice for drawing. The pressure sensitivity can be set to different functions, such as controlling the opacity of an eraser, or the width of a brush.

Grayscale An image or gradient made up of a series of 256 gray tones covering the entire gamut between black and white.

Halftone A technique of reproducing a continuous tone image on a printing press by breaking it up into a pattern of equally spaced dots of varying size—the larger the dots, the darker the shade.

Handle An icon used in an image-editing application to manipulate an effect or selection. These usually appear on screen as small black squares which can be moved by clicking and dragging with the mouse.

Hard light A blending mode that creates an effect similar to directing a bright light on the subject, emphasizing contrast and exaggerating highlights.

High-key image An image comprised predominantly of light tones.

Histogram A graphic representation of the distribution of brightness values in an image, normally ranging from black at the left-hand vertex to white at the right. Analysis of the shape of the histogram can be used to evaluate tonal range.

Lab Color mode An intermediate color mode used by Photoshop when converting from one mode to another. It is based on the CIE L*a*b* color model, where the image is split into three channels, "L," the luminance or lightness channel, and two chromatic components, "a" (green to red) and "b" (blue to yellow).

Layer A feature used to produce composite images by suspending image elements on separate overlays. Once these layers have been created, they can be re-ordered, blended, and their transparency (opacity) may be altered.

Layer styles A series of useful preset effects that can be applied to the contents of a layer. Examples include drop shadows, embossing, and color tone effects.

Layer mask A mask that can be applied to elements of an image in a particular layer, defining which pixels will or will not be visible or affect pixels underneath.

Low-key image A photographic image consisting of predominantly dark tones, either as a result of lighting, processing, or digital image editing.

Midtones The range of tonal values that exist between the darkest and lightest tones in an image.

Motion blur In photography, the blurring effect caused by movement of objects within the frame during the exposure of the shot. Photoshop contains filters to replicate motion blur.

Multiply A blending mode that uses the pixels of one layer to multiply those below. The resulting color is always darker, except where white appears on an upper layer.

Noise A random pattern of small spots on a digital image, usually caused by the inadequacies of digital camera CCDs in low-light conditions. Photoshop's Noise filters can add or remove noise from an image.

Opacity In a layered Photoshop document, the degree of transparency that each layer of an image has in relation to the layer beneath. As the opacity is lowered, the layer beneath shows through.

Overlay A blending mode that retains black and white in their original forms, but darkens dark areas and lightens light areas.

Pen tool A tool used for drawing vector paths in Photoshop.

PPI Pixels per inch. The most common unit of resolution, describing how many pixels are contained within a single square inch of an image.

Quick Mask A feature designed to rapidly create a mask around a selection. By switching to Quick Mask mode, the user can paint and erase the mask using simple brushstrokes.

Index

Acknowledgments

Behind every good book, there's a great wife, and this one would have never happened without mine. Love you Bibs. x

Love and thanks to Mum and Dad for a life's worth of love, support, and constancy, and to Mum King for never losing faith. Many thanks also to Robert Townhill, Dennis and Kelly Kochanek, Paul and Sandra Fort, and everyone at the Priory at Grantham! Thanks to my editor Ben Renow-Clarke, for his endless patience and expertise.

Thanks to everyone else who helped in any way with this project.

And finally, here's to absent friends.

PICTURE CREDITS

Some great professionals helped in the production of this book:

Tim McCann supplied start images for the following spreads:
Day into night
Simulating lightning
Simulating rain
Creating a neon sign
Creative black and white

Alan Mitchell (http://www.alanmitchelldp.co.uk)
supplied start images for:
Tone separations
Infrared photography effect
Painting clouds into skies
Creating snow
Simulating sunsets

Simon Joinson supplied start images for:
Pen-and-ink drawing

Absolutevision.com supplied start images for:
Psychedelic poster effect
Plastic effect
Adding fire and flames
Simulating color filters